MW00637979

Universal Principles of Typography

100 key concepts for choosing and using type

Elliot Jay Stocks
foreword by Ellen Lupton

ROCKPORT

Typographic systems (continued)

OpenType & web typography & variable fonts

Going further

Foreword *by Ellen Lupton*

Reading this book is like sitting down with a friend and learning everything you can about their favorite subject. Your friend is Elliot Jay Stocks, and he knows a lot about typography. Elliot has applied decades of joyful design energy to the worlds of print and web. He has designed fresh and functional projects for clients, and he has edited and authored his own publications, books, brands, and websites. To create the magazine *8 Faces,* Elliot interviewed dozens of designers he admired. He crawled inside their brains and gathered up the very best nuggets. The magazine became a book, and the book became a collector's item. In 2014, Elliot got curious about how creative people go about their daily lives, so he started another magazine, *Lagom,* with his wife, Samantha Stocks. They traveled around the world to learn how artists and makers like to live, work, and travel. Elliot and Samantha filled their magazine with gorgeously photographed stories about how to sustain your soul while flourishing creatively.

Elliot's passion for typography fuels his client work and his independent publishing. Elliot loves typefaces, fonts, and the people who make and use them. Back in the 2010s, when web designers and developers were just starting to figure out how to put more than four fonts on the web, Elliot stepped up and became an advocate for online typography. As Creative Director of Adobe Typekit, he helped transform the organization from a web font service into Adobe Fonts — a comprehensive font-syncing platform encompassing print and digital media. In 2020, he teamed up with Google Fonts to create Google Fonts Knowledge, a library of practical guides that anyone can access. Elliot knows typography, and he knows how to explain it in cheerful and forgiving ways.

If you are a designer or any other person who uses type, you will love your new friend, Elliot. You can hike deep into the woods together for the weekend, immersed in a typographic survival course, or you can drop by with a quick question. This book is called *Universal Principles of Typography*. Each spread explains a single principle — a structure, pattern, practice, or method. Read

the table of contents to see what you already know and what you definitely need help with. Topics like "Adjusting line height is the easiest improvement to make," "Kern only if you have to," "Size doesn't exist," "Keep your content flexible," and "Do better at internationalization" will inspire you to question your assumptions and stretch your field of vision.

Elliot is a digital native who has been playing with type on the web since he was a kid. He tells us that typographic principles are universal across print (where they began) and digital media (where they mostly live now), but his book is tailored for the demands of the screen. *Universal Principles of Typography* explores essential knowledge for UI / UX designers, product designers, and print designers. Beginners will feel comfortable here, and experienced designers will find plenty to learn, as Elliot shows you how to make the most of baseline grids, type scales, stylistic sets, contextual alternates, and other advanced subjects.

Good teachers know how to show and tell. To understand typography, you need to see it in action and — in a more intellectual way — unwind the concepts that make it or break it. Typographic knowledge is an awkward mix of science (how people read), technology (what fonts can do), super-stition (what folks believe on faith), hard-and-fast rules (what editors and publishers have codified over time), and unspoken body language (how designers wiggle and fidget inside the rules, inventing new styles and mannerisms). Elliot explores all these forms of knowledge with pictures and words, helping designers navigate the facts and the fictions, and build their own typographic confidence.

Introduction

Type is set by so many people, so many times a day, in so many different circumstances, that it's all too easy to use it with barely a thought. And yet with type's great familiarity comes great responsibility. Regardless of what our text actually says, poor typographic choices have the potential to miscommunicate and — worse still — load that text with the wrong message. At the very least, they risk making reading more difficult: a typeface with no designs for *foreign* characters, resulting in jarring substitutions for fallback fonts; a paragraph set too wide, causing the eye to struggle finding the next line; a missing italic style that leaves a browser distorting the regular type.

For most, typography means "changing the font." And, although we certainly *do* discuss the huge emotional and technical impact type choice has in the typographic conversation as a whole — including in this book — choosing one is not *technically* part of typography. But I make this point not to burden you with the tedious semantics of an art form hidden behind a veil of pedantry, but to demonstrate that we can actually practice good typography simply by making subtle changes to the font we're already typing with. Rather than mystify the practice, I believe we should be empowering everyone with the skills that can so drastically improve our ability to communicate via text, if only to reduce the amount of poorly set text we see daily, both online and offline.

Good typography is for all, and this book aims to demonstrate that belief. And make no mistake: bad typography is not just a malpractice reserved for parents making kids' party invitations, restaurants printing their own menus, or marketers creating social media graphics without the support of a design team; even for professional designers, it's all too easy to stick with those default settings, reach for a font that lacks certain features, or change a paragraph rule without considering how those tweaks might impact the text overall. And, conversely, practicing *good* typography is not exclusively the domain of experienced designers, either — there's no reason why some informed typographic choices can't elevate even the humble Word document.

NAVIGATING THIS BOOK

You'll notice that the title of almost every chapter contains a key word or two that are emphasized, and each chapter also contains a "see also" section that points to these various key words. Think of this as a way to navigate the book. If you're reading the "Keep things in the family" chapter that says you should also see *Licensing,* you can easily find chapters that contain this emphasized word in their titles, either by flicking through the book or referencing the Contents page.

What does it mean, then, to really *understand* type? To use it with clear intent and purpose? This is the question at the heart of this book.

The art and science of typography combines subtle tweaks to line lengths with harmonious combinations of weights and styles; considered typeface pairings with a robust set of alternate characters; exciting technological advances with the realities of licensing fonts for paying (and occasionally nonpaying) clients. The considerations go way beyond simply scrolling through a font menu.

Universal Principles of Typography seeks to open the world of typography to the curious, but also to offer depth to the seasoned designer. Because we're all users of type, and we're all therefore typographers. And there are so many ways that we typographers can optimize how our text is read and influence the way its message is understood.

In the following 100 universal principles, we'll explore all of the subtle but powerful ways that typography can be used to communicate in the most effective way. "Most effective" means starting with readability—can the reader actually *understand* the text?—before moving on to expression— how does the reader *feel* when they read the text? It's this influence over the reader's emotions that allows us to best convey our message. And it's typography's power to work on a subconscious level that affords the designer great power and, again, great responsibility.

These 100 universal principles are not the only ones, of course. And they're focused primarily through the lens of Latin type, since the nuances of other writing systems go beyond the scope of a single book. But following these principles—or at least exploring them as options—will lead you to a world of better typography, and your readers will thank you for it. Happy typesetting!

Getting to know type

1
Typography matters

Text is the main way we communicate our message, so we need to make sure we're conveying it in the best way possible.

SEE ALSO

Nix's hierarchy of typographic needs · We need more fonts

There are some people who think that typography doesn't really matter—most people, perhaps. They might think that it's not worth fussing over all these seemingly tiny details because the average person is never going to notice. In fact, something a lot of designers ask me is, "how do I convince my boss or client that it's worth spending time and money on typography?"

John Boardley,[1] in his foreword to the first issue of my magazine *8 Faces,*[2] said that *"typography matters because words matter"* and likens the typographer's role to that of a chef, adding *"just a pinch of this, a dash of that; indeed, perhaps so little that most but the informed gourmand would not detect their inclusion."* I've found the food analogy pretty useful: just as you can take great ingredients but completely ruin a meal by not focusing on the proportions and the relation of one ingredient to another, you can give your readers a terrible reading experience by taking great type and setting it without careful consideration.

While explaining all of this can be helpful, my suggestion is usually to show rather than tell: take some text and do some typography on it! Nothing special. In fact, the subtler, the better. Tweak the line height of a paragraph to make it a little more readable. Adjust the measure of a text block to ease the eye. Improve the appearance of all-caps type by adjusting the leading. And make all of these changes in as lo-fi a manner as possible, perhaps even using a word processor or a slide-creation app. Seeing the difference even small changes make in everyday context will pave the way for your boss or client investing in even bigger changes.

I'll quote John Boardley from *8 Faces* again:

"Good typographers and good type designers obsess over the detail, so that readers don't have to."

He concludes by saying that the details' perceived invisibility actually *"confirms their efficacy."* Saying you don't care about typographic details means you don't care about *any* details. Now, is that a good message any boss or client *ever* wants to send?

[1] Founder of ilovetypography.com

[2] *8 Faces* was a typography magazine I founded in 2010, and it ran for eight issues until 2014. It was then republished as a book, *8 Faces: Collected,* in 2018, and lives on at 8faces.com.

→

Manipulating Anybody's width axis—and weight axis in "words"—allows us to get each line taking up the exact same horizontal space, despite the different word lengths. You'll find many benefits of variable fonts included throughout this book.

BECAUSE WORDS MATTER

2

There's *no excuse* for setting bad type

We've got it so good, and we have such great defaults to work from, all we need to worry about is finessing.

SEE ALSO

Font · Line height · Web typography

In a book on typography, it's essential to define what type is. Simply put, type refers to mechanized writing — an invention that made recreating text easier and faster than handwriting. This innovation required numerous decisions about type's organization, usage, and optimization, leading to the practice of what we now call typography.

Typefaces describe the design — the aspect that exists somewhat conceptually — while fonts represent their physical application (explored further on page 14). Since its inception, type has evolved through various forms: initially as wood type, followed by metal type; then the short-lived phototypesetting era, before transitioning into digital fonts with the age of desktop publishing, and then the internet.

Interestingly, the people working with type have evolved drastically, too. Not long ago, it was the printer who held the knowledge about typography, and the average person had no way of setting type; or at least anything that resembled a professional design. Typewriters bridged this gap somewhat, but before commercial availability of desktop typewriters, most keyboards were used by the highly specialized operators of the Monotype and Linotype machines.

My point is this: these days, anyone can set type, and therefore we're all typographers. And, because setting type is so easy — when compared to previous methods in type's history — there's no excuse to set bad type, is there?

⟶

Linotype operator, newspaper office, San Augustine, Texas, 1939. Image obtained from the Library of Congress at loc.gov/pictures/item/2017783030

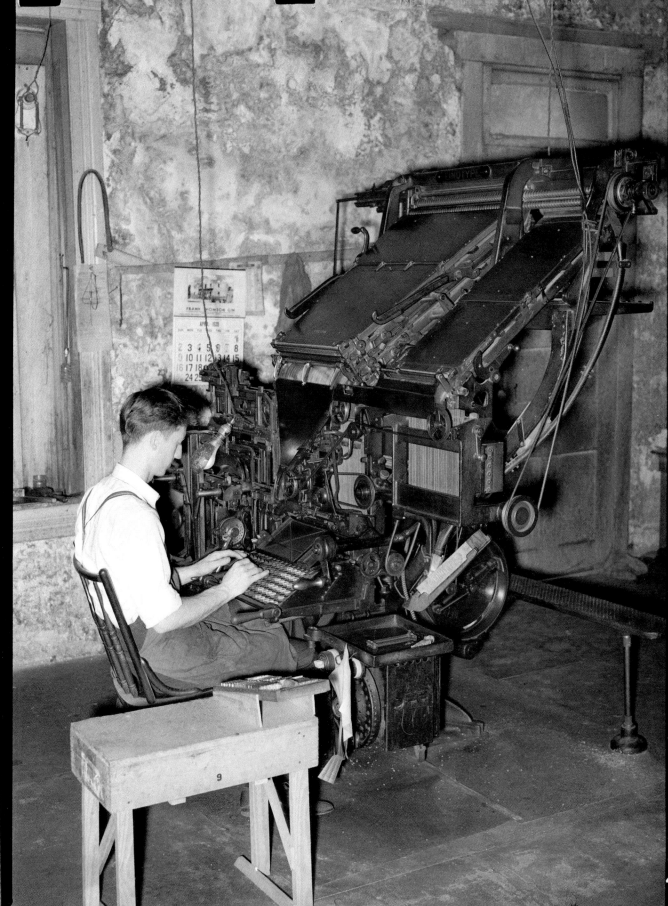

3

A *font* isn't the same as a *typeface*

It might seem pedantic, but the distinction is important when we're talking about type.

SEE ALSO

Choose typefaces • Styles • Weight • Variable fonts

Okay, let's get this one sorted once and for all, because it's not just about being a pedantic type nerd. Well, maybe it's a *little* bit about being a pedantic type nerd. But this stuff is important to get right! Especially at the beginning of a book about typography. Most people—even quite a few type people, actually—use the words "typeface" and "font" interchangeably, but there *is* a subtle difference.

First, let's think of a typeface as the slightly ephemeral, intangible "thing" that is dreamed up. A bit like a song. You can record a song, you can remix it, you can re-record it, but the original composition is still a thing that exists in the ether—that's like the typeface. To experience the song, you need a vessel: an MP3 file, a stream, a video, a performance—that's like the font.

Now, this analogy isn't watertight. After all, the act of designing type digitally also includes a lot of font production decision-making that means that the two processes are very much linked. But that's also perhaps like the creation of electronic music, where the sound design of that particular moment in time is integral to what makes up the composition. At least that's how I view my own musical experiments.[1]

So the typeface is the *design,* the font is the *carrier.*

Got it?

Great.

But this does highlight one extra definition that's worth getting right: a weight or style is a *font* of a particular typeface. For instance, OT Miniature (see opposite) is a typeface; OT Miniature Bold is a font. How does this work if there's only one weight or style of a typeface—is Despeinada (also opposite) a typeface *and* a font? Yes, but again, it comes back to that original definition and the context: we'll likely say "typeface" when we're discussing the use of Despeinada for our brand's blog headings, and "font" when we're talking about handing font files to our developer colleagues. The same is true when discussing variable fonts, where the traditional delineations of weights and styles no longer apply.

In practical day-to-day use, font and typeface are often interchangeable, and validly so, but it's good to keep the subtle difference in mind.

[1] You can listen to some, if you like: my music, released as Other Form, is on all the usual music streaming platforms.

Typeface {

OT Miniature

Font {

OT Miniature Extralight

OT Miniature Extralight Italic

OT Miniature Light

OT Miniature Light Italic

OT Miniature Regular

OT Miniature Regular Italic

OT Miniature Bold

OT Miniature Bold Italic

OT Miniature Black

OT Miniature Black Italic

Typeface and font {

Despeinada

4

Characters **are** **different from** *glyphs*

The character is the concept. The glyph is the thing we actually use.

SEE ALSO

Alternates • Em square • Ligatures • OpenType • Stylistic sets

⟶

Letters can have multiple characters, and characters can have multiple glyphs. And glyphs can contain multiple characters (and therefore letters), too. It's okay to be confused.

Even the most experienced designer can be guilty of using the terms "character" and "glyph" interchangeably, but there's a difference worth remembering. You might not get any applause for it at dinner parties, but you'll avoid looking silly in branding meetings.

A character is the somewhat abstract concept connected to an elemental part of a script or writing system. Consider the way we draw a lowercase "a" — in the Latin script, it has an accepted core structure, despite subtle differences in typefaces, lettering, and handwriting. It doesn't even matter that in some languages and dialects, its pronunciation differers. What's important is that there's an agreed-upon way to visually express the "a" character. The uppercase "A" is its own character, with a totally different structure, but the two are connected by the concept of a single letter.

A glyph, on the other hand, is the concept of the character manifested in the real world. This is slightly harder to grasp with digital type, so perhaps it's easier to think back to the days of metal or wood type, where you could actually hold each glyph in your hand as a block of type. Digitally, a glyph is what's shown to the end user as they type words in a document, and it's those glyphs that we then manipulate typographically, from changing the font size (effectively, the size of the glyph's em square), to adjusting the tracking (the additional horizontal space either side of each glyph).

Importantly, a single character can have multiple glyphs. Thanks to the power of OpenType, we might type the lowercase "a" character with a font that contains alternate glyphs, and then choose to use those other versions manually (as when selecting a particular stylistic set) or automatically (via contextual alternates). And the reverse is true, too: a single glyph can contain multiple characters, as in the case of ligatures. The common "fl" ligature, for instance, contains both the "f" and "l" characters.

Each font contains a database known as a glyph table, and each glyph takes up one space in that table. This table's structure is standardized according to Unicode recommendations, so that when we want to insert an "a" character into our text, it's always found in the same place, regardless of the font.

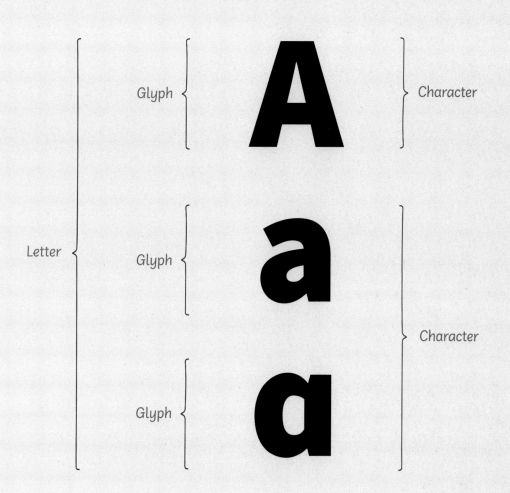

Letter {
 Glyph { **A** } Character
 Glyph { **a** }
 Glyph { **a** } Character

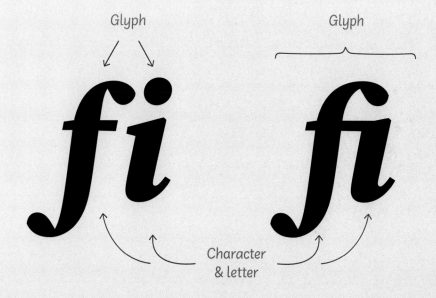

Glyph Glyph

fi *fi*

Character
& letter

5
Understand type *anatomy*

The shapes and the shapes inside those shapes all have names.

SEE ALSO

*Classification •
Metrics • X-height*

There are some basic terms that relate to the anatomy of type that it's useful to know when discussing certain features of different typefaces. Metrics are probably the terms many people encounter first, even if they don't know that they're metrics, and they're especially useful because they're relevant to many typographic changes we make (such as the x-height affecting leading). We explore metrics in detail on the next page.

Other terms are a little more specific to discussing letterforms and are more useful when analyzing type during the typeface-choosing process (such as the shape of the serifs on typeface A versus typeface B). Here's a very quick overview of type anatomy, and please note that these are specific to typefaces for the Latin script.

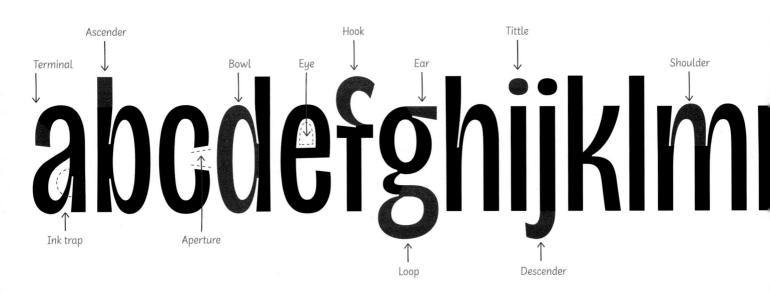

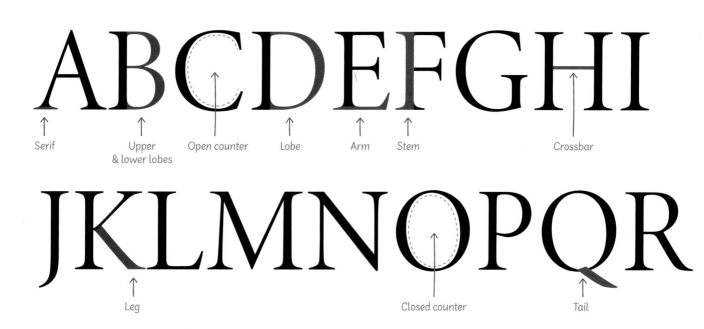

ABCDEFGHI

↑ Serif ↑ Upper & lower lobes ↑ Open counter ↑ Lobe ↑ Arm ↑ Stem ↑ Crossbar

JKLMNOPQR

↑ Leg ↑ Closed counter ↑ Tail

STUVWXYZ

↑ Spine ↑ Foot

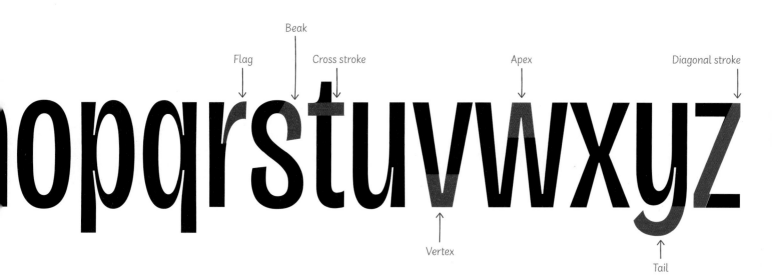

nopqrstuvwxyz

Flag Beak Cross stroke Apex Diagonal stroke

Vertex Tail

6

Become familiar with your font's *metrics*

They're useful to know because they affect the type's perceived size and how it interacts with other type around it.

SEE ALSO

Anatomy • Baseline • Em square • Font • Kern • Line-height • Spaced • X-height

All fonts have vertical metrics, which correspond to the proportions shared across the glyphs in the font file. These measurements are used to determine how the glyphs are rendered on screen, and letterforms' adherence to these metrics is what makes a typeface feel cohesive. However, they are effectively just guidelines, as the type designer is free to position the shapes as they see fit (as they might in an informal design intended to look like messy handwriting).

Starting from the top down, these are the vertical metrics we commonly encounter (and which are made visible in type design software), along with some average values, assuming a typical em square height of 1000 UPM (units per em):

* **Ascender height**: the height of the ascenders in lowercase characters (800)
* **Cap height**: the height of uppercase characters (700)
* **X-height**: the height of lowercase letters, not including any ascenders (500)
* **Baseline**: the line upon which all characters appear to rest (0)
* **Descender depth**: the depth of descenders in lowercase letters (-200)

Although the order of these almost never changes, it's not completely uncommon to see ascender height and cap height sharing the same value in some typeface designs, such in sans serifs. Type design software usually provides customizable visual references for overshoots and undershoots, too.

We focus a lot on the vertical metrics, but let's not forget the horizontal metrics that also exist in a font, and that vary for each glyph. When discussing a well-spaced font, we typically refer to the designer or font engineer's adjustments to the side bearings (horizontal spaces) that achieves an optimal balance of readability among the majority of glyph combinations.

This shouldn't be confused with kerning, which serves as the exception to those rules by providing specialized spacing adjustments for occasionally problematic character pairings, such as the need for reduced spacing between "A" and "V".

⟶

Most typefaces' ascender heights sit slightly above their cap heights; however, many type designers frequently choose to make both heights the same—especially in sans serif designs. On some occasions, cap height might even sit *above* ascender height, although this is far less common. The solid lines show the main (labeled) metrics; the dashed lines are *not* metrics but represent guides for overshoots and undershoots, which exist in type design software to aid the design process. (However, they vary in position depending on the weight and style, unlike metrics, which are persistent.)

Ascender height

Cap height

X-height

Baseline

Descender depth

Algún

At the heart of it all: the *em square*

The invisible (and sort of magical) containing box.

Each glyph in a font sits inside an invisible bounding box known as the em square (or em box). Inside this container, the type designer places the design of the character (whether that's a letter, number, punctuation, or symbol) and defines how much horizontal space (known as side bearings) should sit either side of the letterform. The vertical metrics—ascender height, cap height, baseline, and ascender depth—are also defined in the em square, although obviously these are shared across the font.

The em square is so called because in the days of metal type, it was the width of the uppercase "M" in any font. Although this is no longer the case, it's important to note that an em is a measurement relative to the current size of the font—it's this container that gets resized whenever we change the font size. One em at 16 pt is 16 points wide. One em at 72 pt is 72 points wide.

However, it's perhaps the vertical dimensions contained within an em square that require the most consideration when we're setting type. Although we rarely have access to the specific measurements contained within a font file's em square, these details still have a huge impact on our work when it comes to choosing typefaces, and even more so when pairing them.

What if we're choosing a new typeface for a brand redesign, replacing the current font in a design system? Cycle through a few different fonts from an app's Font menu and you might notice that the type shifts around, despite the font size remaining the same. The reason for this is that the vertical metrics inside the em square can be wherever the type designer chooses, and if the baseline is in a different place in one font to another, the type move up and down within that box.

Shifting aside, though, the potential for every typeface to have its vertical metrics sitting at different points inside the em square also explains why switching between typefaces can often result in the new typeface appearing to be much larger or much smaller the previous choice: in most of these cases, the size of the x-height is what's changing. A typeface with a larger x-height is not actually bigger, but can *appear* bigger, simply because the overall height of the lowercase letterforms occupies more vertical space inside of the em box.

⟶

The three "a" letterforms at the bottom sit in different positions within a text frame because every font has its own internal metrics. Note how the baseline, for instance, sits at a different position inside the box. It's this discrepancy that causes text to shift position when changing between fonts, and it also makes positioning different typefaces next to each other that little bit more challenging.

Flap

a a a

8

X-height is our secret weapon

It's everyone's favorite measurement but it wields more power than you might think.

SEE ALSO

Baseline • Em square • Line height • Metrics • Numerals • Small caps

X-height is one of several vertical metrics in a typeface — the others (in Latin typefaces) being ascender height, cap height, baseline, and descender depth. Not specifically concerned with the height of the lowercase "x" character itself, the term is so-called because that character offers a useful way of representing the overall height — measured from the baseline — of all lowercase characters, given the (usually) flat top parts of the "x" letterform.

Typefaces with large x-heights are typically easier to read at small sizes. But what does having a large x-height actually mean? Inside the em square, the invisible box that contains the letterform in each glyph, a large x-height means that the lowercase characters take up a bigger percentage of this box; the ascenders and descenders, in turn, occupy a smaller area.

Therefore, a typeface with a large x-height can appear bigger when compared to one with a small x-height — something that's especially noticeable when swapping out one font for another, or when positioning two typefaces in close proximity. The type isn't actually bigger, unless the font size is changed, but the proportion of the em box filled by the x-height may very well be larger.

Generally speaking, typefaces with a small-caps style are usually designed so that the top of those particular letterforms sit around the x-height, therefore allowing the small caps to sit more comfortably alongside the lowercase text. Proportional numerals also tend to be make use of the x-height, unlike lining numerals, which adhere to the cap height.

⟶

In the columns of text at the bottom of the page, the type on the left appears to be bigger than the type on the right. However, both are set at the *exact* same font size and with the same line height settings (and line breaks). The x-height of the type on the left takes up more of the em square and therefore makes the type appear larger. This is why there's essentially no such things as a shared font size across different typefaces, unless part of a family.

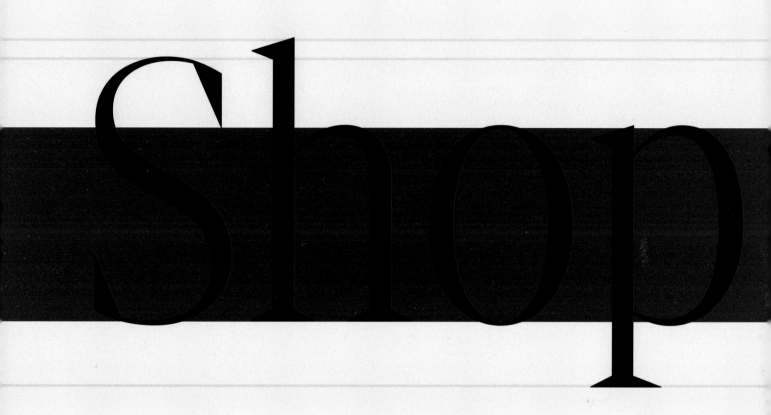

Welche Größe werden Sie
wählen? Könnte ein solches
Konzept jemals verlieren?
Von groß bis klein, von
offen bis eng—finden Sie
unbedingt das Richtige.

Welche Größe werden Sie
wählen? Könnte ein solches
Konzept jemals verlieren?
Von groß bis klein, von
offen bis eng – finden Sie
unbedingt das Richtige.

9

Type *classification* can be useful — and *useless,* too

Being able to classify different typefaces helps us choose and use them, but don't get too bogged down by outdated models.

SEE ALSO

Anatomy • Human hand • Pair type

Classifying type is useful because it gives us a framework to discuss certain styles of design. At the very simplest level, a design brief that specifies the use of a sans serif font gives us some clear parameters to work within, and without even the most basic classification, we wouldn't have that.

But classifications can be overly restrictive, too.

One reason is that to really understand the multiple subcategorizations of type, a fair degree of knowledge is required, including an understanding of the type design trends that marked various periods in history. Designers with an understanding of exactly what to look for when tasked with finding a Neo-Humanist Sans should be rewarded for their expertise, of course, but the learning curve is steep. Besides, historical accuracy isn't all it's cracked up to be. In her talk, *Upping Your Type Game,*[1] Jessica Hische opines the benefits of historical accuracy, but admits that our popular perception of a particular era might be evoked using typefaces that weren't actually released at that time.[2]

Another reason is that type classification has generally been very Latin-centric (and in many cases Anglo-centric), and scripts from around the world are not just underrepresented, but worse: they've often been made to squeeze into classifications that don't make for logical groupings. In recent years, much has been done to rectify this with ATypI unadopting the Vox-ATypI typeface classification system in 2021.[3]

All that said, classification in any form *does* offer us some useful guardrails, serving as a tool to help us choose type and to evaluate it. The online typography resource (and, more recently, font retailer) I Love Typography introduced the CEDARS™ system with the launch of its shop. Co-creator Dr. Nadine Chahine said in ILT's launch announcement that *"the name is the acronym for Contrast, Energy, Details, Axis, Rhythm, and Structure. CEDARS+ is a set of type descriptors that can describe any typeface in any script based on its formal qualities."*[4] Of course, CEDARS™ is not a classification system, per se, but a way of filtering a type catalog, created by a font distributor. But, crucially, it groups type based on its physical traits. Combining this awareness with some knowledge of "traditional" classifications can be helpful in selecting type for our projects.

1 jessicahische.is/
talkingtype

2 jessicahische.is/
internetting/gatsby/
ver1.html

3 atypi.org/2021/04/27/
atypi-de-adopted-the-
vox-atypi-typeface-
classification-system/

4 ilovetypography.
com/2021/06/28/talking-
about-type-introducing-
cedars/

⟶

Mainly inspired by the classifications from Stephen Coles's book *The Anatomy of Type* (Harper Design, 2012), this list is populated by a variety of typefaces, all set at 30 pt in their Regular (or Book, or default) weight. Note that there's often a great deal of crossover between the "script (or calligraphic)", "handwritten", and even "display" classfications, and how the type is grouped usually depends on the specifics of the typeface and the prefer-ences of the person or organization doing the grouping. It's useful to see these as guides rather than finite rules.

Kyrios	**Blackletter**
Trajan	ENGRAVED
Minion 3	Humanist Serif
Adobe Caslon	Transitional serif
Bodoni	Rational serif
Skolar	Contemporary serif
IBM Plex Sans	Grotesque (or Gothic) sans
Helvetica	Neo-Grotesque sans
Futura	Geometric sans
Optima	Humanist sans
FF Meta	Neo-Humanist sans
Superclarendon	**Grotesque slab**
Rockwell	**Geometric slab**
Adelle	Humanist slab
Snell Roundhand	*Script (or Calligraphic)*
Rollerscript	*Handwritten*
Shlop	DISPLAY / MISCELLANEOUS

10

Know where your type is from: the *serif*

A very brief historical overview of serif typefaces.

SEE ALSO

Classification · Human hand · Sans serif · Slab serif

The serif grouping of typefaces is so-called because those faces all share a common design element: the small mark or line at the end of some letterforms' stroke: the "serif" itself.

The underlying design of what we now call serif typefaces—and therefore, by derivation, the underlying design of *all* Latin typefaces—was established in Italy in the mid- to late-15th century, when lowercase forms, inspired by the Carolingian minuscule, were combined with capitals inspired by Roman inscriptions into one "roman" script (in direct contrast to the earliest Western types that mimicked Blackletter calligraphy) and then evolved into a Humanist model (see page 36) by Nicholas Jenson that rejected the Gothic aesthetics of the past. As the popularity of the so-called roman typefaces evolved and France became a printing epicenter, Claude Garamont and his contemporaries in the mid-16th century further evolved roman types to introduce higher contrast and a more refined modulation of stroke. These serifs are so closely related to those in use today that it's easy to see why modern reinterpretations of typefaces from this period are still so popular.

You might've heard people say that serifs are easier to read for long-form text, and so should always be used for body copy, but this theory has been debunked. While it's true that the serif marks in letterforms *can* be a legibility aid, there are many other factors at play (see pretty much any other page in this book) when it comes to overall legibility and readability. Although it's true that you probably don't want to set entire paragraphs in a script typeface, a sans serif or slab serif will be just fine.

❶ A tracing of lettering carved into Trajan's Column in Rome.
❷ An example of Carolingan miniscule calligraphy, which would later be used to influence Humanist miniscule type.
❸ Gutenberg's Bible, set in Blackletter type, which would go out of fashion not much later, replaced by early serif typefaces.
❹ Typical mid-15th century roman type by Nicholas Jenson.
❺ Italic type by Francesco Griffo and Aldus Manutius.
❻ Roman and italic typefaces by William Caslon, *c.* 1734.
❼ Bodoni type specimen printed in 1926.

All images obtained from the Letterform Archive on oa.letterformarchive.org

IMP·CAESARI·DIVI·NERVAE·F·NERVAE
TRAIANO·AVG·GERM·DACICO·PONTIF
MAXIMO·TRIB·POT·XVII·IMP·VI·COS·VI·P·P

CAII IVLII CAESARIS·BELLI AFRICI OPII AVT HIR-
TII COMMENTARIVS QVINTVS.

French Cannon.

Quousque tan-
dem abutere,

Quousque tandem
abutere, Catilina,

Two-Line Double Pica.

Quousque tand-
em abutere, Ca-
tilina, patientia

Quousque tandem
abutere, Catilina,

HALBFETTE BODONI-ANTIQUA

Barke | Felsabhang der Akropolis
4 GEISTWERDUNG 8

Swiatło | Die Kräfte der Weltdramatik
NORDISCHE MÄRCHEN

Ocupaţie | Een Bibliotheek van Beteekenis
TIJDELIJK TE GEMBLOUX

Gieterijen | Doch selbst in Trümmern spricht der
Parthenon die edlen Sprachen Gottes

The Factory | Leidenschaften sind dem Geiste dienstbar
97 DIE ROMANTIKFORSCHUNG 63

Kezdőoldalak | Wenige Augen fingen das Silberlicht Italiens und
den Goldglanz der griechischen Landschaften auf

Amadeus Mozart | Alles entzückende Leben ist dem Tode benachbart
6 PORTRÄTIERUNG VON KÜNSTLERN 5

Die Nibelungensage

22

HALBFETTE BODONI-KURSIV

Bibliothek der Elektrizität
RHEIN UND MOSEL | *Möbel*

History of the Second Empire
12 INDEPENDENCE 34 | *Ostatni*

Kultur und Leben im alten Indien
INDISCHE KUNSTBAUTEN | *Industrie*

Habe immer etwas Gutes im Sinn, und
halte dich für zu gut, um Böses zu tun | *Publicului*

Die Baudenkmäler der Etrusker in Italien
HERBSTMESSE IN KÖNIGSBERG | *Kerületének*

Die Liebe zum Wahren und die Mut zum Rechten
bilden die Grundlagen jeder wahren Erziehung | *Polar-Fahrten*

Ergebnisse auf dem Gebiet der Radiumforschung
23 MODERNE WOHNUNGS-REFORM 45 | *Bilder aus Italien*

Heimat und Glaube

23

11

Know where your type is from: the *sans serif*

A very brief historical overview of sans serif typefaces.

SEE ALSO

Classification · Serif · Slab serif

They say less is more, and if that's true, then surely there's nothing better than a sans serif—a typeface without serifs. This theory has not yet undergone scientific rigour. You know what else is not actual science? The idea that serifs are better suited to long-form reading, and that you should only use sans serifs for short passages. You can just totally ignore that. Use a sans serif whenever you want.

With that off my chest, let's talk about one of the primary classifications in Latin type. The first sans serif typefaces appeared in the 19th century. William Caslon IV (what a dynasty!) designed a typeface called English Egyptian that was published in a type specimen book in 1816, but it wasn't until Vincent Figgins created several sans serif designs in the 1830s that the term "sans serif"—coined by Figgins himself—came into use. William Thorowgood was the first typefounder to create both an uppercase and lowercase sans serif design, and referred to them as Grotesque—so-called, it's believed, because they just looked a bit, well, *odd.*

Berthold's Akzidenz-Grotesk—on which Neue Haas Grotesk (the original version of what would become Helvetica) was based—was released in 1898 and is described as a Neo-grotesque. Futura's geometric design in 1927 and DIN 1451's industrial design in 1931 further rationalized the sans serif style into something all its own, and by the late 1950s and early 1960s, it had finally become a first citizen of type, propelled into the public consciousness with the release of Helvetica, Univers, and Folio, and the popularity of the International or Swiss design aesthetic.

→

[TOP] A trace from a specimen of William Cason IV's typeface English Egyptian.

[MIDDLE] A re-creation of Akzidenz Grotesk, originally released in 1898.

[BOTTOM] Neue DIN, a modern interpretation of DIN, published by FontWerk in 2022, which was redrawn and upgraded with variable font capabilities for fine control over its weight and width via two axes.

W CASLON JUNR
LETTERFOUNDER

Akzidenz

PrenzlauerAllee186

Know where your type is from: the *slab serif*

A very brief historical overview of slab serif typefaces.

SEE ALSO

Classification • Sans serif • Serif

It would be unkind to dismiss a slab as a sans with serifs on, but let's be honest: it's not *entirely* innaccurate as descriptions go, is it? If you were to create a new slab serif typeface today, you'd certainly make your life easier by making the sans version first.

However, slab serifs—originally (and sometimes still) known as Egyptians or Clarendons—predate their sans siblings, having first appeared in the early 1800s. And no, they have absolutely nothing to do with Egypt, except that their rise in popularity coincided with the general cultural fascination with Egypt at the start of the 19th century.

Early slab serif typefaces, also known as Antiques, were closer to their more established serif cousins with features such as ball terminals. Clarendons brought increased contrast and a smoother movement from the stems into the slabs. French Clarendons reversed the contrast so that the slabs themselves became heavier than the stems. (Think of a "wanted" poster in any Wild West movie and you're there.) Perhaps one of the best-known contemporary slab serifs is Courier, a monospaced typeface originally created by IBM for typewriters in the 1950s.

Because of the visual similarities between contemporary slabs serifs and Neo-grotesque sans serifs, many could be considered to be Neo-grotesque slab serifs, but—as I mentioned on page 26—sometimes it's not healthy to get *too* bogged down by type classification.

→

[TOP] A traced detail from *The great Russian athletes* (poster, *c.* 1891). Full info on bdh.bne.es/bnesearch/detalle/bdh0000018768

[BOTTOM] Trace of an early 19th-century reverse contrast typeface in wood. Courtesy of John Boardley.

ATHLETES

HH SAM
HIT STEAM
THAMES

13

Handwriting, calligraphy, and lettering aren't type... are they?

It's useful to distinguish between them, although the lines can definitely blur.

SEE ALSO

Customize • OpenType • Typeface

Although this book deals exclusively with the arrangement and manipulation of type, lovers of type are often lovers of letters in all forms. Let's make sure we've got some definitions correct.

Handwriting is what we do when we—surprise, surprise—write by hand, most often with a pen or pencil. Most people's handwriting is casual (mine is illegible).

Calligraphy is the practice of writing with a deliberate and artistic style; a sort of halfway point between handwriting and lettering. Most expert calligraphers are able to achieve a consistency that in many ways is somewhat like type. However, even if it looks like type, it *isn't* type, because it's not mechanized.

Lettering is less about writing letters and more about *drawing* them. Think of a bespoke arrangement, like a logo, some food packaging, a tattoo, or the cover of a magazine. This collection of letterforms exists for an explicit context or brief. Type can be *turned into* lettering by starting with a font, manipulating it (see page 146), and then outlining it so that its actual curves can be tweaked further still.

Type can mimic handwriting or calligraphy in its design, and indeed "Handwritten" and "Calligraphic" filters can be found on most websites that supply fonts. Type can also mimic lettering thanks to the swapping in and out of alternate glyphs via OpenType. More on that from page 152 onwards.

→

Lettering artist and type designer Francis Chouquet created these demonstrations of (from top to bottom) handwriting, calligraphy, lettering, and type (the latter using his Scusi Bruto typeface), using the phrase "Go play outside." Of course, Francis's handwriting is considerably neater than mine.

There's evidence of the *human hand* in most typefaces

Contemporary type still wears its pen- and brush-based heart on its sleeve.

SEE ALSO

Classification • Love type • Sans serif • Serif

You might've noticed that this book doesn't list all of the various classifications and sub-classifications of Latin type. This is very intentional and I went into exactly why on page 26, but one I *do* want to call out specifically is Humanism, because it could be argued that evidence of the human hand is present in almost *all* type. The very first typefaces mimicked Blackletter calligraphy, and the construction of the letterforms was informed by the marks made by those tools: the angles, stresses, and contrast that occur naturally when using a brush or a pen.

Even when we take the most rational contemporary interpretation of something like a Didone, the points at which the stroke modulates from high to low contrast still mimic ancient penmanship in some way.[1]

When we think of Humanist typefaces, we tend to think of serifs, but it's completely possible for a sans serif to be regarded as Humanist, and even those not directly categorized as such may still incorporate Humanist elements into their designs. Whereas the original sans serifs ("grotesques") were a deliberate attempt to move away from the more humanist serif types of the time, and this was taken further still by the geometric sans serifs such as Futura in the early part of the 20th century (and again in the 1970s), many contemporary sans serifs dial back the geometry in favor of more Humanist proportions, which gives the type a sense of warmth and friendliness.

[1] And although we'd never call a mechanical sans serif with a geometric construction and mono-linear stroke "humanist" — quite the opposite! — there's no denying that the underlying structure of the letterforms still came from a time when the alphabet was established by handwriting.

⟶

Broad-tipped tools such as broad-nibbed pens, flat brushes, and wide-tipped marker pens, achieve contrast in the letterform by changing the direction of the tool, but maintain a consistent pressure. Pointed tools, such as pointed brushes and pointed-nib pens, achieve contrast by varying the pressure of the stroke, but the angle is consistent. Round-tipped tools, such as everyday pens and pencils, result in no contrast in the letterform and hence no inferred angle of stress. This illustration is indebted to Chris Campe and Ulrike Rausch's wonderful book *Designing Fonts* (Thames & Hudson, 2020).

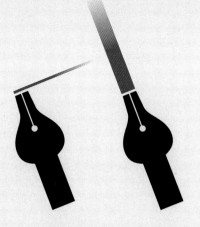
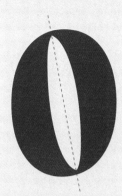

Broad-tipped tools = angled stress

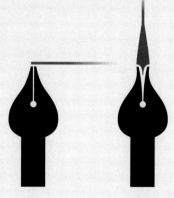
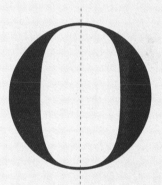

Pointed tools = vertical stress

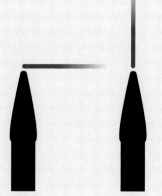

Round-tipped tools = no contrast

15

It's okay to just *love type* for no discernible reason

Is it evidence of the human hand that triggers our emotional response to type?

SEE ALSO

Classification · Human hand · Pair type

⟶

Typefaces: OT Abalos ("je"), Swear Display ("ne"), Bricolage Grotesque ("sais"), and Climate Crisis ("quoi").

Before we start delving into some of the more technical considerations around type, and before we even start to consider actually *using* fonts, I want to interject with a message: if you're excited about a typeface you see, and you just want to set some type with it, you should. We'll explore choosing type for specific purposes later in the book, but I think it's important to state that a typeface's very existence can be enough to get you fired up about creating—and that's a wonderful thing.

Sometimes a typeface just has that... *je ne sais quoi*... that thing that just hits you when you see it, and you think, *"ah, I've just got to use that in a design!"* Or better yet: you set some type with it, and your *readers* are overcome with that sense of something special. Not so much that they're distracted from the reading experience, of course—that would mean the type has failed in its job, on fact. But just enough personality to gently elevate the content, like putting on a nice jacket that makes you feel fancy.

Although it's hard to identify exactly what contributes to this feeling, I have a suspicion that contrast (the difference between the thicks and thins in a letterform's strokes) plays a major role, along with modulation (how that contrast changes in the letterform). Exactly where that movement from thick to thin happens is dictated by the angle of stress. The visual style of early typefaces mimicked calligraphy and lettering, with modulated strokes (strokes that are thicker in some places than other places) that referenced the way a pen or brush might behave when more or less pressure is applied. And despite hundreds of years of type evolution, we still see evidence of this in many contemporary typeface designs, especially serifs. The angle of stress (also known as an axis, although that can be confused with an axis in variable fonts) forms a huge part of a typeface's personality, and is often a direct reference to a particular tool and therefore historical period (see page 26). So again we have this ongoing connection to the human hand.

Whatever the reason, if you see a typeface you love, find a way to use it.

je ne
sais
quoi

Type should be *legible* at the very least

There's no point doing anything typographic if the words can't be understood.

SEE ALSO

Readable

Legibility should be the most basic concern when it comes to type, right? You'd think so. And yet you might be surprised to discover just how illegible some very famous and successful typefaces can be.

Before we go there, let's make sure we've got the term properly defined. Legibility is about how a reader can correctly identify a typeface's glyphs as distinct characters, and therefore how well they can be identified as words once combined. A good legibility test when analyzing type is to look at the characters "1Il" — is it obvious which one is a numeral "1", an uppercase "I", and a lowercase "l"? And how about "0Oo" — is the difference between a numeral "0", uppercase "O", and lowercase "o" obvious enough? There are many characters that at first glance appear to be mirrored — "q" and "p", "d" and "b", etc. — and a typeface that takes legibility seriously will often adjust the letterforms' designs to make sure that they're visually unique, which can be a huge aid for readers with visual or cognitive challenges.

Beyond the design of the typeface, legibility can be affected by the typographic changes we make. Font size is perhaps the most obvious one: if the text is too small, it won't be legible — or at least not easily legible — but simply increasing the font size won't necessarily result in more legible text if it's hindered by the design of the typeface itself. One of the most common mistakes novice (and perhaps not-so-novice) typographers make is to use fonts intended for display sizes for body text. Switching to a body optical size might help, but some typefaces are just only ever intended for large sizes.

To aid legibility when we're forced to work with a brand typeface that isn't ideal, we can adjust our tracking, as well as our leading, or measure — parameters we'd employ whatever the font, of course, but ones that can especially useful when limited to a difficult typeface.

If at this point you're either wondering why I haven't mentioned readability, or how that's any different from legibility, please do turn the page. Spoiler alert: although legibility does indeed affect readability, legibility is not the *same* as readability.

By the way, it's totally okay to design an illegible logotype for a Black Metal band. In fact, the less legible, the better.

→

[OPPOSITE] Compare the designs of characters that could potentially be confused with one another, especially when viewed at a small size. You'll notice that Arial and Gill Sans don't perform very well because many of the letterforms lack distinct shapes. Typefaces that are *more* legible, however, often don't employ mirroring — see how the "d" and "b", for instance, have been made to look more distinct in Bree, Breve Sans, Atkinson Hyperlegible, and PT Sans.

[BELOW] Production Type poked fun at Black Metal logos with a t-shirt design. Reproduced with permission.

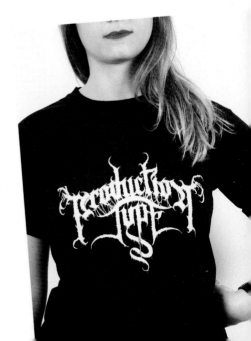

☹ Arial

1lli! 0Oo
qp db un
69 a8 a6 6g
rn m

1lli! 0Oo
qp db un
69 a8 a6 6g
rn m

☹ Gill Sans

1lli! 0Oo
qp db un
69 a8 a6 6g
rn m

1lli! 0Oo
qp db un
69 a8 a6 6g
rn m

☺ Bree

1lli! 0Oo
qp db un
69 a8 a6 6g
rn m

1lli! 0Oo
qp db un
69 a8 a6 6g
rn m

☺ Breve Sans

1lli! 0Oo
qp db un
69 a8 a6 6g
rn m

1lli! 0Oo
qp db un
69 a8 a6 6g
rn m

☺ Atkinson Hyperlegible

1lIi! 0Oo
qp db un
69 a8 a6 6g
rn m

1lIi! 0Oo
qp db un
69 a8 a6 6g
rn m

☺ PT Sans

1lli! 0Oo
qp db un
69 a8 a6 6g
rn m

1lli! 0Oo
qp db un
69 a8 a6 6g
rn m

Making text *readable* is what typography is all about

It's perfectly possible to make legible type unreadable with bad typography.

SEE ALSO

Legible · Small caps

How readable is our text? That's the primary question we should be asking ourselves as typographers. And if you feel like that's too obvious to even state in this book, then please allow me to elaborate.

Readability is often confused with legibility, and understandably so. Both are concerned with how well readers understand text. But although readability is affected by legibility, there are many factors at play. Even if we're working with a legible typeface, that doesn't mean that the text it's set in will be *readable*. That might be because of a typographic decision we've made, or it might simply be that the text is, well, *boring*. Think about legal terms and end user licenses and privacy policies — how readable do you find them? Probably not very. And then there are other factors out of our immediate control, such as visual or cognitive challenges the reader might face, or whether they're interested in the subject.

So we're off the hook? Sadly not. Apart from those parameters we can't adjust, we *can* use our typographic know-how to make legible type more readable — just turn to any page in this book. But adjusting tracking, line height, and measure will always be a good start. Because don't forget that it's totally possible to make perfectly legible type unreadable, such as when the leading is so tight that there are clashes between the extenders. Or when all caps (which can't be processed as easily due to their indistinct letter shapes) are used too generously.

For more information, see *"How type influences readability"* by Hilary Palmen.[1]

[1] fonts.google.com/ knowledge/readability_ and_accessibility/ how_type_influences_ readability

⟶

The Shlop typeface, by Ray Larabie, works really well as a logo for a zombie film — especially with all the multiple versions of each character to make it look more like lettering (see page 27) — but it isn't suitable for longer text and smaller sizes. In the three potential subheadings below the title, we have the same typeface and style as the title (left), then the same typeface but in a different style (middle) — which starts to become more readable — and then a totally different typeface: Anybody by Ty Finck (right). The text set in Anybody has also had its width and weight axes, and its tracking, manipulated to better match the overall typo-graphic color of Shlop.

KERN OF THE DEAD

THIS SUMMER, BEWARE THE SPACES IN BETWEEN!

THIS SUMMER, BEWARE THE SPACES IN BETWEEN!

THIS SUMMER, BEWARE THE SPACES IN BETWEEN!

Optical size lets us set size-optimized type

The design of letterforms can and should adjust according to the size they're set at.

SEE ALSO

Size • Style • Variable fonts

In the days of metal type and wood type, changing font size would mean using a distinctly different piece of type. Therefore a different size meant there could be a slight difference in the design of the type. To be more accurate, there *should* be a difference in the design: generally, more contrast between the thicks and thins for type intended for larger sizes, more open tracking for type intended for small sizes, and numerous tweaks to letterforms' details for the sizes in between.

Once phototypesetting and then digital fonts came along, the notion of optical size went away — it was all too easy for the designer to simply resize the type at their whim, no longer with a need to physically locate and set separate blocks of type for each change in font size. But this new-found freedom meant that all of those size-specific adjustments disappeared, and with them, all of the subtle nuances that make type work better or worse at different sizes.

Thankfully, in recent years, type designers started creating unique fonts to cater for different optical sizes again, and the appetite of users has also increased. Once more, people started buying and using Display / Subhead / Text / Caption variants of their favorite fonts. When variable fonts became mainstream, many type designers started including an axis for optical size — one deemed so important, that it even made the cut as one of the five "registered" variable axes in CSS. At the same time, browsers have implemented a new part of the CSS spec that allows optical size be set automatically if the font contains a variable optical size axis that follows the font size:

```
font-optical-sizing: auto;
```

However, it's easy to use our own custom optical size settings, too:

```
font-variation-settings: 'opsz' 48;
```

For more on this, see the chapters on variable fonts (page 184) and the inheritance problem (page 192). For a detailed look into the history and benefits of optical sizes, be sure to read Shoko Mugikura and Tim Ahrens's book *Size-Specific Adjustments to Type Designs.*[1]

1 Just Another Foundry, 2014

⟶

Arrow Type's Kyrios typeface (top) takes the x-height differentiation to extremes in its Display optical size, and the shape of letterforms changes drastically to make the most of the extra space afforded to larger sizes. OH no's Degular typeface (bottom), used to set this book, perfectly exemplifies how ink traps present in the Text size — which appear cumbersome when reproduced at artificially large sizes — work well when used at the small sizes they're intended for. Also note the tighter spacing for the smaller optical sizes.

karate

karate

karate

karate

karate

karate

200 pt
↓

10 pt
↓

optics

optics

optics

optics

optic

optic

Typographic fundamentals

Try out the *two-lines-of-type* test

Working with just two words, over two lines, can teach you a lot about typography.

SEE ALSO

Justify • Line height • Tracking • Variable fonts • Weight • Widths

There's a little exercise I like to run in my workshops that I call "the-two-lines-of-type test". Not the most inventive of names, I know.

The exercise is based around creating a fictional logotype, with the only brief being that the two-word name of the brand has to be set on two different lines, both lines need to use the same typeface, and both lines need to be center aligned. From here, though, we have a load of options open to us, and it's a great way of quickly exploring many aspects of typography, and understanding how one decision influences the next.

Try it out for yourself! Type "Stocks Industries" (or a much more original fictional brand name of your choosing) on two different lines. With this nearly blank canvas, we now have a few questions to ask ourselves:

⁎ Are both words set at the same font size?
⁎ How much vertical space should there be between both lines?
⁎ Should they be justified? If so, in what way can we justify two lines of a different length? Font size? Weight? Tracking? Width?
⁎ If not, what happens when one of the words is bigger?
⁎ Should the bigger word use a lighter weight to balance out the overall color of the type?
⁎ What if one or both of the words are set in all caps?
⁎ Do any of these then require further adjustments to the line height?

The options are surprisingly plentiful, and they're made even more so if you've chosen a typeface with multiple weights and/or widths. And if you're using a variable font, there are effectively an infinite number of possibilities. If you tried to justify using different widths but they didn't quite fit the space, and additional changes such as tracking were required, a variable width will probably be able to achieve the goal on its own. Have a look at a few potential solutions (opposite).

⟶

Type out two words over two lines, using just one typeface, and the world's your oyster! From here, you can start making any typographic change you see fit, and as you do so, pay attention to how the two lines interact with each other. Here are a few ideas from me, but you can do whatever you like.

Stocks
Industries

As typed, in
Martian Grotesk

Stocks
Industries

Line 1 font size
increased to justify

Stocks
Industries

Line 1 font
weight adjusted
to optically
match line 2

Line 1 tracking
increased to
justify again

Stocks
Industries

Line 1 tracking reset, variable
width increased instead

Stocks
Industries

STOCKS
INDUSTRIES

Case changed

STOCKS
INDUSTRIES

Leading decreased

STOCKS
INDUSTRIES

Line 1 weight increased,
font size shrunk to match

Line 2 tracking increased,
font size shrunk to match

STOCKS
INDUSTRIES

Adjusting *line height* is the easiest improvement to make

Avoid those clashes, but don't get too generous with your leading.

SEE ALSO

Diacritics • Line height • Measure

Almost all typographic tweaks are related to spacing, and as a measure of vertical spacing, line height is perhaps one of the easiest improvements we can make. Most users' first experience of line height is in setting the "line spacing" options in the humble word processor, which often provides values of 1.15, 1.5, and 2. (These are effectively 115%, 150%, and 200% of the font size.) Generally speaking, a line height value of 110% and 150% of the font size will result in a comfortable reading experience. But what actually determines a comfortable reading experience when we talk about line height?

Our first consideration should be to avoid clashes between letterforms on one line with those on the next, ensuring that descenders on the line above don't collide with ascenders on the line beneath. Diacritics (or accent marks) usually sit above ascenders—especially so with uppercase characters—and below descenders, so we should avoid clashes with them, too.

However, being overly generous with our line height runs the risk of losing the reader as they move their eyes from the end of one line down to the beginning of the next, especially when we have a wider measure (line length). In fact, line height values should ideally be set with an awareness of the measure; designing responsively for screens, we should keep our measure narrow and line height open for mobile viewports, then tighten our line height as the measure grows to wider viewports such as tablet and desktop screens.

When working with uppercase text, line height can be considerably tighter, perhaps even straying into negative values when working with display type (i.e., where it will be seen at large sizes).

In the days of metal type, setting type meant inserting literal strips of lead between rows of type to control the vertical spacing between each line, and therefore the act of adjusting line height became known as leading. Line height in digital typesetting is not quite the same as "real" leading, however, mainly due to the way in which it's calculated, and we explore the inconsistencies in these calculations across multiple platforms and environments on page 122.

⟶

Three different line height settings: approximately 100% of the font size (left), 125% (middle), and 200% (right). Note how the left column is too tight with some extenders clashing; the middle columns feels about right; the right column is too open, with the lines appearing disconnected—a problem exacerbated on wider lines. In the example at the bottom, note how the 100% font size is added to by the virtual "leading" both above and below.

En un lugar de la Mancha, de cuyo nombre no quiero acordarme, no ha mucho tiempo que vivía un hidalgo de los de lanza en astillero, adarga antigua, rocín flaco y galgo corredor. Una olla de algo más vaca que carnero, salpicón las más noches, duelos y quebrantos los sábados, lantejas los viernes, algún palomino de añadidura los domingos, consumían las tres partes de su hacienda. El resto della concluían sayo de velarte, calzas de velludo para las fiestas, con sus pantuflos de lo mesmo, y los días de entresemana se honraba con su vellorí de lo más fino. Tenía en su casa una ama que pasaba de los cuarenta, y una sobrina que no llegaba a los veinte, y un mozo de campo y plaza, que así

En un lugar de la Mancha, de cuyo nombre no quiero acordarme, no ha mucho tiempo que vivía un hidalgo de los de lanza en astillero, adarga antigua, rocín flaco y galgo corredor. Una olla de algo más vaca que carnero, salpicón las más noches, duelos y quebrantos los sábados, lantejas los viernes, algún palomino de añadidura los domingos, consumían las tres partes de su hacienda. El resto della concluían sayo de velarte, calzas de velludo para las fiestas, con sus pantuflos de lo mesmo, y los días de entresemana se honraba con su vellorí de lo más fino. Tenía en su casa una ama que pasaba de los cuarenta, y una sobrina que no llegaba a los veinte, y un mozo de campo y plaza, que así

En un lugar de la Mancha, de cuyo nombre no quiero acordarme, no ha mucho tiempo que vivía un hidalgo de los de lanza en astillero, adarga antigua, rocín flaco y galgo corredor. Una olla de algo más vaca que carnero, salpicón las más noches, duelos y quebrantos los sábados, lantejas los viernes, algún palomino de añadidura los domingos, consumían las tres partes de su hacienda. El resto della concluían sayo de velarte, calzas de velludo para las fiestas, con sus pantuflos de lo mesmo, y los días de entresemana se honraba con su vellorí de lo más fino. Tenía en su casa una ama que pasaba de los cuarenta, y una sobrina que no llegaba a los veinte, y un mozo de campo y plaza, que así

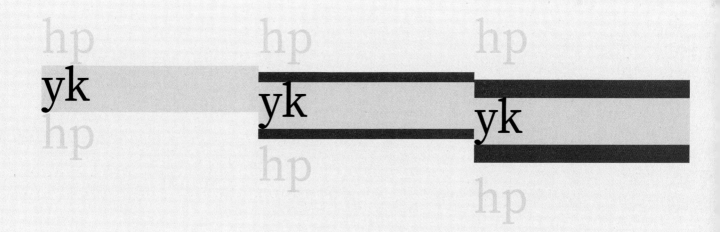

Don't underestimate the power of *measure*

Unruly lines make reading so much harder than it needs to be, so keep them in check.

SEE ALSO

Design system • Line height • Scale

As is the case with line height, adjusting your line length—known as measure—is one of the easiest ways to improve the readability of your text. Narrow lines of text can be disruptive to the reading experience because they cause the reader's eyes to jump to a new line too often; conversely, wide lines of text make it harder for the reader's eyes to find the start of the next line. This was one of the main issues when responsive web design first became adopted: designers started letting their content flex to the container's width, without any thought on what happened when that container became too wide.

In *The Elements of Typographic Style,*[1] Robert Bringhurst says that *"anything from 45 to 75 characters is widely regarded as a satisfactory length of line for a single-column page set in a serifed text face in a text size,"* but of course this varies depending on the typeface used. Extended widths will need fewer characters per line; condensed widths will need more. And what about the tracking values, or the general style of the type? As with many things, this is just a guide. Other reliable sources, such as Google's Material Design guidelines,[2] recommend approximately 40 to 60 characters per line. The wisest thing is to give it a try and see what works.

If you're finding this hard to eyeball, a useful trick (suggested by Trent Walton back in 2012[3]) is to place asterisks before the 45th character and after the 75th character (referencing Bringhurst's recommendation) and make an adjustment (like increasing the font size or shrinking the text box) any time both asterisks appear on the same line. This can be useful as you try to work out the optimum measure in responsive environments.

Interestingly, measure is not one of those things you can just set and forget. As your line height changes, so too should your measure. Longer lines—that is, wider measures—should be complemented by more generous (i.e., taller) line heights. This is worth keeping in mind if you're working in a responsive environment, where you may need to adjust both in tandem.

In CSS, we can define an element's width using the "ch" unit. `1ch` is equivalent to the width of a "0" character at the current font size, so something like `60ch` is usually a fairly safe width to set, but be aware of how that affects alignment.

1 Hartley & Marks Publishers, 1994

2 material.io/styles/typography

3 trentwalton.com/2012/06/19/fluid-type

⟶

[TOP] Using asterisks to mark the 45th and 75th characters, it's possible to judge when a measure is too short (the first asterisk appears on the second line) and too long (both asterisks appear on the same line).

[BOTTOM] The text with the narrower measure is more readable when its leading is reduced. Similarly, the text with the wider measure is more readable when its leading is increased.

Everyone is entitled to all the rights and
fr*eedoms set forth in this Decla*ration,
without distinction of any kind, such as
race, colour, sex, language, religion, political
or other opinion, national or social origin,
property, birth or other status.

Everyone is entitled to all the rights and fr*eedoms set forth in this
Decla*ration, without distinction of any kind, such as race, colour, sex,
language, religion, political or other opinion, national or social origin,
property, birth or other status.

Everyone is entitled to all the rights and fr*eedoms set forth in this Decla*ration, without di
any kind, such as race, colour, sex, language, religion, political or other opinion, national or s
property, birth or other status.

Default leading

Motherhood and childhood
are entitled to special care
and assistance. All children,
whether born in or out of
wedlock, shall enjoy the same
social protection.

Default leading

Motherhood and childhood are entitled to special care and assistance.
All children, whether born in or out of wedlock, shall enjoy the same
social protection.

Reduced leading

Motherhood and childhood
are entitled to special care
and assistance. All children,
whether born in or out of
wedlock, shall enjoy the same
social protection.

Expanded leading

Motherhood and childhood are entitled to special care and assistance.
All children, whether born in or out of wedlock, shall enjoy the same
social protection.

A little *tracking* goes a long way

Optimize the spacing between letters based on their size and context.

SEE ALSO
Optical size · Optical trickery · Small caps · Well-spaced

Type designers have the freedom to space glyphs as they please, resulting in varying degrees of tightness or openness. One of the reasons most versions of Helvetica are unsuitable for long form text is that the type is spaced quite tightly by default. However, as end users of fonts, we typographers hold the power to make additional adjustments for an optimal reading experience. Tracking, or `letter-spacing` in CSS, is one of those powers.

In certain cases, opening up the tracking (i.e., assigning a higher value) can drastically improve readability. This is certainly true with very small text (in this way, we're partly mimicking a small optical size) and it's usually beneficial to positively track uppercase text if it's rendered at a small size. But equally it can be a purely aesthetic choice — maybe it just looks good in a logo, or an advert, or on a button. As with anything in type, just *how* good the tracking looks will of course depend on the typeface, the length of the word, and the size of the font, amongst other factors.

Another aesthetic choice made by many designers is to *negatively* track type, although this should be approached with caution. Use very small negative values if you use them at all. Each font is different, but generally speaking, very tight tracking really only works in logos or display type.

Interestingly, tracking can play its part in optically optimizing text, too. For instance, in order for tracking to feel even across large type and small type, we can afford to track the large type much tighter. Technically the values will be different, but importantly, they'll feel the same. Michan Wichary, in *Typography Is Impossible,*[1] explains that *"letter spacing gets tighter much faster than the font size gets bigger."*

[1] medium.engineering/typography-is-impossible-5872b0c7f891

→

[TOP] Compare the left and right examples: Helvetica Neue benefits from positive tracking at small sizes; it's always advisable to positively track small caps; never set letter spacing with absolute units — tracking (like line height) should always be relative to the type itself so that it scales correctly.

[BOTTOM] Track negatively with caution. Unless purely stylistic, negative tracking usually only works well at very large sizes. Here, the middle example uses -25% and it works, but only because it's large. The default value of 0% is too loose and -50% is too tight.

Helvetica Neue, no tracking

Surely no-one would think this is suitable for an entire operating system, would they?

Helvetica Neue, 25% tracking

Surely no-one would think this is suitable for an entire operating system, would they?

Tabac G2, no tracking on small caps

Esa fue la última vez que el USD estuvo tan fuerte frente al EUR.

Tabac G2, 25% tracking on small caps

Esa fue la última vez que el USD estuvo tan fuerte frente al EUR.

Decoy @ 4.5pt & 10pt, tracking set as 1px for both

Alors que je m'endormais sous le saule, j'ai pris conscience d'une douce mélodie jouée quelque part à proximité.

Alors que je m'endormais sous le saule, j'ai pris conscience d'une douce mélodie jouée quelque part à proximité.

Decoy @ 4.5pt & 10pt, tracking set as 10% for both

Alors que je m'endormais sous le saule, j'ai pris conscience d'une douce mélodie jouée quelque part à proximité.

Alors que je m'endormais sous le saule, j'ai pris conscience d'une douce mélodie jouée quelque part à proximité.

0% -25% -50%

23
Create meaningful
emphasis in your text

*Be intentional with your use of
bolds and italics.*

SEE ALSO

*All caps • Italic • Oblique •
Pair type • Weight*

One of the first typographic changes the average user will make is to embolden or italicize a word in their text to create emphasis. They might even set a word or two in all caps, or use an underline. Ah, the power of the word processor. What's important to remember is that any obvious stylistic change to a word (or words) in text, whether as short as a title or as long as a book, makes the reader *think*. Specifically, it makes them register the change and assign meaning to it. The more obvious you can make that meaning, the less the reader will be wondering why something has changed. In other words, we aim to keep their cognitive dissonance to a minimum.

The easiest way to achieve this is to be consistent. It's generally accepted that when reading text online or on a screen, an underline signifies a link. I know *I've* been caught trying to tap or click on an underlined word that doesn't go anywhere—it's so frustrating. In any medium, save all-caps text for acronyms, lest you make the reader feel like you're shouting at them.

Excluding an actual change of typeface or something slightly unusual like a change in font size, that leaves just emboldening or italicizing as our main tools of emphasis. Technically, there's nothing to say that you can't draw attention to a word or phrase by applying either change—but your readers will be rewarded if you're consistent. Be sure to reference any style guide you might be following, for sure, as there are some common uses of italic type—book titles, film titles, etc.—that are rarely substituted for bolds.

Also remember that just because something's italicized doesn't necessarily mean it's *emphasized;* perhaps the typographic system dictates that all pull quotes are italicized in their entirety or maybe even headings. This could be a purely aesthetic choice.

And for whenever you do decide to use a bold weight, remember that you're not actually tied to using the actual weight called "Bold." If your typeface has a range of weights (and/or is a variable font), you're not beholden to what's commonly assigned a value of 700. Maybe try a 900 (usually a "Black" or "Ultra") weight. In the interest of making your emphasis look obviously distinct from the surrounding text, it can pay to explore weights beyond the obvious.

→

Some examples of using bolds and italics to create emphasis.

Emboldened title
& italicized film name

Revoir *Jurassic Park* une fois de plus

Mon père observait avec douleur le changement perceptible dans mon caractère et mes habitudes et s'efforçait, par des arguments tirés des sentiments de sa conscience sereine et de sa vie innocente, de m'inspirer du courage et d'éveiller en moi le courage de dissiper le nuage noir qui couvait sur moi.

Italicized quotation

« Pensez-vous, Victor, que je ne souffre pas aussi ? »

Italicized foreign words

Mont Blanc raised itself from the surrounding *aiguilles*, and its tremendous *dôme* overlooked the valley.

Italicized emphasis

I had to check, double-check, and then *triple-check* that I hadn't read something wrong, but no, it appears that this is actually

Underlined links

real: <u>Off Type</u> (<u>Pangram Pangram Foundry</u>'s new offshoot, which <u>I linked to not long ago</u>) are offering a bundle called

Emboldened primary link

<u>The Off Set</u>, which collects all 9 of their typefaces (a total of 45 fonts) in one package for just… $14. Yes, $14. You can see why I had to check this. I bought The Off Set and can confirm that this is a total bargain. I feel almost guilty linking to it.

You're going to need *italics*

An italic style is required for almost all typesetting, and not just for emphasis.

SEE ALSO

Faux • Oblique • Style

Ah, the humble italic. Use it to emphasize a word (or words) in your body text. Use it for book titles or quotations, if that's inline with your style guide. Use it for entire sections of text, like pull quotes, if it works. Use it for single words or characters in a logo (like "of" or "&") if that adds a little visual flair.

The italic style (along with bold weight) is perhaps the very first typographic change many people will ever encounter—it offers instant differentiation from the surrounding text. However, unlike the use of an entirely different typeface, the italic shares a common foundation with its upright (or regular) counterpart, and therefore an underlying sense of harmony.

The first italics were based on cursive forms—that is, closer to handwriting—and looked notably different from the uprights. For italics in use today, some look very distinct from the regulars; others change their form only slightly. Italics are almost always slanted (again, like handwriting), but slanting alone doesn't produce an italic—a slanted version of the upright is an oblique (commonly found in Grotesque faces), and even then, the letterforms are still tweaked by the type designer to account for the altered angle, and to stop some parts becoming too heavy or unbalanced. When this isn't done—in other words, when upright glyphs are artificially slanted by software, we call this a *faux* italic. And this should be avoided at all costs. See my dedicated rant on page 64.

Evaluating a typeface's italic style is an important exercise when choosing type. Depending on the project, an italic that appears quite distinct from the upright form might add some much-needed flair to the text... or it could be way too distracting, and perhaps an oblique is needed instead. Of course, the italic or oblique should always be distinct enough from the main text (see "Balance distinction & harmony" on page 106)—otherwise what's the point in using them?

You know what's crazy? Not all fonts have italics! And that's fine. But it's worth checking if you're going to be setting anything other than short headings.

→

Italics are primarily used for emphasis, but their usage can be a purely stylistic one, too. The important thing is to be consistent.

Italics for an album title

I can't believe *Nevermind* was released that many years ago. Are you sure?

Italics for a quotation

"Mr Hoggins says she cannot live many days, and she shall be spared this shock," said Miss Jessie, shivering with feelings to which she dared not give way.

Italics for aesthetic interest

Crossland *&* Kunisch
AGENCE DE LIBÉRATION DES FONTES

Italics for specific elements (pullquotes)

The second thing is that you could export that as an SVG. I had my musician's hat on for the creating process, but the designer's hat on for, *"What am I going to get out of this? I get an SVG file that I can use in my design app of choice. That's great."* The ability to get an SVG super easily doesn't require me, as a total non-developer person, to dig into any code. I just get something that I could throw into an app and design some stuff around. Because it was pattern-based and I chose a Voronoi graph that only had a few nodes so that the focus would really be on those few lines that you see on the artwork, I already had the idea that I would do a cassette. It was a very loose idea, but it was like, *"This ticks all those boxes in*

"This feeds very much into a recent-ish approach to music, just setting some parameters and letting things happen."

Italics adding a different personality

Und jetzt etwas ganz *anderes*

Italics for emphasis, affecting meaning

I didn't say we should kill him!
I *didn't* say we should kill him!
I *didn't* say we should kill him!
I didn't *say* we should kill him!

I didn't say *we* should kill him!
I didn't say we *should* kill him!
I didn't say we should *kill* him!
I didn't say we should kill *him!*

Using *weight* is more than just making something bold

Look for as many weights as possible. You never know when they might come in handy.

SEE ALSO

Italics • Style • Variable fonts

Hitting that "B" button in a word-processing app might be the closest many people come to typography, and that simple act helps introduce even the novice to the concept of creating contrast within some text, using a Bold weight to create emphasis and perhaps some hierarchy. But for the typographer, there's so much more to explore. Bold is just one of several (effectively limitless) weights to choose from. And exactly how lighter or heavier any weight is in relation to another is completely arbitrary and varies from typeface to typeface. A common mistake can be to select a weight that isn't different enough from the body text. Just like pairing type, it's all about *balancing distinction and harmony*—see page 64.

Some typefaces come with only one weight; some offer fonts from Hairline or Thin at the lightest end, to Black or Ultra at the heaviest; others come in the form of a variable font, where a slider for the weight axis allows the end user to set type at completely customized weight values, as well as the traditional instances. Perhaps one of the most interesting things about variable fonts with a weight axis is that the end user can decide exactly how much bolder a Bold actually *is*.

It's worth remembering that using a heavier weight isn't the only way to create emphasis or contrast—we could use use an italic style, small caps, or perhaps even a different typeface. And there's absolutely no requirement for headings to use heavier weights, either. If set at an appropriately larger font size, a heading could even be set in a Thin weight.

→

[TOP] The five weights of OT Miniature (left) and the nine weight of Rewrite (right).

[BOTTOM] In the paragraph text at the bottom, note how there's more contrast between the body and the emboldened words in the right-hand version. The emboldened words are still in the Bold weight of Epilogue, but the body itself is set in the Light weight (versus the Regular weight on the left).

tapas
tapas
tapas
tapas
tapas

cheers
cheers
cheers
cheers
cheers
cheers
cheers
cheers
cheers

s, we became very **wakeful**; so much so that
recumbent position began to grow wearisome,
d by little and little we found ourselves sitting
the clothes well tucked around us, leaning
ainst the head-board with our four knees drawn
close together, and our two noses bending over
m, as if our kneepans were warming-pans. We
very **nice and snug**, the more so since it was
chilly out of doors; indeed out of bed-clothes
, seeing that there was no fire in the room. The
re so, I say, because truly to enjoy bodily warmth,
ne small part of you must be cold, for there is
quality in this world that is not what it is merely
contrast. Nothing exists in itself. If you flatter
irself that you are all over comfortable, and have
en so a long time, then you cannot be said to be
nfortable any more. But if, like Queequeg and me
he bed, the tip of your nose or the crown of your
ad be slightly chilled, why then, indeed, in the
neral consciousness you feel most delightfully

Yes, we became very **wakeful**; so much so that
our recumbent position began to grow weariso
and by little and little we found ourselves sitting
up; the clothes well tucked around us, leaning
against the head-board with our four knees dra
up close together, and our two noses bending
them, as if our kneepans were warming-pans. W
felt very **nice and snug**, the more so since it wa
so chilly out of doors; indeed out of bed-clothe
too, seeing that there was no fire in the room.
more so, I say, because truly to enjoy bodily wa
some small part of you must be cold, for there
no quality in this world that is not what it is mer
by contrast. Nothing exists in itself. If you flatte
yourself that you are all over comfortable, and
been so a long time, then you cannot be said to
comfortable any more. But if, like Queequeg and
in the bed, the tip of your nose or the crown of
head be slightly chilled, why then, indeed, in the
general consciousness you feel most delightfu

Often, the more *styles,* the better

It negates the need to look for a secondary typeface.

SEE ALSO

Alternates • Italics • Numerals • Small caps • Stylistic sets • Variable fonts • Weight

The vast majority of typefaces come in several styles, in keeping with the idea that, when it comes to typography, you rarely need to be stuck with the default options. Different styles are usually contained in their own separate font files, although can be combined in the case of variable fonts. While weight (and arguably even width) could sit under the umbrella of what's deemed a "style," I personally find it more useful to keep them under their own banner, and use style as a way of referring to uprights, italics (or obliques), and small caps.

Uprights (also often called romans) are the default form for most typefaces. Italics and obliques exist to offer ways of emphasizing certain parts of the text from the upright forms, or to provide variation for aesthetic purposes. This is explored at length in "You're going to need italics" on page 58. Small caps are uppercase glyphs that have been designed to sit neatly alongside lowercase type. This allows acronyms like UNESCO to sit in body copy without shouting at the reader (see page 164) — a bit like proportional oldstyle figures (see page 158).

In CSS, `font-style` is used to turn an italic or oblique style on and off. In variable fonts, it's for type designers to use a slant axis (`slnt`) to let users control exactly *how* slanted an oblique appears, and these can even have both positive and negative values, allowing type to slant backwards as well as forwards. Some fonts have controls to adjust the cursive-like styling usually found in italics independently from the specific control over the angle of slant. This is can be found in Stephen Nixon's Recursive typeface.[1]

While usually grouped with OpenType features, stylistic sets are — as the name implies — variations on the default type styles, and can be useful to employ when seeking more beyond the default options made available to us. See page 166 for more info.

1 recursive.design

→

Even when showing just one weight — Regular — it's easy to see how much stylistic variation exists in a typeface such as Recursive. From a sans to a monospaced sans, a Linear (i.e., formal) style to a Casual style, a roman to an italic (including every step in between thanks to a slant axis in the variable font), and multiple alternates accessible via OpenType settings, there's lots to explore here beyond the defaults. And even finer control is afforded with the variable axes, allowing us to us to move gradually between each style and decide exactly when cursive forms (i.e., those usually used in an italic style) should make an appearance or not.

Sans Linear

hamburglfis
@0123456789

hamburglfis
@01234567

Mono Linear

hamburglfis
@0123456789

hamburglfi
@01234567

Sans Casual

hamburglfis
@0123456789

hamburglfis
@01234567

Mono Casual

hamburglfis
@0123456789

hamburglfi
@012345678

Mono Casual with
various alternates
turned on

hamburglfis
@0123456789

hamburglfi
@012345678

Avoid *faux* (synthesized) styles

They're mistakes, and you don't want them in your designs. Ever.

SEE ALSO

Italics · Oblique · Small caps · Style · Weight

Okay, a faux (or fake or synthesized or pseudo) italic never killed anyone. Let's make sure the skeptics are happy. But a faux italic will certainly make you or your client look like you don't care about doing things properly—and that's rarely a message clients want to send.

Faux italics, faux bolds, or faux small caps occur when software tries to emulate a certain style (or weight) in lieu of the correct versions. This can happen for a variety of reasons. The most common reason is when we only have the regular font installed on a machine (or served from a website) and the application (or browser) attempts to simulate an italic for any text that should be italicized. This is especially rampant on the web, where CMS-controlled websites allow any editor to hit the big "I" button and expect (quite rightly) the selected text to be italicized.

The second and often overlooked reason is that an italic might simply not exist! As in: the type designer never drew (or released) an italic style. Nothing can solve this situation, and it's always important to check that a true italic exists before making the decision to use a certain typeface on a popular website.

So what's so bad about a faux italic? Well, true italics are always unique drawings in themselves that look notably different from their upright counterparts—especially so with serif designs. Note how the letterforms of most serifs' lowercase "a" and "g" characters look radically different when italicized. This is why an artificial slant doesn't even begin to accurately simulate a true italic design. And while it's true that the slanted angle is indeed the defining feature of most italics—and is certainly the case with obliques, where the letterforms' design remains largely unchanged—there are still subtle differences made to the strokes to compensate for the altered angle.

Faux bolds are slightly harder to spot because designs differ very little between small weights changes. However, because software adds an outer stroke to simulate a heavier weight, faux bolds usually look bloated, with spacing between characters too small.

Faux small caps are achieved by shrinking regular uppercase glyphs down to the size of the lowercase, which results in those capitals appearing notably thinner than intended. And that looks bad.

⟶

Note the true italic in the top right is a radically different drawing to the faux, slanted version in the top left. The faux bold (middle left) appears too soft and rounded, with letterforms clashing due to the inadequate spacing. The faux small caps (bottom left) appear too thin, as they're shrunken versions of the (much larger) regular upper-case forms.

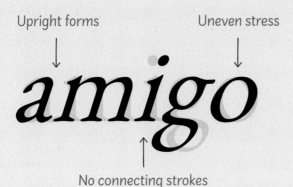

Upright forms

Uneven stress

No connecting strokes

Letterform clashes

Tiny counters

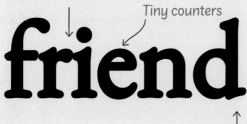

Bulbous serifs

Incorrect proportions

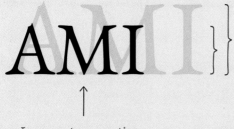

Use true *obliques*

Unlike italics, obliques are slanted versions of the upright forms — but that slant is still optically adjusted by the type designer.

I'm always keen to point out that proper italics are often pretty unique from their upright cousins — and that's usually how to spot faux italics (see my rant on page 64) — but in the case of obliques, they're effectively slanted versions of the uprights. Not that they should be regarded as inferior in any way, of course! Obliques, rather than italics, are very often encountered in sans serif typefaces. However, it's important to remember that true obliques are still created by the type designer, rather than artificially slanted by software, so the distortions to the letterforms caused by the slanting are optically corrected in true obliques, with the type designer adjusting the shape of the letterforms to ensure correct contrast is maintained when slanted.

Just like italics, obliques need not be reserved purely for emphasis, and can be used for aesthetic reasons, potentially communicating a sense of action or urgency, such as in a sports brand or poster for a car chase film. And, like italics, obliques are controlled in CSS by the `font-style` property.

In a variable font with a slant (`slnt`) axis, adjusting that slant means transitioning from an upright to an oblique, and all of the stages in between. This is notably different to an italic (`ital`) axis, where the italic is boolean (i.e., either off or on) and the act of switching to an italic usually means switching between two different font files. Note that it's rare to have a slant axis present alongside an italic axis, but in theory there's nothing to stop both being used.

SEE ALSO

Faux • Style • Variable fonts • Web typography

→

[TOP] Obliques can capture a sense of speed.

[BOTTOM] Recursive's variable "SLNT" axis — which produces an oblique style — can be combined with its "CRSV" axis — which produces an italic style — allowing the end user to decide exactly when the cursive letterforms should make an appearance. It's relatively rare for a typeface to have both oblique and italic versions.

Note: At the time of publication, there is some discrepancy around how the slant direction and positive / negative values are implemented in variable fonts, with some choosing opposite ends of the axis.

FASTER THAN FAST

ag ag ag ag

SLNT 0	SLNT -4	SLNT -9	SLNT -15
☐ CRSV	☐ CRSV	☐ CRSV	☑ CRSV

Use typefaces with multiple *widths*

The freedom to occupy more horizontal space opens up so many more opportunities.

SEE ALSO

Pairing · Variable fonts · Weight · Superfamilies

Width is a bit like the slightly smarter, older cousin of weight. Fonts with multiple widths (or variable fonts with a width axis) are not quite as common as those with multiple weights, but, when available, putting them to use for our typographic needs can be instantly rewarding. Unlike with weight, the stems of the letterforms themselves remain consistent — it's the overall shape of the letterform that grows or shrinks as we adjust width.

Depending on how much differentiation there is between the narrowest and widest extremes, width can be a useful and subtle (or not so subtle) tool. For instance, in order to fit more words per line into a website's article heading, using a Condensed width can really make a difference to the number of characters per line, therefore having the knock-on benefit of making the heading take up fewer lines. Condensed widths need not just be reserved for headings, either — an ever so slightly condensed font (and if we're using the width axis of a variable font, we can get *really* specific) could be a useful trick to employ if we're setting text in very narrow columns, perhaps like those in captions found in a book's margin.

Width can also serve as a powerful means of painting with a broader typographic palette, such as when combining an Extra Wide with an Extra Condensed in a branding project to avoid pairing different typefaces.

→

[TOP] The width range in Ty Finck's Anybody's is quite large. In this blog-like example, the heading uses a width value of 50; the "published" and "tagged" words use 150; everything else uses 100. These therefore represent the three extremes of the scale. The weight value (350) remains unchanged.

[MIDDLE] David Jonathan Ross's Fit takes extremes to the next level, but keeps the counter spaces even, no matter how wide, from "Skyline" to "Ultra Extended."

[BOTTOM] Subtly adjusting the width axis of a variable font allows us to create a fully justified block of type that wouldn't have been possible in other ways. Doing so with tracking or perhaps weight would create inconsistencies, and traditional width delineations would not be precise enough.

I have a logo now

PUBLISHED 26 April 2023
TAGGED #lettering #this-site

At the end of last summer, I attended the very first Letter Luvvers event, put together by Laurence and Borys as a way of bringing together Bristol's type and lettering communities. At the time of writing, there have now been five of them (I spoke at the fifth), but it was at that very first one when I met Emma Luczyn, who did a talk on her hand lettering work. Her presentation was fantastic, we had a great chat afterwards, and not too long after the event, I figured that Emma would be the perfect person to create something I'd been mulling for a while: a logo.

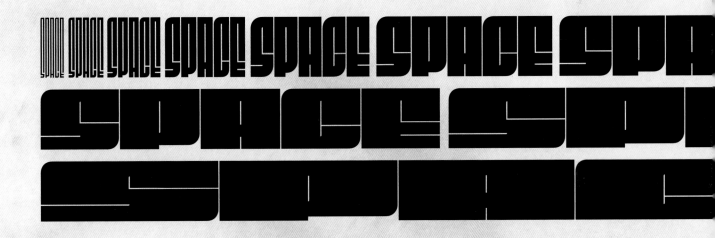

SWIPE UP
FOR MORE
EXCLUSIVES

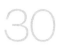

Understand *masters & interpolation*

Type designers don't have to draw every possible weight, width, or style.

SEE ALSO

Style · Variable fonts · Weight · Widths

When contemporary typefaces are designed, there's no need for the type designer to manually create every single possible weight, width, style, optical size, etc. Instead, the type designer creates masters for the more extreme ends of the scale and the software interpolates between the masters to create the weights, widths, styles, optical sizes, etc. in between. These can then be exported as their own individual fonts, or named instances within a variable font, ready for the end user to control. Here, the end user can, in theory, create a potentially unlimited number of variants on the fly by manipulating the variable axes. And the more axes, the more potential outcomes, as the axes are combined.

Depending on the amount of variation required, it's usually sensible to create additional masters for in-between stages where the automatic process of inter-polation doesn't quite cut it. These offer additional guides to ensure a smoother transition between the outlines of the glyphs.

Font-making software is also intelligent enough to create new instances from seemingly different masters. For instance, a Light master and a Bold master (for weights) could be combined with a Wide Light master (for width) to create a Wide Bold variant—see the bottom illustration, opposite. This process is called vector addition.

⟶

[TOP] An XLight weight and SemiBold weight can be interpolated to create a Regular weight.

[MIDDLE] A Semi Condensed width and Semi Wide width can be interpolated to create a Regular width.

[BOTTOM] Using vector addition, different masters for weight *and* width can be combined. Here, a Light, a Bold, and a Wide Light can be used to create a Wide Bold.

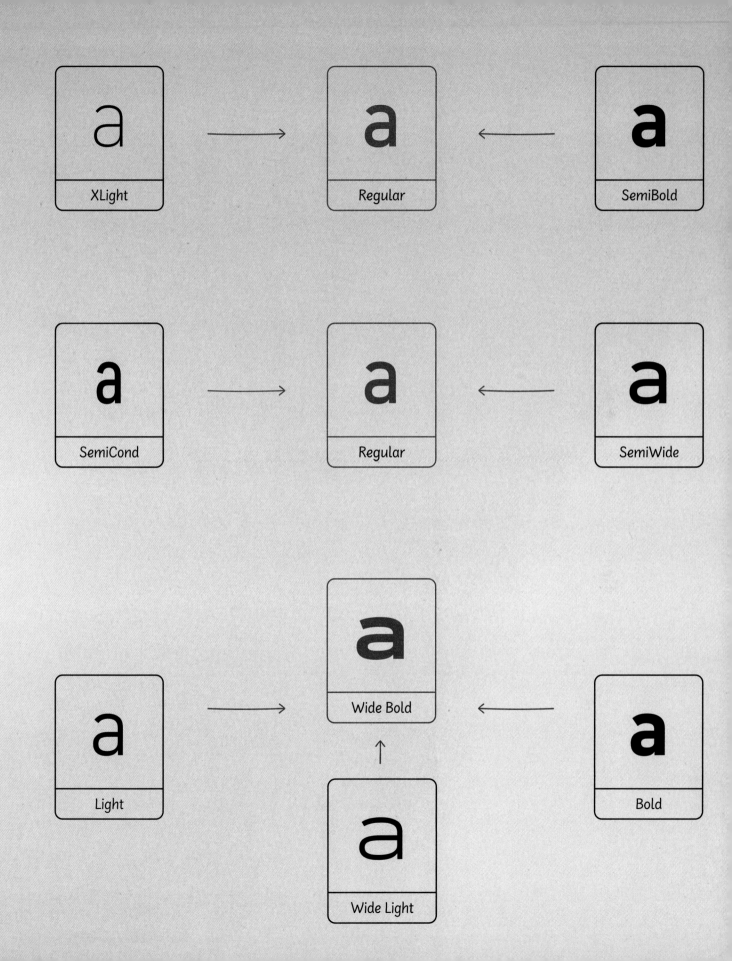

Employ *multiplexed* typefaces for interaction

Change the weight without affecting the horizontal space used by the type.

SEE ALSO
*Monospace • Numerals •
Weight • Widths*

When you switch between different weights of a font, more often than not, you'll notice that the width changes, too: heavier weights, with their thicker strokes, tend to take up more horizontal space, and the space around the letterforms usually needs to grow as well. However, multiplexed typefaces avoid this width change, so that a word set in a light weight will take up the exact same horizontal space as a word set in a heavy weight.

In many ways, the principle is related to monospaced typefaces, where every glyph has the exact same width, and tabular numerals, where every figure has the same width. However, unlike those, it's not every glyph that shares one width: it's every weight of an individual character that shares a width.

Multiplexed typefaces can be useful to employ in scenarios where different weights are required (perhaps for emphasis) but where positioning or alignment cannot be changed. An example might be in a table of text-based data where one row needs emphasizing in a heavier weight, or in an app where a button might switch to a heavier weight when hovered over or made active. For this latter reason in particular, multiplexed typefaces have gained popularity in recent years with user interface designers. Compare the top (nonmultiplexed) example with the bottom (multiplexed) example on the page opposite.

⟶

In the top example, note how the "albums" button becoming selected by the user results in all of the buttons being pushed over to the right because of the change in width. In the bottom example, the width remains the same and the buttons stay in the correct position.

sushi
sushi
sushi
sushi
sushi
sushi
sushi
sushi

albums playlists podcasts

albums playlists podcasts

☹

sushi
sushi
sushi
sushi
sushi
sushi
sushi
sushi

☺

Punctuation & quotation marks aren't just for copyeditors

At the very least, ensure that curly quotation marks are turned on by default.

SEE ALSO
Optical trickery · Spaces

Punctuation comes in many forms, and walks that fine gray line between something a typographer should handle and something a copywriter should handle. I'd argue that it's a skill—no, *responsibility*—that should be shared by both. And, ideally, something that both are deeply passionate about upholding. It is, after all, up to us designers to make sure that the meaning of the text is conveyed in the most appropriate way, and that means using the correct symbols.[1]

One of the main punctuation stumbling blocks comes in the form of the humble quotation mark and its related symbols, the apostrophe and prime. I say "related" as they're only similar in their visual appearance, not their meaning— and *ay, there's the rub!*

Straight double quotation marks and straight single quotation marks (the latter appearing identical to a straight apostrophe) are a hangover from the age of typewriters, where keyboard space was at a premium and, unfortunately, litter contemporary texts. When available, writing and design apps (even your smartphone's messaging app, probably) will use the correct quotation marks — known as "curly quotation marks" or "typographer's quotation marks"—but these can't be relied upon, especially if we're pasting in text from elsewhere.

1 See Jessica Hische's quotesandaccents.com for a concise guide and keyboard shortcuts.

2 Frank Rausch has compiled a handy list on github.com/frankrausch/ Typographizer# supported-languages

Notice how drastically the shapes of quotation marks can change even within the same family, such as in Tabac Big (below) and Tabac Slab Big (opposite, bottom). The horizontal lines indicate the x-height and baseline.

Double quotation mark (for opening in English)

Double quotation mark (for closing in English)

Single quotation mark (for opening in English)

Apostrophe & single quotation mark (for closing in English)

Guillemets

Lower double quotation mark

Lower single quotation mark

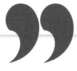

Straight single
quotation mark (also
used as an apostrophe)

Straight double
quotation mark

Single prime

Double prime

Triple prime (absent
in most typefaces)

Different languages and regions use different symbols and/or positioning for their quotation marks [2] — be sure to call in a regional exert to check your work!

* In German and Dutch, most non-typographers use „**this**".
* German and Austrian typographers prefer guillemets, which — according to the style guide — can be used in **»this«** orientation or **«this»** one. In Switzerland, the only correct orientation is **«this»** one.
* In French, guillemets are used, but are accompanied by a hair space or a thin space.
* Single and double options exist in most languages that use the Latin script. American English favors double quotation marks, with singles used for a quote-within-a-quote, and the reverse is true in British English.

Single and double primes — which are usually designed to be slightly slanted — are used to denote measurements of time and distance, but just like quotation marks and apostrophes, often get substituted with their incorrect straight cousins. To be fair, though, they're actually absent from a lot of font files.

When working with a quotation block that appears visually separate from the rest — or, if we're being really diligent, any quotation that starts a paragraph — one of the many typographic improvements we can make is to use hanging punctuation: the act of moving the opening quotation mark, just outside of the text box so that the left margin appears optically aligned (see page 136). Yet another one to file under the banner of breaking the rules or optical trickery.

Differentiate between *logo*, logotype, and logomark

What part are we referring to while we're designing a brand?

SEE ALSO

*Distinction & harmony ·
Kern · Pair type ·
Two-lines-of-type*

Let's be honest: we've all been guilty of saying "logo" when technically we mean "logotype," haven't we? And who hasn't interchanged "logomark" and "wordmark" on occasion? We're sinners, all of us. But forgiveness is on its way: as type is such an integral part of most logos—often, the *only* part—I think it's probably worth being clear on the proper terminology. So let's just get this sorted, shall we?

Erik Spiekermann is well-known for saying that if you have a typeface and a color, then you have a brand, and for many, this is indeed enough. However, for a brand to stand out from the competition, the addition of some kind of mark or symbol is a way of further differentiating it. Therefore, most logos are created by combining different elements—type *and* graphics—in a unique and (hopefully) recognizable way.

Depending on the brand and the context the logo sits within, the elements that constitute a logo can also exist separately. For example, a logomark (a graphic element, symbol, or icon that represents the brand) can be used as a stand-alone element on social media avatars or other promotional materials. A logotype (which is also known as a wordmark if it's made up of just one word) is a specific lockup of the brand's name and can be used when the logomark is absent.

Further differentiation to the logotype can be achieved by some sort of customization: perhaps a unique setting of a typeface (more open tracking, or perhaps a custom kern?), an altered version that actually changes the letterforms' outlines, or a completely bespoke piece of lettering. And if you commission a bespoke typeface for your brand, well, first of all, hats off to you, because I really believe more brands should do that, but secondly, yes, that's a great way of helping you to stand out.

⟶

For a while now, I've had this idea for a sandwich shop: the menu changes every day, but there are only two choices per day: a cold sandwich, or a hot sandwich. *Cold or hot—that's your lot!* So it'd be called Mean Sandwich. Get it? Anyway, don't go stealing my idea and open your own sandwich shop with this awesome premise, will you? I've put it in print now! And I need a Plan B for if this whole typography thing doesn't work out…

Full logo, including tagline

MEAN SANDWICH
Cold or hot — that's your lot!

Logotype, including tagline

MEAN SANDWICH
Cold or hot — that's your lot!

Logomark variations, used for avatars

Licensing is important, actually

You can even let the license help you narrow down your typeface choices.

SEE ALSO

Licensing · Styles · Weight

Font licensing. Boring, right? I mean, why would we—creative people who love to make amazing things with type — want to read some dull document intended for lawyers? Just take me to the fonts!

The thing is, without licensing, we don't have type. The whole industry wouldn't exist, including—believe it or not—free fonts. From a total freebie to the most expensive fee a multinational pays to have all of its staff using a particular typeface, a license is attached to every font we use, whether we take the time to understand that license or not.

At a very simple level, no one should steal fonts, and the license is designed to protect against that. Yes, of course we all start out that way. But any font that's sold *should* be paid for. And just because our employer paid for you to use it at work doesn't mean we can use it for our freelance branding projects. You could show it to your client as an option, and you could use the font files already on your device for some mockups, but if your client goes for that option, you or they should then purchase the appropriate license for that typeface.

Licenses for paid-for fonts are usually priced according to three factors: the first is the number of weights and styles included in the price (often with a significant discount if you buy an entire family or some sort of multi-style bundle); the second, the media (usually desktop, web, and app/ebook); thirdly, the quantity of end users. This is almost always bracketed into actual numbers of people for desktop licenses, monthly page views for web licenses, and downloads for app/ebook licenses (see page 90). Generally, variable fonts are priced the same as a whole family.

Understandably, a lot of people gravitate towards free, open-source fonts —most of which use the SIL Open Font License [1] — like those found on Google Fonts or GitHub. But even those have an associated license, and there are different usage restrictions depending the type of license. I'm not going to cover all those intricacies here—it's just important to understand that "free" doesn't necessarily mean you can do anything with it.

1 scripts.sil.org/ofl

⟶

It was too boring to create an illustration about licensing, so instead I'm showing you a load of artwork I've created over recent years for my music-making alias Other Form. All of the type on the artwork is Nitti Grotesk in just two weights. The reason for this is that when I decided to create the first Other Form website, those two weights of Nitti Grotesk were available in Persona, the tool I was using to build the site. In limiting myself to just using those fonts liensed for the site builder, I found myself working within some pretty strict parameters. I bought licenses for the desktop fonts for those two weights, and they're all I've ever used since for all Other Form artwork and that of the record label, Unknown Movements. Even font licenses can serve as useful tools for choosing type!

Choosing & pairing type

Only ever use a *well-spaced* font

Beautiful letterforms mean nothing if the font's not spaced properly.

SEE ALSO

Glyphs • Kern • Line height • Measure • Numerals • Tracking

Spacing in typography is, well, kind of everything. I mean, maybe not *everything*, but pretty much.

The space between individual glyphs (tracking and kerning), the space between lines (leading), the space taken up by a line of text (measure), the space inside the characters (counters), the space taken up by letterforms in different variants (weight and width)... the list goes on. The vast majority of the changes we make while typesetting are changes to space. Substituting glyphs — whether that's choosing a new typeface, selecting a different weight or perhaps using some sort of alternate glyph via an OpenType feature — isn't immediately about spacing, but even then, those changes affect space. A different typeface will take up a different amount of space, both in terms of its width and potentially where it sits vertically (see "At the heart of it all: the em square" on page 22, to explore some of the complexities this creates), most weights occupy different horizontal spaces, and alternate glyphs occupy different spaces, too. In the case of tabular versus proportional numerals, space is very much the reason for using one over another.

And then there's the act of spacing in terms of type design: the manipulation by the type designer of the space either side of the letterform, known as the sidebearings. These are adjusted on a glyph-by-glyph basis so that the overall distance between characters feels just right. This is different from the act of kerning a font, where the type designer creates exceptions to the rule, manipulating spaces between specific combinations of glyphs (such as "VA"). The combination of this internal spacing, kerning data, and attention paid to the vertical metrics constitute what we commonly refer to as a "well-spaced font." Veronika Burian and José Scaglione, in their article *How to spot fonts worth your money,*[1] say that *"tuning the space inside and in between letters is as important as harmonising the black enclosing the white. They both exist in a permanent state of mutual dependency."*

[1] type-together.com/font-quality

⟶

In this screenshot of the type design software Glyphs, we can see that there's a little negative space on either side of the actual letterform's design. The spacing values are physically shown in the box beneath. The exact values don't matter to us as end users of the font; what's important is that the type designer or font engineer has taken the time to set spacing rules for the font, which results in it actually being usable.

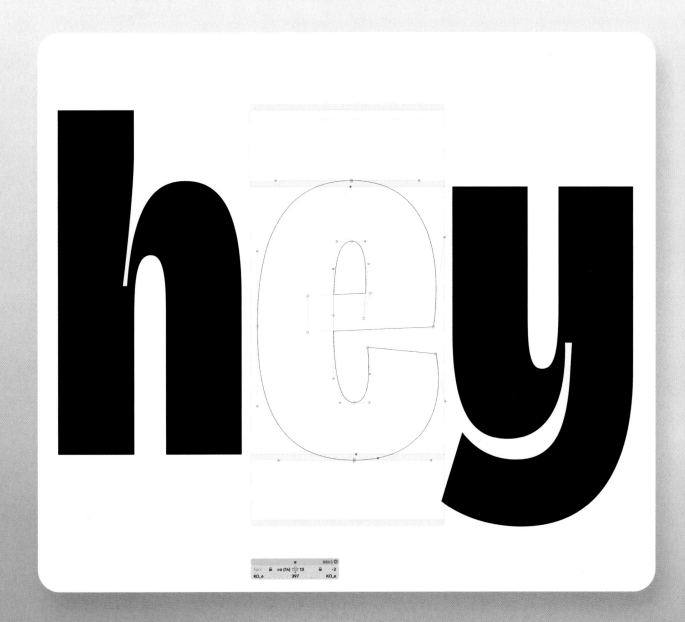

Choose a typeface that suits the purpose of the project

Part one in a four-step process for choosing a typeface and its fonts.

SEE ALSO

Legibile • Readable

I said in this book's introduction that choosing type isn't technically part of typography. In fact, you don't need to choose type *at all* to practice good typography, because there's plenty to do with taking an existing typeface choice and optimizing its font size, leading, measure, or any other parameter discussed in these pages But let's face it, it's not like we're *not* going to talk about choosing type in a book called *Universal Principles of Typography,* is it? And because it needs addressing thoroughly, we've got four principles dedicated to choosing type.

I've established a four-step system, which is also available on GitHub,[1] that can be followed any time we need to choose a new typeface, and the first on that list is, "Choose a typeface that suits the purpose of the project."

There are plenty of examples of typefaces that don't suit the purpose they're intended for. Consider a press release announcing a huge scientific breakthrough. You wouldn't set it in Comic Sans, would you?!? (CERN did exactly that, by the way.[2]) But a poster stuck on the school gates to advertise an extra-curricular sports class? Sure, go for it.

You don't have to know anything about type to have an emotional response to it. As typographers, it's important for us to be aware of what that emotional response could be—and to consider how that might change in different contexts or cultures. And, because all of us—design savvy or not—have emotional responses to type, it's tempting to let emotions dictate our type choices. But emotional responses should be just one of many considerations.

Determining whether or not a typeface suits the purpose of the project also means making sure we're not repurposing an elaborate typeface full of swashes—which might look great in a logo—for body copy. Emotionally, it might resonate correctly, but it's going to make for a difficult reading experience. Realistically, we don't usually know every possible context the type will be used in, but making some high-level decisions about its overall suitability can go a long way.

1 github.com/elliotjaystocks/choosing-type-checklist

2 theguardian.com/artanddesign/2012/jul/04/higgs-boson-comic-sans-twitter

⟶

Some examples of type choices that don't quite work, set alongside some suggestions for potential improvements.

Homemade Doughnuts

OH, YUMMY!

A Blackletter typeface doesn't convey a friendly, informal vibe. How about something more handwritten?

Homemade Doughnuts

Oh, yummy!

Alice & Clem

invite you to their wedding on 15th April 2024

at Bath Registry Office

Please RSVP ASAP!

This calligraphic typeface is beautiful! But hard to read at small sizes, and when all caps ("RSVP ASAP") are required.

Please RSVP ASAP!

Q1 SALES REPORT

$50,512	€99,104
$11,431	€34,511
$61,943	€133,615
£13,601	¥300,245
£12,209	¥498,617
£25,810	¥798,862

Choosing a typeface that doesn't have the option for tabular numerals isn't going to work well for financial reports, where numbers need to line up.

$50,512
$11,431
$61,943

Choose a typeface with a comprehensive design

Part two in a four-step process for choosing a typeface and its fonts.

SEE ALSO

Alternates • Legibility • Line height • Style • Weight

The next step in our four-part type-choosing process is to select a typeface with a comprehensive design. This is removed from the emotional considerations we spoke about in the previous principle; now, we're starting to make more detailed judgements about a typeface's technical suitability. However, we're not evaluating the actual font file yet. First, we need to evaluate the design of the type itself.

A very common mistake many people make is to choose a typeface that doesn't have decent language support; in other words, it's missing characters used in other languages. When these missing characters are substituted and rendered in a different font, it can be very jarring. And even if it's not immediately obvious, the slight change in, say, weight and x-height, causes a little cognitive dissonance for the reader.

All type should be legible, but some typefaces are certainly more legible than others. Some are guilty of containing characters that are potentially indistinguishable from each other, such as the numeral "1", uppercase "I", and lowercase "l". For more on this, see page 40.

Comprehensively designed typefaces should include at least the basic weights and styles of Regular, Italic, Bold, and Bold Italic. It's possible you might only need a typeface for a logo, and then if it's only got one weight, that might be fine, but it's worth thinking about its future extensibility — could that then be reliably used for the brand as a whole?

With the basics covered, it's then time so start looking at what additional features have been considered by the type designer. Are there any alternate glyphs that open up more possibilities to us by allowing us to substitute the defaults? Are there additional weights and styles (or grades) beyond the usual delineations to offer more contrast across multiple scenarios and contexts? And how about additional widths, to make our type even more adaptable to the constraints and possibilities of our project? Optical sizes? These thoughtful considerations from the type designer about how the type might be optimized for different font sizes should *absolutely* be employed if they exist, if for no other reason than they make life a little more fun for us type nerds.

⟶

A selection of typefaces with comprehensive designs, from language support to multiple weights, widths, and optical sizes.

Hāmbürğérføntiç
1Ilio023456789

Def Sans has good non-English coverage in its glyph set, as well as clear differentiation between potentially confusing characters.

mbürğérføntiç
023456789

As well as the Regular and Bold fonts to be expected, the weights range from Thin at the lightest to Black at the heaviest.

Hāmbürğér
1Ilio02345€

Hāmbürğérføntiç
1Ilio023456789

There's a Condensed width, as well as a variable width axis that allows for small refinements.

Hāmbürğérføntiç
1Ilio023456789

Several stylistic sets allow us to swap out alternate glyphs, including those that aid readability.

Hāmbürğérføntiç
1Ilio023456789

Hāmbürğérføntiç
1Ilio023456789

Hāmbürğérfø
1Ilio0234567

In some scenarios, typefaces with optical sizes might be necessary. Note the subtle difference in Case's letterform construction as it moves from its smallest to largest optical size (also available as a variable Optical Size axis).

Choose font files that are reliable

Part three in a four-step process for choosing a typeface and its fonts.

SEE ALSO

Subsetting · Well-spaced

Having settled on a typeface and feeling completely happy with its comprehensive design, we now need to turn our attention to the actual font files we'll be using because not all font files are created equally.

There can be a few reasons the font files don't necessarily have the same design. Older versions of the font might omit certain details or use previous versions of the design that the type designer has since improved upon. It could be that a font file contains a subset of the total glyphs available, perhaps if it's a "lite" version of a font that also has a more expensive "pro" variant. This can be the case if a font is being served via a web font-delivery service, too. A font from Adobe Fonts, or Google Fonts, or from a foundry's website aren't necessarily all the same. It always pays to test your fonts to ensure that the features you need—the things that helped you choose this typeface in the first place—are present in the font file.

Any professionally created font should be well-spaced. In other words, the type designer should've adjusted the interior and exterior space around each glyph to optimize for legibility, as well as information (kerning data) to dictate the space between two or more specific glyphs. But it's also possible that this metadata might have been stripped from a font file. This is rare and probably only occurs in pirated fonts or imitations, but it's certainly possible that kerning data might need to be turned on specifically, depending on the environment. Some non-professional design apps—maybe one your client could be using—won't necessarily have kerning turned on by default.

We've talked a lot about the potential drawbacks of some font files, so let's also consider a potential benefit that might've not been immediately obvious: with an increasing number of typefaces being made available as variable fonts, it could be that the additional weights, styles, widths, optical sizes, etc. exist as axes within a newer, variable version. Then we've got even *more* options at our disposal!

⟶

Occasionally, a subset might not include international characters —or perhaps *only* contain those characters. Subsets can also be created on-the-fly by font delivery networks' APIs.

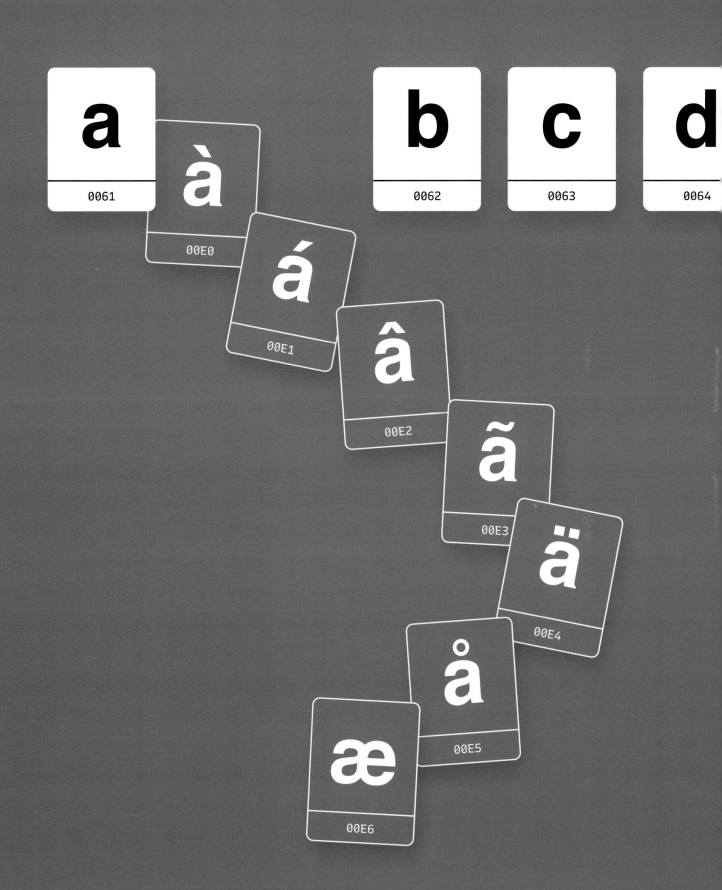

Choose font files that are usable in the situation(s) required

Part four of the four-step process for choosing a typeface and its fonts.

SEE ALSO

Licensing · Pair type

Having followed the first three steps of our four-step process, you could be forgiven for wondering how it'd be possible to get this far and yet somehow find that the fonts aren't usable, but it can happen. Before we give our type choice the thumbs up, there are a couple of final checks.

The first is to make sure that we have—or our client has—the appropriate font license for the desired use. If you have a desktop license to use the font in design work, you'll probably need an additional license (and different font files, too) to use it in a web project. If the website has a large amount of traffic, you'll likely need a higher-tier license to account for that. Some licenses cost considerably more if the font is to be embedded in an app. Whether the fonts are totally free or hugely expensive, we should always pay attention to the license, and we should always try to educate our clients about font licensing, too. In many scenarios, it's the client who could be paying for the license.

The second thing to consider is applicable when we're pairing typefaces. We could have a beautifully designed typeface, containing all of the comprehensive details we've said are required, and available in reliable font files, but it could still be unsuitable when it comes to how it works alongside a primary typeface. Together, do they successfully strike the balance between distinction and harmony (see page 106)? If not—perhaps the secondary typeface is different, but not different enough from the primary choice—then nothing else matters. For this reason, it's worth considering this pairing scenario very early on in the type selection process; I'm only putting it here in the final step because it doesn't need considering if we're only thinking about our primary choice.

→

Licensing options differ by foundry and distributor, but generally when purchasing a license, end users have to select the intended use or medium, and the estimated number of users via drop-downs.

- ☑ **Desktop** `1-3 computers` ⌄
- ☑ **Web**
 - `0-100k monthly page views`
 - `100-250k monthly page views`
 - `250-500k monthly page views`
 - `500l-1m monthly page views`
 - `1m-5m monthly page views`
 - `5m+ monthly page views`
- ☐ App
- ☐ eBook

40
Keep things in the *family*

A shared skeleton and similar proportions take the guesswork out of pairing.

SEE ALSO

Pair type • Superfamily

Type families are great. You know what you're getting with a family. Each member of the family has a shared skeletal structure (common ground that makes them interact well together). I probably don't need to use the "type families are like human families" analogy here, do I? You've probably heard that many times before. Besides, you're never going to get a semirelated monospaced script version of a typeface spouting questionable political opinions at seasonal family get-togethers, are you?

What actually constitutes a family or superfamily is somewhat open to interpretation by different foundries and distributors. Is a serif and sans enough to call a family? When does a family become a superfamily? Can you call different optical sizes a family? Does adding a monospaced version of a typeface define it as a distinct family member? Are any—or all—of these considerations moot in the age of variable fonts, anyway, where you can potentially traverse the entire spectrum of a superfamily's various traits with the gentle nudge of a slider?

I don't spend too much of my time concerning myself with these arbitrary groupings or non-groupings, but instead continue to espouse the benefits of working with type families whenever possible, especially as this is one of those cases where "less is more" really does not apply. The more members of a family you've got to work with—Serif! Sans! Slab! Script! Mono!—the less need you have to employ a second family at all.

The two easiest hacks when it comes to type pairing are pair typefaces from the *same* family, and pair typefaces by the *same* designer or foundry. The interesting thing about that first hack is that you're also getting the benefits of the second one: beyond the skeletal structure, you're also getting the same ways of drawing type and building fonts, and that just makes life so much easier.

[TOP] IBM Plex Sans and IBM Plex Serif, designed by Mike Abbink, share an obvious skeletal structure.

[BOTTOM] IBM Plex Sans and IBM Plex Mono, with Mono being a monospaced variant of Sans.

familiar
familiar

y the time passes here, encompassed as I am
d snow! Yet a second step is taken towards
rise. I have hired a vessel and am occupied in
my sailors; those whom I have already engaged
be men on whom I can depend and are certainly
 of dauntless courage.

How slowly the time passes here,
by frost and snow! Yet a second s
my enterprise. I have hired a ve
collecting my sailors; those whor
appear to be men on whom I can de
possessed of dauntless courage.

Make life easier and use a *superfamily*

With a superfamily at your disposal, there's rarely a need for a secondary family at all.

SEE ALSO

Family · Pair type

You know what's better than a family? A *superfamily!* Because type pairing can be kind of tricky, if you've got a load of extra options at your disposal, why not pick one of them instead?

A superfamily is a collection of typefaces that all share the same skeletal structure, proportions, and motifs. As mentioned in the previous chapter, the definition of exactly what a superfamily is and isn't varies, and can even just be a collection of different weights and widths, but generally superfamilies tend to be larger groupings of different typeface classifications, like a serif, sans serif, and slab serif. Perhaps a monospaced version or maybe a script variant! The specifics matter less than the overall concept: a superfamily allows you to explore many more options outside of your default styles, but with the added bonus that any other typeface from within the superfamily will just work. Consider it a quick win. And with some superfamilies being so robust, there's certainly an argument for *never* introducing a second typeface into your typographic system. Consider the Breve superfamily, shown opposite.

In terms of font technicalities, glyphs in a superfamily likely share the same or similar vertical metrics, and therefore proportions such as x-height are very likely in the same position in the serif, sans, slab, etc. Even if the position of the x-height within the em square shifts according to optical size, that shift should, in theory, remain consistent throughout the superfamily.

It's possible for a superfamily—traditionally, taking the form of several individual font files—to all be accessible via one variable font file, if the type designer assigns different aspects of the design to variable axes. For example, a "monospace" axis could be used to turn a standard sans into a monospaced version, such as in Recursive;[1] similarly, a "serif" axis could turn a sans into a serif by adding serif marks to the sans' letterforms, such as in VZWO VARIANZ.[2]

[1] recursive.design

[2] viktorzumegen.de/varianz.html

→

Promotional specimens released alongside DSType's Breve superfamily. Both the typefaces and their specimens were designed by DSType. Reproduced with permission.

Breve Text™

Breve Text is part of the most complete
type system ever designed by DSType.

For Breve Text we decided to *reduce the height of the uppercase* letters by 40 points, in order to *establish a more adequate* relationship with the lowercase. *Most letters are slightly different* from the Title version and the *contrast is less evident due to the* increased thickness of the *serif shapes and the increased angle* of the italics make it more *fluid for long passages of text.*

Breve Title™

Breve Title is part of the most complete
type system ever designed by DSType.

Breve Title was designed for use in *blocks of text. Simple but with enough* personality to stand by is own. *The uppercase is sturdy, yet elegant,* distinguished by non-descending *letterforms, making the titles and* headlines much more uniform *and interesting. The slightness of the* italics enrich the robust look and *straightforward appearance, in a* quest for a more forceful *and contemporary presence.* All upright versions include *a Stylistic Set with dingbats.* Available in 8 weights and italics, *ranging from Thin to Black.*

Breve Sans Text™

Breve Sans Text is part of the most complete
type system ever designed by DSType.

By introducing a more humanistic *approach, with ascenders that end* obliquely and are taller than the *capital letters, along with a curved* tail on the lowercase 'a', Breve Sans *Text gives a bit of a softer and* warm feel to the typographic *palette and is intended for use in* longer passages of text, performing *well in any size. The goal was* to accomplish a workhorse *typeface with calligraphic forms.*

Breve Sans Title™

Breve Sans Title is part of the most complete
type system ever designed by DSType.

Following the same principles of it's *serif counterpart, Breve Sans Title* shares the same exact structure, *both in terms of anatomy and* functionality, with non-descending *forms in the uppercase. The* disconnection of the counters with *the vertical stems in some glyphs is* one of the main characteristics of *the entire Title set. A wonderful set* of dingbats can be accessed through *the Stylistic Set feature,* from A to Z, perfectly matching *the height of the uppercase letters.* Available in 8 weights and italics, *ranging from Thin to Black.*

Breve Slab Text™

Breve Slab Text is part of the most complete
type system ever designed by DSType.

The straightforward serif treatment *with omission of the serifs in* the inner spaces, the italics *showing curved terminals on the* oblique letters, the exclusion *of serifed terminals on certain* letters, contribute to the *personality of Breve Slab Text.* The result is the perfect match *for the complete type system,* and also works as a counterpoint *to Breve and Breve Sans.*

Breve Slab Title™

Breve Slab Title is part of the most complete
type system ever designed by DSType.

Like Oscar Wilde once wrote *"Life is not complex. We are complex.* Life is simple, and the simple thing *is the right thing". For the design of* Breve Slab Title, we decided to start *from the simplest place – placing* rectangular bracketed serifs onto *Breve Sans – and see if it worked.* And it worked! Although there *were plenty of adjustments, both in* terms of design, spacing and *optical compensation.* Available in 8 weights with *matching italics, ranging from Thin* to Black, including a *Stylistic Set with dingbats.*

Breve News™

Breve News is part of the most complete
type system ever designed by DSType.

Breve News shares the same basic *structure of Breve Text, although,* in order to get a more classic *appearance we managed to increase* the contrast between the thicks *and the thins. With the addition* of ball terminals on a few selected *characters, Breve News gets* an increased invisibility and doesn't *stand out so much. The* italics are much more slanted *for improved distinction.*

Breve Display™

Breve Display is part of the most complete
type system ever designed by DSType.

Breve Display series is, somehow, the set of fonts we had to do. It's in our genes to design extra-black, ultra-contrasted, proud-display fonts that stand out, shouting: We are here!

Pair type only if you have to

It might be that you already have a type family that does everything you need.

SEE ALSO

Family · Pair type

[1] A Book Apart, 2014

⟶

The extensive options available in some families and superfamilies, such as Suitcase Type's Tabac, might mean that there's rarely a need to introduce an additional typeface, especially when we consider the multiple weights in each family. In this example, the weight is kept the same as the family changes, until the final iteration.

Before we start talking about combining one or more typefaces, it's worth remembering that we should always ask ourselves: *do* we actually need another typeface? With all of the great type out there, the temptation to use it all can be huge. But we have to remember that there are many options open to us.

Combining typefaces can be a difficult task, because it requires us to make all of the decisions we made to settle on a primary typeface and then apply them again for the secondary typeface, except with the added pressure of it needing to play nice with the first. In many circumstances, we might inherit an existing design and need to add another typeface without necessarily knowing the requirements that lead to that initial choice. But with the right framework, we can take the guesswork out of pairing type, and apply that any time we need to add a second — or third or fourth — typeface to our project.

And because this framework is hard to cover in one chapter, we've got four dedicated to the subject of pairing type!

In his book, *On Web Typography,*[1] Jason Santa Maria suggests we *"choose typefaces that don't compete too much with each other, but aren't so similar as to be indistinguishable."* Finding this balance between distinction and harmony is a challenge throughout design as a whole (we explore this in detail in "Balance distinction & harmony" on page 106), but perhaps none more so than when pairing type. So this is where we'll start: our secondary typeface needs to be significantly different from our primary typeface, and yet there needs to be a relationship between the two. This harmony will be felt subconsciously by the reader; it's our job as typographers to make that transition between typefaces as smooth and as logical as possible.

Tabac G2 Regular @ 16pt
+ Tabac G2 Regular @ 30pt

just because we *can*
it doesn't mean
we *should*

Tabac G2 Regular @ 16pt
+ Tabac Slab Regular @ 30pt

just because we *can*
it doesn't mean
we *should*

Tabac G2 Regular @ 16pt
+ Tabac Sans Regular @ 30pt

just because we *can*
it doesn't mean
we *should*

Tabac G2 Regular @ 16pt
+ Tabac Big Glam Regular @ 30pt

just because we *can*
it doesn't mean
we *should*

Tabac G2 Regular @ 16pt
+ Tabac Big Glam Black @ 30pt

just because we *can*
it doesn't mean
we *should*

Pair type that's related

Fonts from the same designer often have a lot in common.

SEE ALSO

Em square · Family · Metrics · Pair type · Superfamilies

Let's say that we've established the need for a secondary typeface to complement our primary one. Perhaps we need to change context, add another element of a brand's personality, or account for missing features. Where do we start?

As we mentioned previously, we've got to balance distinction and harmony: this new typeface needs to look obviously different enough from the original choice, but also complement it. So a logical first step is to look at other members of the family, if they exist. If our primary typeface is a serif, we could look to see if it has a sans serif or slab serif companion. Perhaps even a monospaced or script variant.[1]

If there are no other typefaces in the family, or perhaps no suitable ones—the biggest challenge is making sure there's enough differentiation in the same family—then the next logical step is to look at other typefaces created by the same designer.

From a design point of view, there will be natural similarities—you could call it evidence of the same artist's hand—and from a technical point of view, there will likely be similar production similarities, too—perhaps the letterforms' positions sitting in the same place in the em square, or shared OpenType features being present. To a slightly lesser extent, some of the latter might also be true if the font is from the same foundry.

These are not hard-and-fast rules, of course, but jumping-off points when faced with the often overwhelming task of finding a secondary typeface.

[1] Note that in some variable fonts, these other styles might even exist as a variable axis, blurring the lines between what constitutes a style or a family member within a single font file.

⟶

There's no guarantee that typefaces created by the same type designer will share attributes, but you can see that Quatro Slab, Decoy, Hatch, and Neighbor—all designed by Mark Caneso for his p.s.type foundry—share *very* similar metrics. And because of this, they make logical pairings.

bonjour bonjour
bonjour bonjour

Tell us a bit about your album cover design process.

I started the label in 2017 just to release my own music, and then it sat dormant until 2020. I had these plans in 2019 that I would release a bunch of stuff in 2020. So, at the beginning of 2020, the compilation I used Components AI for was a fresh start. I used the same type, so there's an inherent system there through the typography. But, apart from that, visually, it was open to doing something completely different.

I think partly because it was a compilation, I didn't want to do anything photographic, which I'd previously done a lot of: shallow depth of field textures of moss and trees and

Tell us a bit about your album cover design process.

I started the label in 2017 just to release my own music, and then it sat dormant until 2020. I had these plans in 2019 that I would release a bunch of stuff in 2020. So, at the beginning of 2020, the compilation I used Components AI for was a fresh start. I used the same type, so there's an inherent system there through the typography.

But, apart from that, visually, it was open to doing something completely different. I think partly because it was a compilation, I didn't want to do anything photographic, which I'd previously done a lot of: shallow

Pair type using the font matrix

A method for analyzing typefaces that might reveal a hidden connection.

SEE ALSO

Classification • Human hand • Pair type

So far, we've looked at some general methods (page 84) and some more specific methods (page 86) for pairing type; now, let's take a look at a method proposed by Indra Kupferschmid[1] that acts as a framework for pairing typefaces based on the various layers of a typeface's construction.

The huge benefit of this method is that it requires no knowledge of historical type classifications or arbitrary genre definitions—you just look at what's in front of you and analyze from there. Kupferschmid's proposal revolves around breaking the letterforms' construction into three separate layers:

1. Skeleton (form model)
2. Flesh (contrast and serifs)
3. Skin (finer differentiation)

The three form models that make up the first layer are **dynamic** (more pen-like), **rational** (more mechanized), and **geometric** (more, well, geometric).

Moving onto the next layer, we look at the **contrast** (and the angle of stress that dictates the modulation of the stroke), and **if serifs are present** in the design or not.

The final layer looks at additional details that contribute to the type's personality: the specific **shape of the serifs**, simulated **textures**, **decorative elements**, and so on.

With these three layers established, we're ready to move onto the actual pairing. Kupferschmid and Schöndorfer suggest that combining typefaces from the same form model should make for a harmonious pairing (see B, opposite). Pairing typefaces that have *different* contrast and serifs should work well, too (see C, opposite). If we combine typefaces that have different form models but the same level of contrast and/or the same serifs, that *won't* work, as there's just not enough differentiation (see D, opposite).

It's interesting to see this at work, because the font matrix shows us in a very literal way what *balancing distinction and harmony* actually looks like in a practical sense. But it's also important to remember that not every typeface fits neatly into these groupings. As with all type pairing techniques described in this book, this is just a suggestion. Treat it as a set of guides rather than a set of rules.

1 This method was originally proposed by Indra Kupferschmid and then summarized by Oliver Schöndorfer on pimpmytype.com/font-matrix

→

In each of the four instances of the font matrix that appear at the bottom of the page, the three columns represent a skeleton—dynamic, rational, and geometric — and the four rows represent flesh — contrasting sans, contrasting serif, linear sans, and linear serif. Instance B shows how typefaces with the same skeleton pair well. Instance C shows how typefaces with opposite skeleton and flesh pair well. Instance D shows how typefaces with the same flesh *don't* pair well. These are adaptations of illustrations originally created by Oliver Schöndorfer, reproduced with permission.

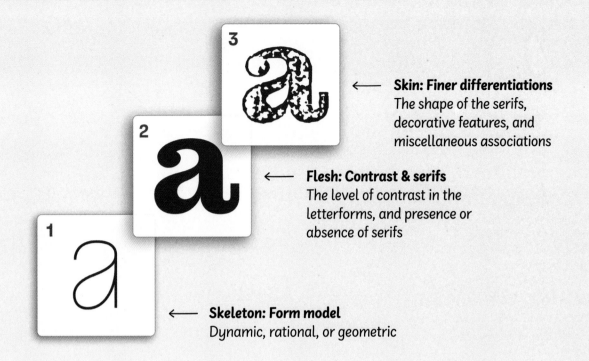

3 → Skin: Finer differentiations
The shape of the serifs, decorative features, and miscellaneous associations

2 → Flesh: Contrast & serifs
The level of contrast in the letterforms, and presence or absence of serifs

1 → Skeleton: Form model
Dynamic, rational, or geometric

Pair type that aligns

Side-by-side type might need some additional consideration to play nice.

SEE ALSO

Metrics • Pair type • Typographic color • X-height

A lot of the work in combining multiple typefaces—especially when the pairings are viewed side by side, or inline, such as in the title above—essentially means navigating the fonts' internal metrics. Put simply, a metric such as x-height in typeface A, set at 16 pt, is unlikely to align with the x-height in typeface B, also set at 16 pt. We delve into this topic extensively in the "X-height is our secret weapon" chapter on page 24.

The two different typefaces used in the headings of each chapter in this book are Degular and Swear, both designed by James Edmondson of OH no Type.[1] Swear (used for the emphasized words) is set at 37.8 pt so that its x-height matches Degular's, even though that's set at 40 pt. With the font size reduced, the overall typographic color is changed, too, but the Black weight of Swear still sits nicely alongside Degular's Black weight. A different typeface or a different weight will harmonize or contrast in different ways, but in my opinion,[2] this particular combination achieves a consistent typographic color throughout the chapter titles, despite the drastic difference in personalities.

Although I'm talking a lot about x-height here, there is of course way more going on. I've already mentioned typographic color, weight, and personality, but there are other considerations when combining typefaces in such close proximity. Do the ascenders and descenders clash (and therefore do we need to adjust line height)? Do the size adjustments require any further adjustments to weight (something usually more customizable with variable fonts)? Are there any design motifs in one typeface that clash with those in the other? The only way to know is to try it out and then adjust one parameter at a time.

[1] Pairing typefaces by the same designer or foundry is a sort of shortcut to finding related structures.

[2] And in James's opinion, too. Shout-out to James for giving this his thumbs up on this combo!

⟶

The difference is pretty subtle, so it's best to look at large sizes. Note that when both Swear and Degular are set at 40 pt, Swear (on the left) appears slightly larger because of its taller x-height. To compensate, Swear's font size is reduced to 37.8 pt in order to create a better optical match.

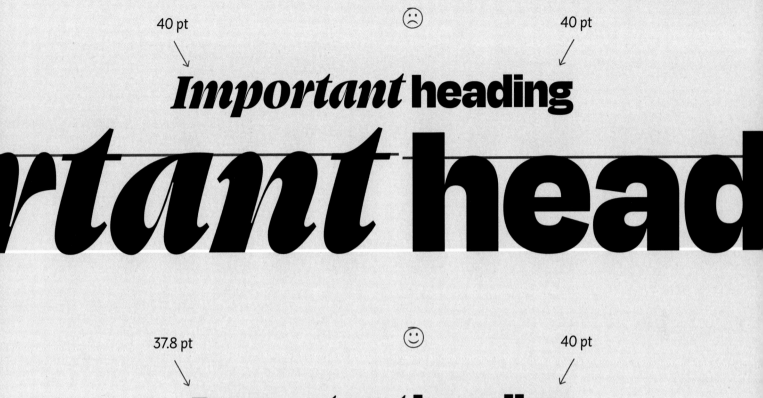

40 pt ☹ 40 pt

Important heading

37.8 pt ☺ 40 pt

Important heading

Add a *monospaced* typeface as a complement

They're great for setting lines of code —
but are by no means limited to that alone.

SEE ALSO

Multiplexed • Numerals •
Variable fonts

Monospaced typefaces were originally created for typewriters, where every single glyph takes up the same horizontal space. Uppercase "W", lowercase "i", apostrophe... they're all the same width. If you've ever used a code editor, you will have used a monospaced typeface, since it's much easier to keep an eye on your code indents this way. Choosing a monospaced typeface doesn't just have to be about technical requirements, though — they can be a great addition to a brand's identity, especially when used as a complement to a primary typeface.

In some families or superfamilies, monospaced versions of proportionally spaced fonts might exist, and these are great for when you need the fixed width for some scenarios, but need to keep your brand intact. Fira Sans for most of your text, but Fira Mono for your captions, perhaps?

Tabular numerals (see the chapter on numerals on page 158 for details) are monospaced, too — their uniform width means they're perfectly suited to... wait for it... tabular data! But the rest of the glyphs in the font are proportionally spaced.

Multiplexed typefaces (see page 72) are somewhat related to monospaced ones in that the width of a particular character remains the same across its various weights. Sure, an uppercase "W" might take up more horizontal space than a lowercase "i" or an apostrophe, but the Thin, Light, Regular, Bold, Black uppercase "W" glyphs (etc.) will have the same width, and that's handy for when we change weights during, say, a hover animation on a button.

→

The metadata and image caption in this example use the Monospaced style of Stephen Nixon's Recursive, whereas the rest of the text is set in its proportional style. And, as Recursive is a variable font with a "MONO" axis, these variations can all be accessed from within the same font file. For more information, see recursive.design.

Choosing & pairing type

On digital publishing

POSTED
Nov 27, 2023

TAGGED
#publishing #ipad #business

As a maker and publisher of any form of content that can be consumed—but most importantly distributed —digitally, freeing oneself of the business models inherited (by default) from the physical world is perhaps the most liberating step one might take.

Of course, this is nothing new. It's been several years now since Radiohead and Nine Inch Nails (and many more acts in their wake) began to distribute music directly to fans, and allowed each buyer to decide how much they'd like to pay—including an option, for at least some versions, to pay nothing at all.

A proposal for a new model.

Does this make business sense? Possibly not, if the price increases scare off potential new supporters. But if I can get enough low-paying supporters to fund the bulk of the work, it shouldn't matter. Plus, even the higher-tier prices would never be prohibitive. I haven't decided on them yet, but the absolute

Balance *distinction & harmony*

Whether pairing typefaces or just combining different styles from one font, we've got to find that sweet spot between too different and too similar.

SEE ALSO

Metrics · Pair type

In his book *On Web Typography* Jason Santa Maria suggests we *"choose typefaces that don't compete too much with each other, but aren't so similar as to be indistinguishable."* Finding this balance between distinction and harmony is at the very heart of what we do when pairing type, and extends to almost all aspects of design when you really think about it. But let's focus on the type pairing side of things for now.

The most common mistake people make when combining different typefaces is to not make them different enough. This is jarring for the user not because it's noticeable, but precisely because it's *barely* noticeable. They'll pick up on some subconscious level that something has changed, but there's no clear intent. *(This words looks different, but why? Is it meant to be emphasized?)* This is a form of cognitive dissonance.

There are a number of ways we can find harmonizing elements from two (or more) typeface designs. Do they share underlying skeletal structures, metrics, or proportions? Do they reference a particular historical design trend? Do they have a similar vibe, feeling, or personality? These things can be hard to idenitify and even harder to articulate, but Indra Kupferschmid has developed a structure around this called the font matrix — see page 100.

It's also worth thinking about occasions when we might intentionally go against balance and harmony, and instead combine elements that should, in theory, not actually work together. In music, playing two or more notes that don't sound good together creates dissonance. Tension! Bad feelings. Metaaal! And we can employ the same tricks in typography.

In fact, a lot of the time, it's perfectly fine to break the rules. If there's one consistent thread that runs throughout the pages of this book, it's that there are multiple occasions where practicing better typography means breaking the supposed rules. (No, really, see "Break the rules with optical trickery" on page 136.)

→

[TOP] A heading set in Meta doesn't pair well with a paragraph set in PT Sans because they're not quite different enough. Meta and Meta Serif pair well, though, because of the distinction between their different forms (sans versus serif) and harmony in their shared skeleton. If even more contrast is required, something drastically different, such as the handwriting-like typeface Rollerscript, creates a very deliberate contrast between heading and paragraph.

[BOTTOM] This approximation of the "Grunge" style, popularized by designers such as David Carson in the 1990s, uses distinction for aesthetic reasons, and does so by employing seemingly chaotic tracking and leading values to the type. But even here there's harmony: the typeface remains the same, as does the size and weight of the font; there's alignment between letterforms above and below; even the floating "the" aligns its x-height to the cap-height of "SPIRAL." Harmony and contrast sit in an almost secret balance in designs such as these.

Article 18

Pero, con todo, alababa en su
autor aquel acabar su libro con la
promesa de aquella inacabable
aventura, y muchas veces le vino
deseo de tomar la pluma y dalle
fin al pie de la letra, como allí
se promete; y sin duda alguna
lo hiciera, y aun saliera con ello,
si otros mayores y continuos

Article 18

Pero, con todo, alababa en su
autor aquel acabar su libro con la
promesa de aquella inacabable
aventura, y muchas veces le vino
deseo de tomar la pluma y dalle
fin al pie de la letra, como allí se
promete; y sin duda alguna lo
hiciera, y aun saliera con ello,
si otros mayores y continuos

Article 18

Pero, con todo, alababa en su
autor aquel acabar su libro con la
promesa de aquella inacabable
aventura, y muchas veces le vino
deseo de tomar la pluma y dalle
fin al pic de la letra, como allí se
promete; y sin duda alguna lo
hiciera, y aun saliera con ello,
si otros mayores y continuos

further down the S P I R A L

Typographic systems

Create a *design system* with type

It needn't be complicated, it just needs to be consistent.

SEE ALSO

Baseline • Em Square • Fluid type scales • Line height • Scale

Just as type is one of the most important — if not *the* most important — elements in design, it's also therefore one of the most important — if not *the* most important — elements in a design system. And creating a design system doesn't really require much to start. Do you have a typeface? A couple of different sizes or treatment options? Then you already have a design system. A typographic scale is most certainly a basic design system — just one with a less-trendy name.

Importantly, a full design system deals not only with font sizes and treatments, but also documents how typographic elements play with other elements, such as buttons, borders, and overall positioning. A good design system should set a number of rules and constraints, offer a limited amount of options via customizable components, and document the whole thing so that any other designer can take the system and achieve consistency with whatever it is that they're designing.

One of the biggest challenges in achieving consistency with a design — and therefore also in creating an effective design system — is dealing with the nuances type can bring with it. Very often, these revolve around vertical margins and padding that are effected by the font size, line height, and the font's internal metrics — see the card example on page 123.

As we discuss in "At the heart of it all: the em square" on page 22, exactly where a letterform sits inside its em box varies from typeface to typeface, and there are no hard and fast rules. If a designer wants there to be more space beneath the baseline than there is space above the x-height, they can. And even if the heights of ascenders and depths of descenders look like they're calculated from a shared central point, that's not necessarily always the case.

There have been some recent efforts to create fonts with metrics that are friendlier for UI designers, or anyone working with a design system geared towards on-screen use. Typefaces like Rasmus Andersson's Inter (itself wildly popular thanks to its inclusion in Figma) and Roman Shamin's Martian Grotesk (and Martin Mono) aim to address this issue head-on by using equally balanced metrics in their fonts — see the illustration on page 125.

→

Many organizations make their design systems' documentation public, so one of the best ways to learn about typography's role in a design system is to explore these resources online. Google's Material Design and Shopify's Polaris (both opposite) are well-established and extremely useful. Note how, in Polaris, color also plays an important role in establishing the correct hierarchy. See also: Carbon, by IBM (carbondesignsystem. com/guidelines/ typography/overview), the Atlassian Design System (atlassian.design/ foundations/typography), and the UK government's GOV.UK Design System (design-system.service. gov.uk/styles/typography).

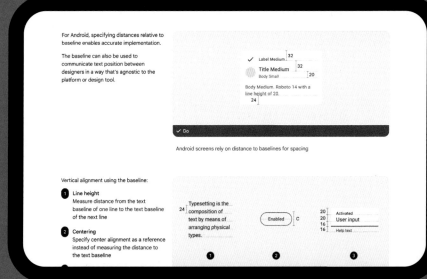

For Android, specifying distances relative to baseline enables accurate implementation.

The baseline can also be used to communicate text position between designers in a way that's agnostic to the platform or design tool.

✓ Label Medium 32
◐ Title Medium 32
 Body Small 20

Body Medium. Roboto 14 with a line height of 20.
 24

✓ Do

Android screens rely on distance to baselines for spacing

Vertical alignment using the baseline:

1 **Line height**
Measure distance from the text baseline of one line to the text baseline of the next line

2 **Centering**
Specify center alignment as a reference instead of measuring the distance to the text baseline

24 ⌐ Typesetting is the composition of text by means of arranging physical types.

(Enabled) C
20
20
16
16

Activated
User input
Help text

1 2 3

md.sys.typescale
Display Ⓛ

md.sys.typescale
Display Ⓜ

md.sys.typescale
Display Ⓢ

md.sys.typescale
Headline Ⓛ

md.sys.
Headl

md.sys.
Title

md.sys.
Title

md.sys.
Title

md.sys.
Body

↑ m3.material.io/styles/typography/applying-type ↗

Font sizes

All font sizes have a ratio of 1.2, known as the major third type scale. This means that each size is multiplied or divided by 1.2 from the previous size, starting with the base size, and rounded to a multiple of 4px.

Token	px value	rem value
p-font-size-700	40	2.5
p-font-size-600	32	2
p-font-size-500	28	1.75
p-font-size-400	24	1.5
p-font-size-300	20	1.25
p-font-size-200	16	1
p-font-size-100	14	0.875
p-font-size-75	12	0.75

Type styles ⎘

Polaris type styles are grouped into two categories: heading and body. Each has a default set of variants along with a set of options to allow for flexibility and a wide range of applications within the user interface. They use one scale, so they can be applied to any screen size.

Body styles ⎘

Body styles are used within components and blocks of text.

↑ polaris.shopify.com/ design/typography ↘

Color

Color can be used to add contrast and reinforce the hierarchy between text.

For example, one way to distinguish between a title and a subtitle is to apply `--p-color-text` to the title, and `--p-color-text-subdued` to the subtitle. Using a lighter color for secondary information provides contrast between the text and helps reinforce hierarchy even when the text is the same size and weight.

Same color Adjusted

Space ⎘

We can help merchants navigate the UI by grouping related information together. One way to do this is to use space to create relationships between elements on a page.

Ambiguous spacing can cause confusion and make it hard to understand the content.

Customer accounts

○ **Don't use accounts**
Customers will only be able to check out as gu

○ **Accounts are optional**
Customers can create accounts or checkout a

○ **Accounts are required**
Customers must create an account when they

Customer accounts

○ **Don't use accounts**
Customers will only be able to check out as gu

○ **Accounts are optional**
Customers can create accounts or checkout a

○ **Accounts are required**
Customers must create an account when they

Same spacing Adjusted

49

Define a *baseline* grid — and let it influence everything

Set the size of your body text, decide on its leading, and you have a baseline grid.

SEE ALSO
Line height · Rhythm

The baseline is one of several vertical metrics inside a glyph, and perhaps the one that the reader "feels" most instinctively when they look at a block of text, because — assuming the type is set on a straight path and not a curved one — the baseline creates a vertical rhythm throughout the lines of type. In doing so, it helps define a baseline grid for the page. A 24 px baseline grid — literally, a line every 24 vertical pixels — probably makes sense for your page if your body type uses a line height value of 24 px.

If we have smaller text on the page with a line height value of 12 px, then we could define a 12 px baseline grid and then have our body type (with its 24 px leading) align to the grid every *two* lines.

However, if we have several text elements on a page — perhaps a heading, a subheading, or a pullquote over to one side of the main text column — we ideally want them to be aligned to the baseline grid as well. But if they're set in different font sizes, they'll likely have different line height values, and matching them to multiples of the baseline grid probably won't work: it'll result in some lines being too tight, and others being too open. In this scenario, we can use incremental leading for those text elements: a process where every *n*th line (likely the third, fourth, or fifth line) meets the main baseline grid. This has the advantage of keeping leading appropriate to the element's font size intact, while still implying an overall vertical rhythm that's shared throughout all type on a page.

On the web or on screens in general, maintaining a baseline grid is considerably harder to accomplish than it is in print design, because the viewport is adaptable and malleable and doesn't conform to the fixed dimensions of traditional pages. However, some thoughtful considerations to the line height values of typographic elements should still result in an inherent vertical rhythm being maintained throughout the page, even if individual elements like images and embeds don't exactly hit the baseline grid.

→

This book uses a 12 pt baseline grid. Why 12 pt? Because 12 pt is the line height value for the book's body text, set at 9 pt, so it makes sense to base everything else off this. Note how the line heights of other text elements on the page align to this grid. For the caption text you're reading now, which uses a smaller font size (8 pt) and a smaller line height (9 pt), the baselines align to the primary baseline grid every fourth line. This is incremental leading. On the opposite page, you can see the full 12 pt baseline grid in gray, with the accented colors showing where each text elements' baselines interact with the grid.

Imply *rhythm* with intention, especially on screen

Vertical rhythm is even more important when you can't adhere to a baseline grid.

SEE ALSO

Baseline • Line height

When we set some type, we immediately create a sense of rhythm for the reader—all you need is one word. Their eyes move horizontally across the letterforms, subconsciously processing the rhythm of their shapes. This is why it's harder for us to read all-caps type longer than a few words: uppercase forms have a very similar shape, character to character.

Beyond this letter-by-letter and word-by-word horizontal rhythm, though, another rhythm starts to establish itself for any text block longer than one line of type: vertical rhythm. It goes without saying that line height plays a huge role here, dictating the vertical space between each line—and in many print scenarios, dictating the baseline grid—but vertical rhythm is also implied by other elements outside of the body text, such as various levels of headings, captions, quotations, and the vertical space between each of them, including the humble paragraph space that sits between each paragraph of body text. Often that's two full line breaks, sometimes 150% of the line height, but it could be any value. It's also usually zero if new paragraphs are styled to have an indentation on their first line, as with the body text in this book.

Adhering to a baseline grid on the web and screens is notoriously difficult, and one of the main reasons for that is the nontext elements that regularly sit in between text, such as images, videos, and embeds. Maintaining their ratio but forcing their height to a value that aligns with the baseline grid is nigh on impossible, and is only achieved by some clever automatic cropping of the embedded content or automatic manipulation of the element's margin values. It's best to accept that baseline alignment on the web and screens is unlikely to happen, and for this reason it's even more important to maintain a solid vertical rhythm with our text elements, so that the rhythm remains implied throughout the page in the absence of a true baseline grid.

⟶

[TOP] Horizontal rhythm: compare the blockiness of the all-caps type versus the more irregular movement in the lowercase type.

[BOTTOM, LEFT] Vertical rhythm: the baseline grid is implied by the line height of the body text. Note how the heading adheres to this, too, even though the larger type has to momentarily resort to incremental leading.

[BOTTOM, RIGHT] All is fine and well on screens until we encounter a nontext element such as an image. Note that even though the spacing above and below the image is equal, the fact that its height varies—and therefore cannot adhere to the inferred baseline grid—means the text that follows the image will therefore also become out-of-sync with the grid, too. As this is almost unavoidable, it makes the case for implying vertical rhythm *where we can*.

ADAPT adapt

Miss Bartlett, in her room, fastened the window-shutters and locked the door, and then made a tour of the apartment to see where the cupboards led, and whether there were any oubliettes or secret entrances. It was then that she saw, pinned up over the washstand, a sheet of paper on which was scrawled an enormous note of interrogation. Nothing more.

"What does it mean?" she thought, and she examined it carefully by the light of a candle. Meaningless at first, it gradually became menacing, obnoxious, portentous with evil. She was seized with an impulse to destroy it, but fortunately remembered that she had no right to do so, since it must be the property of young Mr. Emerson. So she unpinned it carefully, and put it between two pieces of blotting-paper to keep it clean for him. Then she completed her inspection of the room, sighed heavily according to her habit, and went to bed.

Chapter II
In Santa Croce with No Baedeker

It was pleasant to wake up in Florence, to open the eyes upon a bright bare room, with a floor of red tiles which look clean though they are not; with a painted ceiling whereon pink griffins and blue amorini sport in a forest of yellow violins and bassoons. It was pleasant, too, to fling wide the windows, pinching the fingers in unfamiliar fastenings, to lean out into sunshine with beautiful hills and trees and marble churches opposite, and close below, the Arno, gurgling against the embankment of the road.

Over the river men were at work with spades and sieves on the sandy foreshore, and on the river was a boat, also diligently employed for some mysterious end. An electric tram came rushing underneath the window. No one was inside it, except one tourist; but its platforms were overflowing with Italians, who preferred to stand. Children tried to hang on behind, and the conductor, with no malice, spat in their faces to make them let go. Then soldiers appeared — good-looking, undersized men — wearing each a knapsack covered with mangy fur, and a great-coat which had been cut for some larger soldier. Beside them walked officers, looking foolish and fierce, and before them went little boys, turning somersaults in time with the band. The tramcar became entangled in their ranks, and moved on painfully, like a caterpillar in a swarm of ants. One of the

"Poor girl? I fail to understand the point of that remark. I think myself a very fortunate girl, I assure you. I'm thoroughly happy, and having a splendid time. Pray don't waste time mourning over me. There's enough sorrow in the world, isn't there, without trying to invent it. Good-bye. Thank you both so much for all your kindness. Ah, yes! there does come my cousin. A delightful morning! Santa Croce is a wonderful church."

She joined her cousin.

Chapter III
Music, Violets, and the Letter "S"

It so happened that Lucy, who found daily life rather chaotic, entered a more solid world when she opened the piano. She was then no longer either deferential or patronizing; no longer either a rebel or a slave. The kingdom of music is not the kingdom of this world; it will accept those whom breeding and intellect and culture have alike rejected. The commonplace person begins to play, and shoots into the empyrean without effort, whilst we look up, marvelling how he has escaped us, and thinking how we could worship him and love him, would he but translate his visions into human words, and his experiences into human actions. Perhaps he cannot; certainly he does not, or does so very seldom. Lucy had done so never.

She was no dazzling exécutante; her runs were not at all like strings of pearls, and she struck no more right notes than was suitable for one of her age and situation. Nor was she the passionate

A *type scale* is the foundation of any typographic system

Pick whatever ratio you like, as long as each font size has a relationship to the size above and below it.

SEE ALSO
Fluid type scales · Rhythm

A scale is a way of defining different font sizes for different elements and reusing them in a system. Ideally, each step in a scale is defined by an overarching ratio; that is, one size relates to the one above and below it. In other words, there's an inherent rhythm throughout as the font size increases or decreases.

Some people will go to great lengths to explain how scale A is better than scale B, but honestly, it's pretty arbitrary. There are some scales we can borrow from the world of music theory, where the intervals between each size mimic the intervals between notes in that scale. For instance, in a major third scale, each font size is 1.25 times larger than the ones that precedes it and, in theory, quite pleasing to the eye in the way that a major third is quite pleasing to the ear.[1] But really a scale can be anything you want, as long as there's an implied rhythm throughout. And if you want to stick with the so-called classical scale of 6, 7, 8, 9, 10, 11, 12, 14, 16, 18, 21, 24, 30, 36, 48, 60, 72, 96, etc., then that's fine, too, although it's worth noting that even that doesn't conform to the actual proportions it implies, as outlined by Spencer Mortensen on *The Typographic Scale:* the rounding errors mean there are effectively missing notes, and also notes that are too sharp or flat for the scale.[2]

Does this matter? In reality, few people will be able to identify the typographic scale being used while reading text, let alone pick out an element sized at a slightly different size than dictated by its scale. But just as few people can identify *why* exactly something sounds out of tune, most can sense that it does somehow sound inherently "off." The same could also potentially be true with an ill-considered typographic scale.

Could be. You see, my personal belief is that designers can sometimes get too hung up on precise scales. There are a variety of ways that one element can relate to another that sit outside of the traditional ideas of scale — perhaps the font size of an all-caps heading is two times the body's x-height value, for instance — and it's better to ensure there's some sort of rhythm and connection through these little thematic references rather than worry too much about making sure something fits 0.157% of a pixel.

There have been some interesting experiments in recent years that seek to make scales more suitable for the web, which we explore overleaf.

[1] Jeremy Church's type-scale.com illustrates this very well.

[2] spencermortensen.com/articles/typographic-scale

⟶

These two scales — the major third at the top and the golden ratio at the bottom — lead to fairly different results, because although the "base" font size is 16 pt (FYI, 16 px is a browser's default font size) in both, the multiplier is different. In the major third scale, the font size is multiplied by 1.25 (16 pt × 1.125 = 20 pt, etc.). But in a golden ratio scale, the font size is multiplied by 1.618 (16 pt × 1.618 = 25.89 pt, etc.), so the difference between each point in the scale is much larger. In other words, your headings are going to be much larger than your body text in such a scale. Of course, these are just two examples.

48.83 pt Major third

39.06 pt Major third

31.25 pt Major third

25 pt Major third

20 pt Major third

16 pt ★ Major third

12.8 pt Major third

10.24 pt Major third

177.42 pt Gold

109.66 pt Golden r

67.77 pt Golden ratio

41.89 pt Golden ratio

25.89 pt Golden ratio

16 pt ★ Golden ratio

9.89 pt Golden ratio

6.11 pt Golden ratio

Don't forget the basics of *hierarchy*

Size, weight, and spacing all help imply order within a document.

SEE ALSO

Styles • Typographic color • Weight

Typographic choices can give a document hierarchy. That's not to say that all documents necessarily *need* hierarchy, but most would benefit from some form of it. It's also an area where there's a lot of room to get things wrong.

Perhaps the most common mistake is not being explicit about the hierarchical connection between different elements. Take the humble heading: if it floats in the middle of two paragraphs, with equal spacing above and below it, the heading appears to be a lone object, unrelated to the content beneath it.

Another common issue is when there's no noticeable change in size or weight between the heading and body copy, meaning that, again, it might not be obvious that it is indeed a heading. This is something you see a lot online, where a website has been redesigned, and the styles have different level headings have not been accurately accounted for.

There's nothing to say that a heading should be heavier in weight, of course. A change in size alone should be enough, as long as it's significant (150% of the body size, for example). And if you wanted your headings to be set in a *lighter* weight than the body, the greater the size differentiation, the more that's possible.

Even a little consideration can radically affect the way text is read and understood by the reader, and reduce the amount of times they have to subconsciously interrupt their reading flow to wonder why something is the way it is.

⟶

[TOP] Avoid floating headings that aren't connected to their actual content.

[BOTTOM] Headings needn't use a weight that's heavier than the body text, but if you go with a lighter option (here, the Light weight for the heading and Regular for the body), you'll need to ensure the heading uses a significantly bigger font size so that it has enough *perceived* weight. In practice, this means ensuring that the stroke thickness is at least as thick as it appears in the body text to create a more even typographic color overall. (Compare the left and right examples while squinting.)

Tutustukaamme pääpiirteissään heidän työhönsä, silloin heidän muistettava merkityksensä meille selvenee.

Sivistysolomme ennen Gezeliusten aikoja

Agricola oli luonut alun suomalaiselle kirjallisuudelle. Koko raamattu saatiin suomeksi sitä varten asetetun komitean toimesta v. 1642. Oli myöskin olemassa katkismus, samoin virsikirja ja postilla. Olipa valtakunnan lakiakin jo yritetty suomentaa. Kirkollista elämää ja hartauden harjoituksia varten oli siis olemassa tarpeellisimmat kirjat. Mutta niitä käytettiin hyvin vähän. Kirjain kustantaminen ei niihin aikoihin olisi ollut laisinkaan kannattavaa liiketointa. Agricola jo valittaa, että vaikka kirjoja suurella vaivalla toimitettiin,

Building the studio space

My main inspiration for renovating the studio came from a single Pinterest pin, where someone had created several shelves, running the length of one wall, with the bottom one being deepere to act as a desk. The idea is that the whole desk space would be big enough for me at one end, Sam at the other, and with spare space in the middle for the kids or a guest. I commissioned a firm called Urban Grain to do just that – ensuring that the additional length required would be stabilised to support all of the extra weight – and we ended up with a wonderful solution made from reclaimed scaffolding boards.

Tutustukaamme pääpiirteissään heidän työhönsä, silloin heidän muistettava merkityksensä meille selvenee.

Sivistysolomme ennen Gezeliusten aikoja

Agricola oli luonut alun suomalaiselle kirjallisuudelle. Koko raamattu saatiin suomeksi sitä varten asetetun komitean toimesta v. 1642. Oli myöskin olemassa katkismus, samoin virsikirja ja postilla. Olipa valtakunnan lakiakin jo yritetty suomentaa. Kirkollista elämää ja hartauden harjoituksia varten oli siis olemassa tarpeellisimmat kirjat. Mutta niitä käytettiin hyvin vähän. Kirjain kustantaminen ei niihin aikoihin olisi ollut laisinkaan kannattavaa liiketointa. Agricola jo valittaa, että vaikka kirjoja suurella vaivalla toimitettiin,

Building the studio space

My main inspiration for renovating the studio came from a single Pinterest pin, where someone had created several shelves, running the length of one wall, with the bottom one being deepere to act as a desk. The idea is that the whole desk space would be big enough for me at one end, Sam at the other, and with spare space in the middle for the kids or a guest. I commissioned a firm called Urban Grain to do just that – ensuring that the additional length required would be stabilised to support all of the extra weight – and we ended up with a wonderful solution made from reclaimed scaffolding boards.

Typographic color is about density

Not like actual color. Well, kind of.

SEE ALSO

Hierarchy • Pair type

Typographic color, unrelated to actual hues, refers to the text density on a page. It's about the balance between black text on a white background (or vice versa for light-on-dark scenarios). Consider it a squint test—how much space does the text occupy? Is there sufficient spacing to maintain readability without overcrowding? And, by the way, we're not just talking about spaces like line height or tracking; color is dictated by all those in-between spaces, too, like counters, serifs, and the very shapes of the letterforms.

Numerous factors do influence typographic color beyond the choice of typeface, though, including font weight (and grade), line height, and even the ink itself. (Hmm. Perhaps it is somewhat about color after all.) Robert Bringhurst says in *The Elements of Typographic Style:*

"Once the demands of legibility and logical order are satisfied, evenness of color is the typographers normal aim."

Achieving this evenness of color should also be a primary concern when pairing typefaces that are meant to sit together seamlessly, such as when we might swap to another typeface for a slight change of context. This is something I've tried to do with the chapter headings in this book! Although Degular and Swear have a very different feel, their overall color (at these specific sizes and weights) feels balanced.

→

Can you read this out-of-focus type in this photo? No? Good! This is the equivalent of the squint test. Instead of trying to read, look at the page's typographic color: the density of the text on the page, the space it occupies, and the interaction between different text-based elements. Even when blurred this much, we can see there's a heading set in larger type, followed by a block of body text.

Line height can be a headache

The invisible white space within text boxes, caused by a font's metrics and line height, is usually the source of any alignment woes.

SEE ALSO
Line height · Em square

Line height inconsistencies can appear quickly when we're designing for screens—especially when creating design systems for multiple platforms.

With metal or wood type, strips of lead were inserted between each line (hence the name "leading"), and the total line height would be the size of the font (e.g., 16 pt) plus the size of the lead (e.g., 2 pt) to get the total line height value (e.g., 18 pt). When the web came along, CSS calculated total line height by taking the font size and then adding *half* of that size as its leading equivalent; e.g., 16 px + 8 px = 24 px line height. This approach has remained unchanged since then and is used on the web, in design apps, and across iOS and Android.

There are actually some subtle clipping differences between platforms,[1] but even if we ignore those, varying font sizes alone results in different amounts of white space above and below the letterforms. Imagine a card-like UI that contains an image, a heading, some metadata, some body text, and then a button. How do we space them accurately so that there's a uniform amount of vertical space between each?

Let's say we're trying to achieve a vertical space of 20 pixels between the image, heading, metadata, body copy, and button. If we set a blanket 20 px[2] `margin-top` on each element, it'll actually be 20 pixels *plus* whatever whitespace is inside each text element—and that will be more pixels in the heading, which is larger, and fewer pixels in the body text, which is smaller. Ideally, we need to "trim" the whitespace away so that the measurement is made from the bottom of the letterforms on one line to the top of the letterforms on the line below, allowing us to achieve an optically balanced vertical space between each text element.

But where do we even place our hypothetical trim lines? Do we want 20 pixels as measured from baseline to baseline? Or descender depth to ascender height? Or baseline to ascender height? Depending on the typeface, the font's internal metrics, and the kind of element, something that looks right for one thing will look off for another, but usually x-height in lowercase type (or cap height in all-caps type) serves as a good optical measurement.

To continue on our quest for a solution, or at least a semisolution, turn the page.

[1] The implementation isn't *exactly* the same, with Android clipping the top and bottom of the text box to the top and bottom of the font size—see opposite. This means that more top and bottom padding will need adding on the text block's containing element for cross-platform consistency.

[2] In most situations, using relative units such as ems, rems, or percentages is preferable to pixels. However, the problem remains the same.

⟶

[TOP] On the web and in most screen design apps, the default line height is calculated by adding an additional 50%, which is then split above and below each line. However, note that this is removed from the top and bottom lines on Android (left).

[BOTTOM] To achieve balanced and even margins between text elements, the text box itself should be ignored.

No half-leading for top line ↙

you can wake
urself in nature
hour drive from
raway paradise.

No half-leading for bottom line ↖

Half leading,
split above
and below

100%

Why walk to the

up on the beach?

in beautiful Tofi

Vancouver that f

Balanced and
even margins
based on actual
x-height

Arbitrary and
uneven margins
based on text
box height

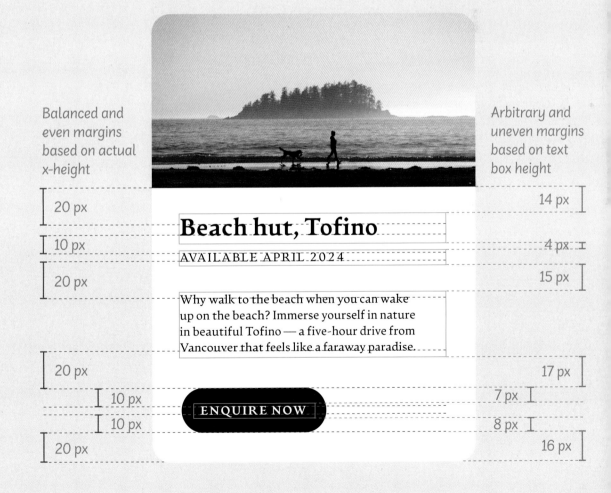

Beach hut, Tofino

AVAILABLE APRIL 2024

Why walk to the beach when you can wake
up on the beach? Immerse yourself in nature
in beautiful Tofino — a five-hour drive from
Vancouver that feels like a faraway paradise.

ENQUIRE NOW

20 px
10 px
20 px
20 px
10 px
10 px
20 px

14 px
4 px
15 px
17 px
7 px
8 px
16 px

Mastering *line height* means making manual changes

There's no easy way out, but being aware of what to look for will help.

SEE ALSO

Em square · Line height · Metrics

As explored on page 22, a font's vertical metrics can be in any position inside the em square. This means its ascenders and descenders might touch the top and bottom parts of the box, or have a little padding between the boundary, or have a totally disproportionate relationship to the bounding box, such as descenders appearing much closer to the bottom than ascenders are to the top. If you have some text inside a button element in your design system and you change the font, this is the reason that you might find the text suddenly appears much closer to either the top or bottom of a button.

If you consider the ultimately unknowable and disparate vertical metrics contained within different fonts, and then combine that with the ever so slightly different calculations for line height (outlined on the previous page), life can get a little tough, especially if we're tasked with maintaining a complex design system.

One solution is to make sure that all of your text elements are spaced manually, and that these spaces are re-examined any time a typeface is changed. Spoiler alert: this is no small task.

Another solution is to only use fonts that have equal metrics—ones where the letterforms are vertically centered, and the space above and below uppercase letterforms is equal. This is the case with Roman Shamin's typefaces Martian Grotesk and Martian Mono, which were designed to specifically counter this issue, as well as play nice with the pixel grid due to the ratio between the different metrics. The added bonus of these typefaces' metrics is that they can be placed next to other elements like icons for easy vertical centering.[1]

There are also plans to help tackle these issues directly in CSS, although at the time of publication, the exist only as proposals, with only experimental browser support. Once fully implemented and adopted, `text-box-trim`[2] should be able to effectively remove the vertical white space from the glyphs, leaving us to space directly from where the top and bottom of the letterform begins and ends.[3]

1 twitter.com/romanshamin_en/status/1562801657691672576

2 w3.org/TR/css-inline-3/#propdef-text-box-trim

3 medium.com/microsoft-design/leading-trim-the-future-of-digital-typesetting-d082d84b202

⟶

These graphics were created by Roman Shamin to demonstrate the equal metrics used in his Martian Grotesk typeface. Reproduced with permission.

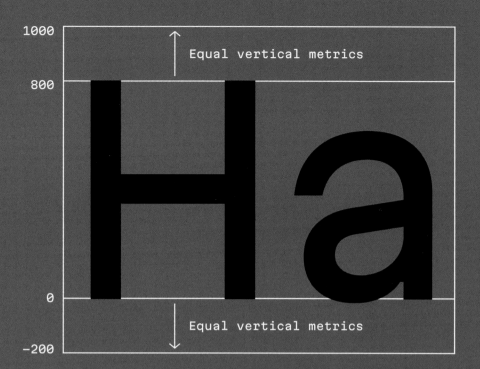

1000

800

0

-200

Equal vertical metrics

Equal vertical metrics

Ha

+ Add

Q Search

>< Hug Contents ∨

✓ Show

🕐 Reminders →

🥕 Groceries →

Hx

Not all *dashes* are equal

Different dashes are different lengths, and exactly how different they are is up to the type designer.

SEE ALSO

*Em square •
Punctuation • Spaces*

Dashes are a type of punctuation, but they're so often misused—even by apparently seasoned designers—that I feel like it's worth calling them out specifically. And yes, sure, much like any punctuation, this is walking a gray area between the responsibilities of the typographer and the responsibilities of the copywriter, but really there's no excuse to not know this if you have even a passing interest in typography.

Let's talk first about the **hyphen**, which is the narrowest dash (apart from the minus symbol). It's probably the dash people use the most, and yet also the one people use incorrectly the most. You use a hyphen to break a word over two lines, or connect words. Nothing else.

Next up, the **en dash**, which in theory is the equivalent of one en, or about half an em. Use it to connect date ranges.

Finally, the longest dash, and my personal favorite: the **em dash**. This is for connecting ideas—and for going off on a quick tangent—and in that sense is very similar to a colon or parentheses, but I'm not going to go into the usage specifics here—that's the job of whichever style guide you're following. You might occasionally see people using two or three hyphens in place of an em dash, which is a hangover from the typewriter days, and for which there is no excuse. Unfriend them immediately.

Lastly, it's important to note that the exact length of any of these dashes is purely down to the type designer. If they want to make an em dash that's only slightly longer than an en dash, they can. If they want to make an em dash that's exactly as wide as a hyphen, they can (inadvisably). The point is: know which one you're using. And if, like me, you're a liberal user of the em dash, it might even pay to help its length play a role in your choice of typeface—how's that for an idea?

From a semirandom selection of just five typefaces—set at both 9 pt and 30 pt—it's easy to see how they each handle hyphens, en dashes, and em dashes differently. Not only does the overall width of the dash characters vary considerably, but within each typeface, the differentiation varies considerably, too: they're nearly the same width in Def Sans, but wildly different in Minion 3. Also, notice the height of the hyphen is also changeable. Note: all examples here are set with no spaces on either side of the hyphen and en dash, and thin spaces either side of the em dash.

Def Sans

- well-known
- 1967–1994
- a paw paw – or a prickly pear

well-known
1967–1994
a paw paw – or a

Minion 3

- well-known
- 1967–1994
— a paw paw — or a prickly pear

well-known
1967–1994
a paw paw — or a pr

Faune

- well-known
– 1967–1994
— a paw paw — or a prickly pear

well-known
1967–1994
a paw paw — or a p

Martian Grotesk

- well-known
– 1967–1994
— a paw paw — or a prickly pear

well-known
1967–1994
a paw paw — or

Neue DIN

- well-known
– 1967–1994
— a paw paw — or a prickly pear

well-known
1967–1994
a paw paw — or a p

Combine *dashes* with alternative *spaces*

Not all spaces are created equal either.

SEE ALSO

Dashes • Punctuation

It's impossible to talk about dashes without talking about spaces, which is why I've created a dedicated principle on the matter. And not that spaces are tied exclusively to dashes, of course, but it's in their combination with dashes that they really come into their own.

When we have an en dash or an em dash, flanking it with a regular space character—the kind that sits in between words—is all fine and well, and some style guides advocate the use of no spaces at all before and after a dash, but something in between no space and a regular space—perhaps a thin space, or a hair space—is usually preferable.

Before we get too caught up in exactly which one is better, however, it's very important to remember that the actual width of each kind of space is totally dependent on the typeface you're using. If the type designer wants to make a regular space, a thin space, and a hair space (and there are others, too) wildly different, they can. If they want them to be almost totally indistinguishable, they can. Much how an em dash in one typeface can be very wide and obvious, and then look almost like a hyphen in another, it's best to evaluate the tools at our disposal with a bit of trial and error. And, if you know that your text will be full of em dashes—you might've noticed that I'm a big fan of them—then perhaps the width of a typeface's dash characters and space characters can be a key criteria when it comes to narrowing your type choice selections.

Nonregular space characters can usually be inserted from the Edit or Insert menus in popular software. On the web, you'll need to use the HTML entities (e.g., ` `), and admittedly that does make things a little harder when the site is powered (as most are) by a CMS, because convincing your writers and editors to add them might be a little cumbersome. For this reason, regular spaces (or no spaces) tend to get used around dashes on the web and screens—if writers even use the correct dash at all, that is. Don't even get me started...

⟶

A single sentence that uses em dashes to denote a break in thought is set four times: firstly, with regular spaces around the em dashes, followed by thin spaces, then hair spaces, and, lastly, no spaces. These four settings are shown in Case (top), Tabac Slab (middle), and Minion (bottom), all set at 9 pt. See how the space characters not only differ from each other, but also differ in each typeface. This is more obvious when looking at the magnified versions on the right, set at 34 pt.

Pedantic note: The highlighted areas make the different space widths more obvious by touching the letterforms on either side; in other words, they don't account for the sidebearings (minute inter-glyph spaces to the left and right of the character) in each glyph. The actual spaces are therefore slightly narrower.

If we have several text elements on a page — perhaps
a heading, a subheading, or a pullquote — we ideally want
them to be aligned.

If we have several text elements on a page — perhaps
a heading, a subheading, or a pullquote — we ideally want
them to be aligned.

If we have several text elements on a page—perhaps
a heading, a subheading, or a pullquote—we ideally want
them to be aligned.

If we have several text elements on a page—perhaps
a heading, a subheading, or a pullquote—we ideally want
them to be aligned.

If we have several text elements on a page — perhaps
a heading, a subheading, or a pullquote — we ideally want
them to be aligned.

If we have several text elements on a page—perhaps
a heading, a subheading, or a pullquote—we ideally want
them to be aligned.

If we have several text elements on a page—perhaps
a heading, a subheading, or a pullquote—we ideally want
them to be aligned.

If we have several text elements on a page—perhaps
a heading, a subheading, or a pullquote—we ideally want
them to be aligned.

If we have several text elements on a page — perhaps
a heading, a subheading, or a pullquote — we ideally want
them to be aligned.

If we have several text elements on a page—perhaps
a heading, a subheading, or a pullquote—we ideally want
them to be aligned.

If we have several text elements on a page—perhaps
a heading, a subheading, or a pullquote—we ideally want
them to be aligned.

If we have several text elements on a page—perhaps
a heading, a subheading, or a pullquote—we ideally want
them to be aligned.

page — per
page — perl
page—perh
page—perh

page — perh
page—perh
page—perha
page—perha

page — perha
page—perhap
page—perhap
page—perhap

Italicize *punctuation & spaces, too*

Subtle considerations like this improve the overall readability of your text.

SEE ALSO
Optical trickery • Spaces

When italicizing a word, ensure that any following punctuation, such as a comma or quotation mark, is also italicized to avoid clashing letterforms and inadequate spacing. This helps to maintain a consistent appearance across the text. And, although you can file this next one under "almost invisible," if you're a true typographer, be sure italicize *spaces* after italicized words, too, as this can help to ensure the spaces between words are as optimized as much as they can be. To clarify, if you have a quote, and that's italicized, you also need to italicize the comma or period at the end of the quote, the quotation mark, and the space after that quotation mark.

The opposite is true when it comes to a bold font: punctuation and spaces should *not* be emboldened as well, because there's little chance of clashes between forms and they look odd when emphasized in this way. Plus, a bold space will likely end up looking too wide, which is distracting to the eye.

The seemingly contradictory advice of these two rules—after all, aren't italic and bold both a form of emphasis?—demonstrates how, with type, what *looks* right is what *is* right.

→

Be sure to also italicize any punctuation around italicized text, including the space character that comes immediately after it. Emboldening, however, should not continue to punctuation outside of the emboldened text.

☹ Potremmo supporre che questo potrebbe essere
ciò che Smith descrive come *"comportamento
modellato"*, ma ricerche recenti suggeriscono che tale
comportamento potrebbe non essere effettivamente
modellato! Questo potrebbe, infatti, far parte della
programmazione manuale del software. Per ulteriori
informazioni, assicurati di leggere il loro post sul
blog, **Audio Mapping Expanded.**[1]

☺ Potremmo supporre che questo potrebbe essere
ciò che Smith descrive come *"comportamento
modellato"*, ma ricerche recenti suggeriscono che tale
comportamento potrebbe non essere effettivamente
modellato! Questo potrebbe, infatti, far parte della
programmazione manuale del software. Per ulteriori
informazioni, assicurati di leggere il loro post sul
blog, **Audio Mapping Expanded.**[1]

Justify & hyphenate with caution

Hyphenation is essential if your type is fully justified — but mind where you break those words.

SEE ALSO
Widows & orphans

For the majority of the type that I set, I like it to be right ragged — as in, aligned to the left edge of the text block, with an uneven edge over on the right-hand side. This is the way the majority of text is set in left-to-right systems. But sometimes — especially in very long-form texts such as those found in mainly imageless books like novels — typographers may choose to justify the type, with the type aligned to both the left *and* right edges, creating a more formal-looking rectangle. That's not the only scenario, of course. Even social media graphics might look better with the more solid *block* of text that justification provides.

The thing is, knowing the reasons for using justification is perhaps less important than knowing about the potential issues that can arise. In unjustified text, the space between each word and each glyph is the same.[1] In justified text, the word space changes per line, and, in some justification algorithms, the tracking is altered as well. This not only creates inconsistency throughout the text, but also allows large gaps to appear. When scanned by the eye, line-to-line, these create "rivers" throughout the text.

To counter this, it's advisable to use hyphenation — more liberally so than in non-justified text. However, hyphenation can create its own problems. Exactly how much hyphenation is too much hyphenation? It depends on the overall length of the text, and it's best to experiment. Most desktop design apps have automatic hyphenation settings that can be tweaked. Always check your hyphenation and adjust as necessary. Generally speaking, breaking words either between syllables or their component parts (e.g., "hypen-ating") usually makes the most sense for English-language text.

However, even with the most robust hyphenation rules in place, and a justification algorithm that leaves each line looking beautiful, it's almost impossible to avoid widows and orphans. For more on that, turn the page...

[1] Okay, not technically the same because it depends on the font's internal spacing, plus any kerning data, but at least uniform in their default setting.

⟶

[TOP] The simplest justification algorithms — represented in the left column — move words down to the next line as necessary, and increase the word spacing of the current line to fully justify the text. However, more complex algorithms, such as Knuth & Plass — shown in the right column — reevaluate previously justified lines to end up with more evenly spaced lines overall in a multi-line block of text.

[BOTTOM] For ragged-right text, lines can be more evenly balanced by introducing the occasional hyphen for long words. (Like I just did here!)

Note: These illustrations were originally created by Bram Stein for the seventh issue of my typography magazine *8 Faces*. Reproduced with permission.

In olden times when wishing still helped one.

In olden times when wishing still helped one, there lived a king whose daughters were all

In olden times when wishing still helped one, there lived a king whose daughters were all beautiful

In olden times when wishing still helped one, there lived a king whose daughters were all beautiful; and the youngest was so beautiful

In olden times when wishing still helped one, there lived a king whose daughters were all beautiful; and the youngest was so beautiful that

In olden times when wishing still helped one, there lived a king whose daughters were all beautiful; and the youngest was so beautiful that the sun itself, which…

In olden times when wishing still helped one, there lived a king whose daughters were all beautiful; and the youngest was so beautiful that the sun itself, which…

In olden times when wishing still helped one, there lived a king whose daughters were all beautiful; and the youngest was so beautiful that the sun itself, which…

In olden times when wishing still helped one, there lived a king whose daughters were all beautiful; and the youngest was so beauti-ful that the sun itself, which…

Avoid *widows & orphans* whenever possible

It might mean breaking a few rules along the way — and that's an acceptable trade-off.

SEE ALSO

Justify & hyphenate

There are quite a few occasions while setting type when it's not desirable to let the text flow by itself, even if you've set up some good parameters, like a sensible measure or leading: scenarios like the last line of type making its way over from the previous column to the top of the next column, or — even worse — a single word. They're widows. Or a single word being left all on its lonesome at the end of a text block, or the first lines of a new paragraph that start at the bottom of a text frame. They're orphans.

On the face of it, neither a widow nor an orphan is the worse typographic faux pas, and often they can't be avoided anyway (more on that shortly). But, whenever it's possible to break the rules to make for a better reading experience, we should.

In print, there are a number of things we can do, from adjusting the heights of our text boxes to actually editing the text, if possible. (It should also be a proofreader's responsibility to avoid widows and orphans.) While it might seem counterintuitive to change the actual dimensions of text boxes, and have one column appear one line shorter than the others, it's usually less visually jarring than having an orphan or widow present. Most design tools have built-in settings to counter this issue, and if you get stuck, there's always a line break.

Unless you're working on the web, or on-screen, that is.

Hard line breaks persist no matter what else you do to the type, and will come along if copied and pasted by end user, too, so it's best not to use them. The web is a fluid medium, where the content reflows according to the requirements and restrictions of the end user and the device they're using. As such, it can be nearly impossible to eliminate orphans and widows.

At the time of writing, there are no automatic tools built into CSS that can handle this issue for us in the way that we currently enjoy with print design apps — although the experimental `text-wrap: balance` proposal is beginning to gain traction. There are (mainly Javascript-based) plugins and workarounds, but the reality is that implementing these require an overhead that can be hard to justify in many projects.

→

[TOP] When the last line of one paragraph (which could even be just one word) appears at the top of a new column, consider finding a way to move it. That could be extending the height of the previous column, editing the text to be shorter, or editing the text to be longer (therefore taking up two lines at the top, which doesn't look so bad).

[MIDDLE] The same applies for orphans: when the first line of the next paragraph appears on its own at the bottom of the current column, consider how to remove it. Here, we're reducing the actual height of the text box itself — a little rule breaking to create a better reading experience overall.

[BOTTOM] Pushing "de la" down to the next line prevents an orphan.

**Widow
(top line)**

la moindre attention.

D'Artagnan raconte qu'à sa première visite à M. de Tréville, le capitaine des mousquetaires du roi, il rencontra dans son antichambre trois jeunes gens servant dans l'illustre corps où il sollicitait l'honneur d'être reçu, et ayant nom Athos, Porthos et Aramis.

D'Artagnan raconte qu'à sa première visite à M. de Tréville, le capitaine des mousquetaires du roi, il rencontra dans son antichambre trois jeunes gens servant dans l'illustre corps où il sollicitait l'honneur d'être reçu, et ayant nom Athos, Porthos et Aramis.

**Orphan
(bottom line)**

D'Artagnan raconte qu'à sa première visite à M. de Tréville, le capitaine des mousquetaires du roi, il rencontra dans son antichambre trois jeunes gens servant dans l'illustre corps où il sollicitait l'honneur d'être reçu, et ayant nom Athos, Porthos et Aramis.
Nous l'avouons, ces trois noms étrangers nous

D'Artagnan raconte qu'à sa première visite à M. de Tréville, le capitaine des mousquetaires du roi, il rencontra dans son antichambre trois jeunes gens servant dans l'illustre corps où il sollicitait l'honneur d'être reçu, et ayant nom Athos, Porthos et Aramis.

**Orphan
(bottom word)**

Quieren decir que tenía el sobrenombre de Quijada, o Quesada, que en esto hay alguna diferencia en los autores que deste caso escriben; aunque, por conjeturas verosímiles, se deja entender que se llamaba Quejana. Pero esto importa poco a nuestro cuento; basta que en la narración dél no se salga un punto de la verdad.

Quieren decir que tenía el sobrenombre de Quijada, o Quesada, que en esto hay alguna diferencia en los autores que deste caso escriben; aunque, por conjeturas verosímiles, se deja entender que se llamaba Quejana. Pero esto importa poco a nuestro cuento; basta que en la narración dél no se salga un punto de la verdad.

Break the rules with *optical trickery*

Make things look aligned by misaligning them. Wait, what?

SEE ALSO

*Baseline • Grade •
It depends • Punctuation*

So much of type and typography is about breaking the rules. But not just breaking the rules for the sake of a little anarchy. Almost all of the rule breaking we do when working with type is about achieving a degree of optical trickery. Okay, maybe the word "trickery" sounds a little harsh, but the point is that our eyes are kind of weird, and sometimes for things to look right, our eyes need to be coerced into thinking that some things are not quite as they truly are.

⟶

From top to bottom: Overshoots and undershoots in typeface design; moving references outside of punctuation; italicizing punctuation and spaces (see page 130); using incremental leading to align smaller type to the main baseline grid (see page 112); overriding paragraph indentation rules when a paragraph follows a heading; nudging the bounding box of display type to create a better optical margin.

Take the humble overshoot and undershoot—two of type design's most well-known optical tricks. The top curve of a lowercase "o" extends ever so slightly above the x-height, and its bottom curve extends ever so slightly below the baseline, and the same is true of any character with similar shapes. This is because a circle sized the same as a square appears optically smaller, so we need the overshoots and undershoots to correct that. For a similar reason, the vertex and apex of the letter "v" or uppercase "A" often use them, too. The extensions to these letterforms result in these characters appearing optically aligned to others they sit next to that don't require such modifications.

When it comes to typography, there are a number of ways to break the rules to achieve a better reading experience, and we cover them in dedicated chapters throughout this book, but here are a few smaller tips worth covering briefly:

* Move footnote references outside of punctuation marks. Because even though they should sit next to the text they relate to, they'll just make a weird gap.
* Italicize punctuation (and spaces) that immediately follow an italicized word. An upright comma is going to butt up against italic letterforms.
* Use incremental leading. Baselines are not always going to line up. It's okay.
* Don't indent paragraphs after a heading. Even if all your new paragraphs start with a left indentation, the space created when they follow an *unindented* heading will just look strange.
* Nudge display type. Even if all of your text boxes are perfectly left aligned with each other, the ones with large type in will also have larger white space between the edge of the text box and the letterform itself, so nudge that over a bit so that an optically aligned margin is achieved.

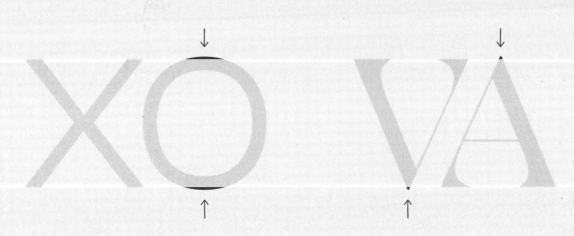

XO VA

He endeavoured to make peace with Miss Jenkyns [1] soon after the memorable dispute I have named, by a present of a wooden fire-shovel (his own making),[2] having heard her say how much the grating of an iron one annoyed her.

"Mr Hoggins says she cannot live many days, and she shall be spared this shock," said Miss Jessie, shivering with feelings to which she dared not give way.

La découverte d'un manuscrit complètement inconnu, dans une époque où la science historique est poussée à un si haut degré, nous parut presque miraculeuse. Aussi nous hâtâmes-nous de solliciter la permission de le faire imprimer, dans le but de nous présenter un jour avec le bagage des autres à l'Académie des inscriptions et belles-lettres, si nous n'arrivions, chose fort probable, à entrer à l'Académie française avec notre propre bagage. Cette permission, nous devons le dire, nous fut gracieusement accordée; ce que nous consignons ici pour donner un démenti public aux malveillants qui prétendent que nous vivons sous un gouvernement assez médiocrement disposé à l'endroit des gens de lettres.

Fortell oss litt om designprosessen for albumomslag.

Jeg startet plateselskapet i 2017 bare for å gi ut min egen musikk, og så satt den i dvale til 2020. Jeg hadde disse planene i 2019 om at jeg skulle gi ut en haug med ting i 2020. Så i begynnelsen av 2020 brukte jeg kompilasjonen Komponenter AI for var en ny start. Jeg brukte samme type, så det er et iboende system der gjennom typografien.

Men bortsett fra det, visuelt, var det åpent for å gjøre noe helt annet. Jeg tror, delvis fordi det var en samling, jeg ikke ønsket å gjøre noe fotografisk, som jeg tidligere hadde gjort mye av: grunt dybdeskarphet teksturer av mose og trær og sånt.

Den andre tingen er at for å få en SVG superenkelt krever ikke jeg, som en total ikke-utviklerperson, å grave

Überschrift

Ich würde nicht eine Minute lang vorschlagen, dass das Unternehmen seine ältere Hardware aus dem Verkauf nimmt (obwohl ich vielleicht vorschlagen würde, diese Verkäufe durch reduzierte Preise anzukurbeln), aber die Verfügbarkeit von Modellen, die früheren Konventionen folgen, ist hier

Check your *diacritics*

Don't forget the extra space required for accents and the like.

SEE ALSO

Glyphs • Internationalization • Line height

Diacritics, known colloquially as accent marks, are supplementary elements added to letters, typically altering their pronunciation. Examples of diacritics in the Latin script text include acute and grave accents above the letter "e", or the cedilla in a soft "ç". In some cases, diacritics can completely change the meaning of a word, as with "a" ("have") and "à" ("to") in French.

And yet so many fonts don't include glyphs for non-English characters, which is ludicrous, because therefore my fellow British friend Zoë can't even type her name correctly. If a font doesn't include even the most basic of accented glyphs, it's a reliable indication of it not being particularly well made. Type designers are encouraged to include Latin Extended character sets in their fonts, and contemporary type design software makes the process extremely easy. Doing so means you support not only European-centric languages, but also others that use the Latin script, such as Vietnamese.[1]

It's worth considering that when you set your leading. A line height that's too tight for English text (and results in the occasional clash between a descender on one line and an accent mark on the line beneath) might just about be excusable, but if that languages makes extensive use of diacritics, you're going to have horrible, distracting clashes all over the place. Proof once more that one typographic setting doesn't fit all.

[1] The Vietnamese language also contains characters that have diacritic-like parts of their letterforms. However, they're not diacritics because they're distinct characters in their own right. For more information, see vietnamesetypography.com

→

Most lowercase diacritics tend to fall within the same measurements as ascenders and descenders, so as long as the extenders aren't already clashing, no further adjustment should be required. However, with uppercase text—which has no extenders—it can be easy to forget that diacritics will significantly add to the height and depth required for lines to not clash. Note how the black uppercase text needs additional leading in order for the same "safe zone" to be maintained.

Garçon GARÇON

Gärten GÄRTEN

Dziękuję DZIĘKUJĘ

Città CITTÀ

Kåpefôr KÅPEFÔR

Pójdźże POJDŹŻE

Thập ngũ THẬP NGŨ

Drop caps can enliven the text

There's absolutely no functional purpose for a drop cap. But they sure do look pretty.

SEE ALSO

*Design system •
Line height*

Drop caps are large first letters in long texts, and they originate from the decorative initials used in illuminated manuscripts such as bibles. They can be decorative, perhaps referencing those historic origins; or they could simply use a different typeface to contrast with the body text; or they might rely solely on the change in font size as a way of differentiating themselves; or anything in between.

When using a simple drop cap — that is, a semi automatic change in font size alone — we can actually be posed with an interesting design challenge due to alignment. Design software usually offers options for drop cap sizes to be relative to 2, 3, or 4 line heights. The focus is on conforming to the overall line height for better alignment rather than matching the surrounding font size.

Implementing drop caps on the web can be more demanding than in desktop software, as direct control for specifying a drop cap font size equivalent to a specific line height value is absent. However, it could be argued that what CSS' implementation lacks in automation — aligning these elements poses the same challenges as baseline alignment on the web — it makes up for in flexibility. By employing the `:first-letter` pseudo class, we can style the initial letter of the body text however we desire.

Or just go and illustrate something crazy and throw that in there. It was good enough for the monks.

→

[TOP] A drop-cap using the exact same font weight and style, but set in design software to automatically occupy two full lines of type.

[MIDDLE] The same again, but with the setting changed to three lines.

[BOTTOM] If you're feeling adventurous, or perhaps in a setting where automatic control doesn't quite cut it, like on the web, why not use a completey different font or something more illustrative?

2

Always ask a maker and publ
of any form of content that
can be consumed—but most im
distributed—digitally, freeing o
of the business models inheritec
default) from the physical

3

Always ask a maker and pu
of any form of content th
can be consumed—but r
importantly distributed—digita
freeing oneself of the business r
inherited (by default) from the p

lways ask a maker and pu
of any form of content th
can be consumed—but r
importantly distributed—digita
freeing oneself of the business r
inherited (by default) from the p

Size doesn't exist

Even absolute units don't produce reliable results — it depends where the reader is.

SEE ALSO

Em square • Flexible • Fluid type scales • Metrics

Size, in essence, is a nonexistent concept when it comes to digital typography. Hear me out.

Specifically, when discussing font size or type size, we're actually referring to the dimensions that the em square is scaled to. The letterforms' actual sizes within the em box depend solely on the choices of the type designer and differ for each font. Even if you take a seemingly simple character, such as an uppercase "H", if you measure its width and height at, say, 60 pt, then change the font but keep the font size intact, and then measure again, those measurements will very likely be different. For more on this topic, head over to page 22.

And even if we forget the technical specifics for a second, it's important to remember that the size of type is relative to its distance from the reader. In much the same way that huge, 400 pt type becomes small if viewed when a reader is on the street, looking up at a billboard 100 yards (91 meters) away, the minuscule differences as the reader moves their head slightly closer or farther away from their laptop screen will *also* have an effect on the perceived size of type.[1]

When it comes to the web and screens in general, the inherent *unknowability* of a viewport's dimensions means we need to set our typography up so that it can flex and bend in with sensible responses to this uncertainty — this is responsive web design (more on page 176). And this is taken to the next level with the utopian methodology, which allows us to work with multiple type scales, which are then intelligently implemented by the browser.

But no, there's no such as thing as "how big is that text?"

1 Nick Sherman explores this at length in *The complications of typographic size on the web* — fonts.google.com/ knowledge/using_type/ the_complications_of_ typographic_size

→

[TOP] As expressed many times throughout this book, some typefaces appear larger than other because of the difference in their vertical metrics. Mainly, a larger x-height makes the type look bigger overall.

[MIDDLE] The width of the visible letterform in this "a" is 2 cm (.8 inches) wide. Or is it? What if you're looking at this as a PDF, and you've zoomed in or out? What if you're moving your head closer and farther from the book or screen? Even absolute measurements cannot guarantee what size they're perceived at.

[BOTTOM] This image was adpated from one made for Google Fonts Knowledge at fonts. google.com/knowledge/ readability_and_ accessibility/how_type_ influences_readability

vpda vpda

a

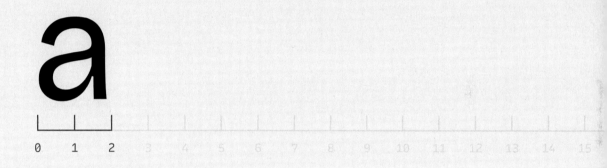

| 0 | 1 | 2 | 3 | 4 | 5 | 6 | 7 | 8 | 9 | 10 | 11 | 12 | 13 | 14 | 15 |

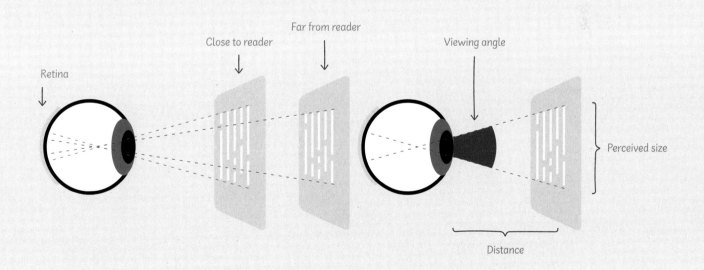

Retina

Close to reader

Far from reader

Viewing angle

Perceived size

Distance

Be consistent with your *units*

Relative units for screens, absolute units for print, but above all: consistency.

SEE ALSO

Size • Type scale

There are many units used to measure different things out there in the world, and typography is no different—we have a surprisingly large number of choices to use when we're measuring type. Perhaps most obviously, we need some sort of unit to measure font size, but the same kind of unit can also be used to measure things *around* the font size, such as the leading or measure.

The point—perhaps one of the most established of typographic units, if we ignore historical font sizes such as the pica, cicero, primer, etc.[1]—was standardized in the 1980s to equate to $\frac{1}{72}$ of an inch in print. When browsers' CSS specification came along, one point was defined as 1.333 pixels. But exactly how big is a pixel? Pixels in early desktop displays were considerably bigger than the physically tiny pixels we now enjoy on our hi-res devices. Therefore, a "software pixel" or "reference pixel" is now completely separated from the dimensions of a physical hardware pixel on a modern screen. Nick Sherman outlines this in detail in his article, *The complications of typographic size on the web.*[2]

Whichever unit you to decide to use to measure your type and type-related dimensions, remember to be consistent. Combining units can cause things to get confusing pretty easily. The most important thing to remember is that some units are absolute and some are relative. Elements measured with absolute units—such as points, picas, inches, and centimeters—appear at the same size whatever the context, so are useful for print and physical media. Elements measured with relative units—such as percentages, ems, rems, viewport height, and viewport width—are rendered in relation to other elements, so are more suited to web, app, and general on-screen use. Somewhat confusingly, using absolute units on-screen makes them relative, *in a way,* due to the discrepancy in the actual physical size of a pixels, as described above.

1 See the University of Cambridge's Dr. Markus Kuhn's article on cl.cam. ac.uk/~mgk25/metric-typo for an overview.

2 fonts.google.com/ knowledge/using_type/ the_complications_of_ typographic_size

→

Absolute units are fine as long as you know every possible way in which the type will be rendered, such as in print. On the web and on screens, relative units offer more flexibility. In the top example, even though font size has been set in rems (a relative unit that derives its sizing from the root font size), the line height has been set in pixels. Therefore, if the text is resized, or if another text element derives its line-height measurements from the parent element, that absolute measurement (12 px) will remain intact, and result in almost unreadable text. In the bottom example, line height has been set as a percentage of the font size, and will therefore adapt appropriately, regardless of font size adjustments. (Of course, for larger type, we might manually want to tighten the line-height ourselves.)

☹ 1 rem type,
12 px line height

Everyone has the right to education. Education shall be
free, at least in the elementary and fundamental stages.
Elementary education shall be compulsory. Technical
and professional education shall be made generally
available and higher education shall be equally
accessible to all on the basis of merit.

2 rem type
12 px line height

Everyone has the right to edu
free, at least in the elementar
Elementary education shall b
professional education shall l
and higher education shall be
the basis of merit.

☺ 1 rem type
120% line height

Everyone has the right to education. Education shall be
free, at least in the elementary and fundamental stages.
Elementary education shall be compulsory. Technical
and professional education shall be made generally
available and higher education shall be equally
accessible to all on the basis of merit.

2 rem type
120% line height

Everyone has the right to edu
free, at least in the elementar
Elementary education shall b
professional education shall b
and higher education shall be
the basis of merit.

Customize type when required

You could type out your brand name and be done. But you'd rather go further, right?

For the vast majority of the time that we work with type, we work with what we've got. Typography is about making the best decisions with a particular font, or a combination of fonts, and if we get to choose the typeface we're working with, then even better. But even then, the type itself is still a fixed thing we have to work around — or is it?

There are times, such as when we're creating a logo or lettering-like lockup — perhaps a product name on some food packaging or a headline for a magazine cover — when we can go that little bit further. Outline your type, take a look at those Bezier curves, and get editing! Done with care, a little customization to the outlines can go a long way in making type look less like, well, *type*.

But before we even consider going that far, it's good to be aware of all the tools we already have at our disposal, baked right into many of our fonts.

The first is alternate glyphs, which are usually accessible via OpenType controls, and take many forms, including ligatures, swashes, and contextual alternates. Swapping out one version of a character for another is a great way of taking your type beyond its default settings to make it resemble something a little more bespoke.

The second is the huge amount of possibilities offered by variable fonts. Being able to decide exactly how heavy, wide, or slanted our type is — rather than picking from predefined instances — allows us a degree of flexibility that until recently would've only been possible by painstakingly manipulating outlines ourselves. And weight, width, slant, and optical size are just the standard axes! When you consider that any parameter of a typeface's design could become a variable axis, the potential for customization is effectively limitless.

Not only do these not-always-obvious superpowers free up our creative potential, but they also provide us with useful criteria for when we're making our type-choosing decisions, too.

SEE ALSO

Alternates • Kern • Parametric axes • Two-lines-of-type • Variable fonts

→

Similar to the *two lines of type* exercise on page 48, see how a logo can take shape with just a few thoughtful typographic tweaks. Here, we type the fictional brand name, "make & go," with its default font settings, improve its leading, swap out two alternate glyphs, select a different weight, then a different width, make a further refinement to the weight thanks to a variable "weight" axis (which in a nonvariable font would've required editing the outlines), and finally custom kern the space between the "&" and "g" to end up with something resembling a finished logotype.

make

make
& go

Stinger Regular,
as typed, with
"auto" line height

make
& go

Line height
reduced

make
& go

make
& go

Alternate "&"

Alternate "k"

make
& go

Weight changed
to "Bold"

make
& go

Width changed
to "Wide"

Custom kern
between "&" and "g"

make
& go

make
& go

Weight axis value
changed to "612"

OpenType
& web
typography
& variable fonts

Know which font *format* to use

Fortunately, we have fewer to choose from these days.

SEE ALSO
OpenType • Variable fonts • Web fonts

Let's be honest: font format is hardly the most riveting of subjects. Try opening a dinner party with *that* one. But knowing which format to use is helpful, and I want to discuss this because it might not be immediately obvious what the difference is between each of them.

OpenType, OTF, and TTF

If you want to install a font on your device, you'll need a font in the OpenType font format. This is the global standard, recognized by Microsoft, Adobe, Apple, Google, and countless other software makers. So OpenType fonts are very widely supported and it's what you'll receive if you download free fonts from Google or license commercial fonts from a font distributor or independent foundry. Note that Adobe Fonts also delivers fonts in the OpenType format but does not allow you to access the font files other than via the font menu.

OpenType is built upon the earlier TrueType font format, adding new possibilities for font makers—the wonderful OpenType features that you'll see dotted throughout this book (ligatures, alternates, small caps, stylistic sets, proper fractions, different numerals, etc.), and more recently "OpenType variations" (AKA variable fonts) that allow users to change their weight, width, slant and other properties in a smooth and continuous way.

OpenType fonts can have an .OTF or .TTF file extension, which usually reflects the mathematics used to define the curves of glyph shapes: cubic Bézier curves for OTF, quadratic Bézier curves for TTF.[1] This difference has no effect on font quality, but is simply a choice by the font maker.

WOFF2

If you're working on the web and serving fonts using CSS' `@font-face`, then it's better to serve them as compressed fonts in the WOFF2 format, which helps prevent font piracy by making them uninstallable on desktops. It's lossless compression, well worth using since it reduces file size (and therefore bandwidth) by 30% to 50%. WOFF2 compression works on all OpenType fonts.

[1] Microsoft supplies quadratic fonts such as Calibri with an .OTF extension.

→

I couldn't think of an interesting way to illustrate font formats, so I decided to play around with Jamie Clarke's Rig Shaded instead. Each colored layer is a different text box that uses one of Rig's different styles, all placed on top of each other. Nice, eh? More info on page 198.

.OTF
.TTF
.WOFF2
ETC.

Harness the power of *OpenType*

The technology that allows us to do more with our fonts.

SEE ALSO

Alternates · Ligatures · Small caps · Stylistic sets · Swashes · Variable fonts

OpenType is a font format and associated technology jointly developed by Adobe and Microsoft in the 1990s, allowing us to access additional settings in fonts, mostly related to the substitution of alternate glyphs. Ligatures, contextual alternates, stylistic sets, swashes, and small caps are all examples of what we generally call OpenType features, and we cover each of these in their own dedicated chapters in this book.

Most OpenType features would previously have to be included in separate font files, and occasionally this still happens—you might've come across a font file that only contains the swash glyphs, for instance. However, combining these features into one file and allowing the end user to access them with ease (in desktop design apps, usually just a button press away) opens up many more typographic opportunities. These include improving overall readability with ligatures, lining up tabular data using tabular numerals, adding flair to a logotype with swash glyphs, or making type look more like handwriting or lettering by implementing stylistic sets or contextual alternates.

On the web, OpenType features are accessed via CSS. Note that in most modern browsers, kerning—one of the few OpenType features *not* related to alternate versions of characters—is turned on by default, so there's rarely a need to control it via CSS (unless we want to turn it off). We've got a dedicated chapter on implementing OpenType features for the web on page 182.

Variable fonts—officially, OpenType Font Variations—are, as the name implies, an extension of the OpenType format, allowing for much greater control over multiple typographic parameters, all contained within one single font file.

⟶

Adorn Smooth Pomander, by Laura Worthington, has a huge number of swash alternates, all accessible via the OpenType menu in design apps or via CSS. Using these alternate glyphs allows us to make our type look much more like lettering. Of course, swashes are just *one* OpenType feature!

Give yourself more options with *alternates*

Most OpenType features are about substituting glyphs for alternative versions.

SEE ALSO

*Ligatures • Numerals •
OpenType • Small caps •
Stylistic sets*

In many fonts, there are numerous options available to us as typographers beyond the defaults, from different drawings of certain characters — perhaps a swashed "S" to work better in a logo, or an alternate lowercase "z" to make body text a little less quirky — to readability aids such as ligatures and small caps. These alternate glyphs can be grouped generally under the umbrella term "alternates," and when they exist, try them out! The type designer has put them in the font to make our lives as typographers easier.

Most kinds of alternates are made available to us as OpenType features, and can therefore be accessed via design software's OpenType menu (or the deeper parts of an application's Type panel), or manipulated on the web using CSS' OpenType controls. As such, many can be substituted automatically, as is the case with ligatures and contextual alternates. Others usually (but not always) exist as stylistic sets that we can cycle through.

However, some alternates might be separated out into entirely separate font files, as can sometimes be the way with swash or small caps variants. This was also how things were done in the days before OpenType, when font file sizes were much smaller, or in predigital type, when any alternate was (obviously) a literally different piece of wood or metal.

To delve into the details, please read the dedicated chapters on ligatures (page 156), numerals (page 158), swashes (page 160), fractions (page 162), small caps (page 164), and stylistic sets (page 166).

There isn't a dedicated chapter for contextual alternates, but they're useful to have turned on, as it means that certain sequences of glyphs will be swapped out as required — a bit like how ligatures work, but without combining different characters into a single glyph. For more information, see the illustration opposite.

⟶

[TOP] The quirky appeal of a typeface might work well for a logo, but when it comes to setting body text, those quirks can become distracting. Type-Together's Bree contains a stylistic set that allows us to substitute the default drawings for "g", "y", and "z" for more formal interpretations.

[MIDDLE] Some typefaces, such as p.s.type's Neighbor, feature many alternates purely to offer some aesthetic variation. These are accessible as several named stylistic sets, such as the "Diamond E F" set used in the last line.

[BOTTOM] In Mark Simonson's Bookmania, with discretionary ligatures (themselves a kind of alternate) enabled, the dot of the "i" is a little too close to close to the ascender of the "h". However, with contextual alternates also enabled, the dotless form of the "i" is automatically employed with this sequence of glyphs.

fizzy gummies

Do not exceed the recommended daily dose of fizzy gummies. Individuals taking medication should consult a health practitioner prior to use. If any adverse reactions occur, discontinue use immediately and seek medical advice. Please contact us if you find a gummy of an unsual size.

hamburgerfonts

hamburgerfonts

hamburgerfonts

hamburgerfonts

HAMBURGERFONTS

HAMBURGERFONTS

HAMBURGERFONTS

HAMBURGERFONTS

HAMBURGERFONTS

Chicken

Chicken

Chicken

Ligatures are more useful than you might think

As well as avoiding awkward clashes, they can avoid repeating letterforms, too.

SEE ALSO

Alternates • OpenType

Isn't it irritating when the hook of an "f" collides with the dot on an "i"? While wars haven't been started on such trifles, these collisions have certainly interrupted the reading experience for a fair few unsuspecting souls. Thankfully, ligatures can resolve this issue by substituting the offending glyphs with a new glyph that combines the letterforms into one new form. This seemingly simple feature improves readability, so it's worth checking ligatures exist in any typeface you might currently be in the process of choosing.

Ligatures can be used provided they exist in your chosen typeface and its fonts. Like all OpenType features, it's not a given that all versions of a font include the glyphs you require. If they *are* included, they can be accessed via OpenType controls in your favorite design software, and in many scenarios they're enabled by default, so they should appear automatically. That's even true on the web—you no longer even need to turn common ligatures on with CSS.

We tend to divide ligatures into two groups: common ligatures are called such because they're functional—they counter these unsightly letterform clashes and therefore improve the readability of text—whereas discretionary ligatures are more decorative in nature—and, ironically, have the potential to reduce readability because contemporary readers are not used to seeing them. But they do make use of gadzooks ("god's hooks") so there's that.

The fact that ligatures replace two or more glyphs with one new glyph can occasionally present a problem, however. In some circumstances, copying text that contains ligatures and then pasting that text into another context—perhaps from a PDF into a website's CMS—can cause the ligatures to either be rendered in a fallback font or perhaps not at all. If you experience missing characters somewhere, it might be worth checking ligatures first.

⟶

[TOP, LEFT] Common ligatures found in many typefaces, here set in Case Bold.

[TOP, MIDDLE] Discretionary ligatures found in many typefaces, here set in Minion 3 Display.

[TOP, RIGHT] A paragraph set in Minion 3 with common and discretionary ligatures enabled. Note how the common ligatures aid readability, whereas the discretionary ligatures are more decorative in nature.

[MIDDLE & BOTTOM] Type designers are free to make as many discretionary ligatures as they like. Changing, by Pintassilgo Prints, has loads of them, and using them makes our type appear more like lettering, because the standard letterforms are not repeated as frequently (much like the effect of the swashes on page 153). Compare the two versions of the "checking account" example, and note how the "c" and "n" are all different in the larger version, which has the ligatures enabled.

ff → ff ct → ct

fi → fi sp → sp

fj → fj st → st

fl → fl Th → Th

ffi → ffi

ffj → ffj

ffl → ffl

Autumn has to be our favorite time of year, so we put a lot of pressure on ourselves to select some recently-released tracks for this season. So light that fire, wrap around that scarf, and join us for the *Lagom Autumn Playlist* — and be sure to listen out for *Hotter Colder,* by This Is The Kit, who we interviewed in our latest issue. The photo on the playlist's cover was taken by Tiffany Coleman for her piece on hiking around Burlington.

Checking account

Checking account

ay ay ad an ch ck cc dd et er ee ed en ff fr int id in kr la ll le lo ls oo on pp res rab rk rr ri ro ra rs re ss th tv ta to te th te ta ty xe xa yn afi ax am an ac ap at ab an cos ck cy ce co cc dd de ed ex ee ej fth ff fs ht ing ilg is ip ix in kas ki ke ko ka ky lig ll ny ng oo pp fth rej res ri rm rk ry re tv rr ru ra ss tw tv ta tz th ty ts tu te ti un vu vo ve va wn wo wa wh xe xi

Know your *numerals* (or figures)

There are four distinct kinds, and it's useful to have all of them at your disposal.

SEE ALSO

Metrics · Monospaced

A recurrent theme in this book is that more options are *a good thing*. And, if you have multiple options available to you when it comes to numerals (or figures) then it makes sense to use them. There are effectively four different kinds of numerals, and a professionally made font should ideally contains all four.

1. **Proportional lining** numerals are so-called because, just like letters, they each have a different width—compare a proportional "1" with an "8". The "lining" part of the name means they look a lot like uppercase letters: the lowest part of the letterform sits on the baseline, and the tallest part of the letterform matches the cap height of regular letters.
2. **Proportional oldstyle** numerals again have varying widths, but they look a lot more like lowercase letters; that is, some have ascenders that extend above the x-height (6, 8) and some have descenders that extend below the baseline (3, 5, 7, 9).
3. **Tabular lining** numerals are sometimes called monospaced numerals and, like monospaced typefaces in general, their glyphs take up exactly the same horizontal space. Again, the lining part means that they appear more like uppercase letters.
4. **Tabular oldstyle** numerals—you've probably spotted the pattern here—have glyphs of the same width, but appear more like lowercase letters.

 Generally speaking, oldstyle numerals are best for running text, such as when you have figures within a sentence of regular prose. Lining numerals, appearing much like uppercase letters, tend to "shout" at the read (as with all-caps type). Tabular numerals are best for representing tabular data, since they all line up neatly above and below each other.

 It's also important to note that the default figure kind—that is, the one used without us changing anything via OpenType—can be *any* of them. It's up to the type designer. Most fonts use proportional lining numerals by default, but occasionally you'll encounter proportional oldstyle numerals such as with Georgia.

→

[TOP] Proportional numerals have varying glyph widths, just like most letters and symbols. Oldstyle numerals' letterforms have ascender-like and descender-like designs.

[MIDDLE] Tabular numerals have a consistent width.

[BOTTOM] When proportional numerals are used in the table on the left, the numbers don't line up. With tabular numerals selected for the sample on the right, better alignment is achieved.

0123456789

0123456789

0123456789

0123456789

	EU	UK
Sales, Q1	1041	1009
Sales, Q2	3069	2116
Sales, Q3	2783	2488
Sales, Q4	7119	6056

	EU	UK
Sales, Q1	1041	1009
Sales, Q2	3069	2116
Sales, Q3	2783	2488
Sales, Q4	7119	6056

Swashes can enhance your type

But watch out for unsightly clashes between letterforms.

With great power comes great responsibility, right? And swashes wield *a lot* of power. Add a swash glyph to your type and you're making a statement. So let's make sure that power is handled with care.

First, let's establish this: there are two kinds of swash. Much like "serif," a swash can be part of the letterform — usually a decorative element that can range from the relatively simple (such as the extended leg of a "k") to the incredibly complex (such as those in Mala, shown opposite). Here, we'll focus on the second kind: the swash *glyph;* the decorative, alternate version of a letterform for a particular character.

Swash variants are usually found in serif and script typefaces, and generally for uppercase characters. Picture a title where the first letter of each word takes a more elaborate form. Now, although swashes don't *have* to sit at the front of a word, special attention has to be paid to how swash alternates can affect spacing. A very common mistake — weirdly, by a lot of sign makers — is to throw a swash right in the middle of the word, only to have it create a great chasm of space between it and the next letter. (There's a pub in my village does exactly this, and I'm incensed every time I drive past it.)

Using swash glyphs in design software is usually a case of turning them on or off in your OpenType settings, and the same goes for using them in CSS. We can also specify which swash to use if there's more than one, like so:

```
span.first-swash {
    font-feature-settings: "swsh" 1;
}

span.second-swash {
    font-feature-settings: "swsh" 2;
}
```

Note that some swash variants might actually ship in an entirely separate font file, however. In that case, using them is a case of switching between fonts on a character-by-character basis.

SEE ALSO

Alternates • Inheritance problem • OpenType

⟶

[OPPOSITE] A page from the specimen for Mala, a typeface published by Bold Monday. Both the typeface and the specimen were designed by Barbara Bigosińska. Reproduced with permission.

[BELOW] It's possible I might've gone a little crazy with the swashes in Mark Simonson's Bookmania for our wedding invitations.

Use proper *fractions*

If you're setting recipes, your readers will appreciate this subtle but important change.

SEE ALSO

Inheritance problem • OpenType

It's not that interesting to write about fractions. Honestly, I thought I'd left this kind of stuff behind in grade school. But every now and again you need to use a fraction in your text and it can look so much better—and therefore be a whole lot more readable—if you use a *proper* fraction. That is, when the numerals are correctly sized and positioned above and below the diagonal line, rather than sitting side by side.

Unicode has characters for proper fractions, but to insert them you'll need to know the unicode reference (or paste in the character from elsewhere) and they'll need to be present as glyphs in the font. It's far more efficient to automatically turn your captions into proper captions using OpenType (with the caveat that, like all OpenType features, they also need to be present in the font you're using).

Turning on proper fractions is usually done via your app's OpenType menu, and on the web, they can be turned on in CSS like so:

```
ul.ingredients li {
    font-feature-settings: frac; /* Older browsers */
    font-variant-numeric: diagonal-fractions; /* Newer browsers */
}
```

If you're designing a recipe website, you'll *dramatically* improve a user's experience by using proper fractions, as the quantities of the ingredients are significantly more readable. But really, just switch them on whenever you've got *any* content that uses fractions. It'll look better.

→

This is a recipe we commissioned for our magazine *Lagom*. We still regular make this shakshuka. You might like it, too: readlagom.com/stories/recipe-shakshuka-from-waxed-hossegor.html

1/2 → ½
2/3 → ⅔
3/4 → ¾

OpenType

✓ Fractions

Shakshuka

Ingredients — serves 1

½ onion
1 red pepper
1 yellow pepper
2 tbsp cold-pressed organic olive oil
1 tbsp harissa paste
1 tbsp tomato paste
2 garlic cloves, grated
½ tbsp paprika powder
½ tbsp cumin powder
½ tbsp brown sugar
400g ripe (or canned) tomatoes
2 eggs

Spicy hummus
Chopped parsley
Dried black olives

Method

Prepare your vegetables: mince the onion, peel the s
the bell peppers, and chop them roughly into small c
We peel the bell pepper to make it softer and to get
the bitter taste it can have. Heat the olive oil over m

Use *small caps* to avoid shouting at the reader

If you've got text containing acronyms, it's useful to have small caps to hand.

SEE ALSO

Alternates • Faux • Inheritance problem

In certain situations, we may need to use all-caps text. However, using regular uppercase letters can make the text seem like we're SHOUTING AT THE READER. (See?) In these cases, it's beneficial to utilize small caps since their proportions more closely resemble (but don't match entirely) lowercase characters, and sit much more gently within the text.

⟶

Most small caps are designed to be slightly taller than lowercase characters, but they're noticably smaller than the standard uppercase.

Like all OpenType features, small caps can only be activated if they're present in the font you're using. Check in your OpenType controls in design apps, and in CSS like so:

```
span.acronym {
    font-feature-settings: "smcp"; /* Older browsers */
    font-variant-caps: small-caps; /* Newer browsers */
}
```

Exactly how many uppercase characters you set before converting to small caps is up to you or the style guide you're following. For instance, while it's a no-brainer to set UNESCO in small caps, what about US (as in "United States")? In some typefaces, where the design of the lowercase "u" and "s" is quite similar to the small caps "u" and "s", there's potential there for the small caps acronym to be read as the word "us." As with so many things in typography, there's no definitive answer on how to counter this, and it might be good to review any rules put in place whenever you change a typeface. And be sure to consult with any copyeditor, proofreader, or custodian of the style guide when you do!

When setting small caps, they often have wider spacing built-in, but if not, increasing tracking is recommended for a more pleasing reading experience. In fact, the same rule can be applied to any uppercase type when rendered at small sizes. Sometimes this extra tracking can also help in alleviating the problem described above, too.

And although most of the time, small caps are there to stop uppercase type from getting a bit aggressive, they can actually coexist with regular capitals when those are needed at the beginning of words. This feature can be activated through the OpenType setting called "all caps to small caps" or the `c2sc` code in CSS.

The first trip to the world-famous
UNESCO heritage site was not without
its challenges, however. This wasn't long
after the CIA had ended its investigation

Without small caps
& 0% tracking

The first trip to the world-famous
UNESCO heritage site was not w
its challenges, however. This was
after the CIA had ended its inves

With small caps
& 25% tracking

UNESCO unesc

UNESCO unesc

Stylistic sets offer even more options

Swap out alternate glyphs en masse.

SEE ALSO

Alternates • Choose type • OpenType

⟶

Degular's four stylistic sets have descriptive names rather than the default ss01, ss02, etc.

Throughout this book, you'll find many references to alternate glyphs, OpenType features, and the general impression that I heartily recommend exploring all of the options made available to us by our kind type designer friends. Stylistic sets (occasioanlly referred to as "style sets") are a way of accessing alternate glyphs for a whole block of text. A common one might be a set called something like "single storey a" that substitutes all of the default lowercase "a" glyphs for their alternate, single storey cousins. Similar thing with single storey "g" glyphs, too. But whether or not the type designer decides to name the stylistic sets like this or not is entirely up to them. (It's hard to beat James Edmonson's "Jesus t" stylistic set naming in Ohno's Degular.) Perhaps more commonly, we might find the "ss01" code used instead—and this is the four character reference we'll need when turning these on and off for our web type with CSS.

The type designer can also choose to group alternates in a single stylistic set. Perhaps, if several alternates logically sit together, such as the "Geometric open lowercase" set in p.s.Type's Neighbor (see the illustration on page 155), they might sit inside one particular set. Ultimately, it's up to the type designer to choose. And they're also free to make one, two, three, or perhaps even the maximum of 20 stylistic sets if they want. Or none. And that's fine. Most professional fonts' documentation and websites will usually make a pretty big thing of these features, so finding out whether or not they're included is quite straightforward.

As with all OpenType features, it's important to remember that not all versions of the font will necessarily contain the stylistic set you're after, even if advertised in the promotional materials. See page 90 for more information on what to look out for.

Degular Text Regular
Stylistic set: "Single storey a"

a → a

The more I thought about it, the more it became apparent that Gareth had agitated me when we'd been children, constantly testing my patience with games intended to taunt me. "Get the ball for me," he'd say.

Degular Text Regular
Stylistic set: "Single storey g"

g → g

The more I thought about it, the more it became apparent that Gareth had agitated me when we'd been children, constantly testing my patience with games intended to taunt me. "Get the ball for me," he'd say.

Degular Text Regular
Stylistic set: "Simplified G"

G → G

The more I thought about it, the more it became apparent that Gareth had agitated me when we'd been children, constantly testing my patience with games intended to taunt me. "Get the ball for me," he'd say.

Degular Text Regular
Stylistic set: "Jesus t"

t → t

The more I thought about it, the more it became apparent that Gareth had agitated me when we'd been children, constantly testing my patience with games intended to taunt me. "Get the ball for me," he'd say.

Kern only if you have to

Tracking will probably get you most of the way there.

SEE ALSO

Logo · Optical sizes · Tracking · Well-spaced

Everyone likes to point out bad kerning, don't they? But more times than I see some bad kerning, I hear someone tell me about some bad kerning when they don't actually mean kerning at all! Most of the time they mean tracking (the overall letter spacing in a block of text) or perhaps the general spacing in a font. Kerning, specifically, is the alteration of the horizontal space between two or more glyphs. For instance, a tighter space between "A" and "V", or a more open space between each "w" in "www". This can be handled by the type designer, with that custom spacing information built into the font file in the form of what's known as "kerning pair data", or it can be handled manually by the end user.

In almost all circumstances, it's wise to turn on any kerning that's built into the font; the type designer has painstakingly taken the time to optimize that spacing, after all. If the option exists in your design app of choice, make sure "metrics" is checked, not "optical". In CSS, kerning is now generally turned on by default in browsers these days, but if required, you can turn it on (or off)[1] like so:

```
font-kerning: auto;     /* Let the browser decide */
font-kerning: normal;   /* Enable kerning */
font-kerning: none;     /* Disable kerning */
```

The kerning data built into fonts is designed for most scenarios, and occasionally there'll be a situation that requires a more bespoke approach. Sure, it's possible we might disagree with the type designer's spacing decisions, but in practice that's pretty rare (unless we're forced into using an unprofessional, badly spaced font). A more common scenario is when we're creating a specific lockup for a logo: it might be that using the type at certain sizes warrants tighter or looser spacing, and tracking (letter spacing) only gets us some of the way toward that perfect lockup.

[1] If set to "auto," the browser will decide whether or not to apply the kerning data depending on the size of the type and, on some small type, kerning might be disabled. Implementation varies, so testing is advised.

⟶

Some manual kerning (indicated by the arrows) has been applied to tighten up the spacing before and after the punctuation in the small text, and between the "r" and "t", and "a" and "y", in the large text. The larger text is also negatively tracked by 50% to tighten the letter spacing overall. For display-size type in a logo-like configuration such as this, manual kerning can help add that final layer of polish.

It's my Birthday & I'll kern if I want to!

Subsetting can be useful

Font files can be big and, for websites, that has an impact on users' bandwidth.

SEE ALSO

*Choose font files •
Licensing • OpenType*

The process of taking a font file, removing specific glyphs from it, and creating a new font file from those glyphs that remain, is called subsetting. Subsetting can be done by the end user, using either font editing software or some form of automated script; by a service via an API, such as Google Fonts delivering a subset of a particular font to optimize loading speeds; or by the type foundry itself, which may offer different subsets depending on licensing. More features = higher cost.

Around the year 2000, Adobe differentiated between different versions of their popular fonts using the "Std" and "Pro" extensions to their names. The Standard versions were a subset of the Pro versions, with a reduced glyph set to cover fewer languages and fewer OpenType features. Monotype adopted a similar naming system at around the same time. Of course, exactly what "Pro" means has changed, as the name has been adopted by other foundries and distributors. Any type designer can add "Pro" to their font to make it *seem* more appealing, after all.

Regardless, subsetting itself is not dependent on font naming tactics. Prior to OpenType and the ability to fit multiple alternate glyphs inside a single font file, it was common for features such as small caps or stylistic sets to exist in their own subset. And it's long been a practice (in digital fonts) for foundries to offer a subset that intentionally omits certain glyphs so that those fonts can be distributed as "trial" versions. It's common for trial fonts to omit punctuation (which generally makes them unusable in most real-world scenarios), and kerning data (which makes them easier to spot when they *are* used).

→

When we look at the whole glyph set of a font, it's easy to see how certain groups could — if so desired — be broken up into their own subsets. The glyphs highlighted in pink should be present at a bare minimum for any font to be usable — although opinions differ. Generally speaking, any professional font would not dare to be so minimal. The typeface shown here is Def Sans, which includes *all* glyphs by default, with no subsetting. Also note that for the sake of illustration, I've not included Def Sans' alternates, such as the single storey "a".

Latin uppercase

ABCDEFGHIIJKLMNOPQRSTUVWXYZ

Latin lowercase

abcdefgghiijklmnopqrstuvwxyz

Latin uppercase
with diacritics

ÁĂẮẶẰẢẴẤẦẬẦẨẪÄĀẠÀÅĀĄÅÃÆĆČÇ
ĈĊĎĐḌḎĐÉĔĘÊÉỆÊỂỄËĖẸÈẺĒĘẼƏĞ
ĜĢĠḠGĦĤḤIJÍĬÎÏĬİỊÌÌĨĪĮĨĴĶĶĹĽĻĻŁŃ
ŇŃŅŅÑŊÓŎÔŐ Ộ Ồ Ổ Õ Ö Ō Ọ Ò Ỏ Ơ Ớ Ợ Ờ
Ở Õ Ő Ō Ố Ò Ø Ǿ Õ Ő Œ Þ Ŕ Ř Ŗ Ś Š Ş Ŝ Ș ẞ Ŧ Ť Ţ
Ṭ Ṯ Ú Ŭ Û Ü Ų Ù Ủ Ư Ứ Ự Ừ Ử Ũ Ű Ū Ų Ů Ũ Ŵ Ŵ Ẅ
Ý Ŷ Ÿ Ỵ Ỳ Ỷ Ỹ Ź Ž Ż Ẓ

Latin lowercase
with diacritics

á ă ắ ặ ằ ả ẵ ă â ấ ậ ầ ẩ ẫ ä ā ạ à å ā ą å ã æ ć č ç ĉ
ċ ď đ ḍ ḏ đ ð é ĕ ę ê é ệ ê ể ễ ë ė ẹ è ẻ ē ę ẽ ə ğ ĝ ĝ ǵ
ġ ḡ ħ ĥ ḥ ı í ĭ î ï ĭ i ị ì ỉ ĩ ī į ĩ i j j ĵ ķ ķ ĺ ľ ļ ļ ł ń ň ņ ņ ṅ ņ ɲ ñ ŋ
ó ŏ ô ő ộ ồ ổ õ ö ō ọ ò ỏ ơ ớ ợ ờ ở õ ő ō ố ò ø ǿ õ ố
œ þ ŕ ř ŗ ś š ş ŝ ș ẞ ŧ ť ţ ṭ ṯ ú ŭ û ü ų ù ủ ú ứ ụ ừ ủ
ŭ ű ū ų ů ũ ŵ ŵ ẅ ẁ ý ŷ ÿ ỵ ỳ ỷ ỹ ź ž ż ẓ

Proportional figures

0123456789

Tabular figures

0123456789

Subscript & superscript

0123456789 0123456789

Fractions

½ ¼ ¾ ⅛ ⅜ ⅝ ⅞

Currency

₢ ¢ ¤ $ € £ ₺ ₹ ₣ ¥

Arrows

↑ ↗ → ↘ ↓ ↙ ← ↖ ↔ ↕

Punctuation
& symbols

. , : ; . . . ! ¡ ? ¿ · • * #
/ / \ - – — _ () { } []
' " " " ' ' « » ‹ › "' ƒ @
& ¶ § © ® TM ° | ¦ † ‡
№ • + − × ÷ = ≠ > < ≥
≤ ± ≈ ~ ¬ ^ % ‰ ◊

It's hard to imagine a web without *web fonts*

Any font that's not preinstalled on a user's device is a web font.

SEE ALSO

Deliver • Variable fonts • Web typography

Not long ago, web designers were very limited in terms of their typographic palette, with only a small number of typefaces to choose from. These system fonts, or "web-safe fonts", were the ones you could largely guarantee would be preinstalled on every computer across the world. Microsoft introduced support for `@font-face` in CSS with Internet Explorer 4, but it didn't catch on with other browsers until much later, around 2008. And even then, there remained the problem of piracy: if a web designer uploaded a font file to a server, anyone viewing the source could then download it and use it as their own.

The solution came in two forms around the early 2010s: firstly, from Typekit (which later became Adobe Fonts), a service that used some clever code to obfuscate the font file; secondly, from the new WOFF format, that offered a new wrapper for OpenType fonts that prevented them from being usable in desktop environments. Eventually, when support for WOFF became universal, there was no need for the obfuscation method, and WOFF has been the *de facto* format for web fonts ever since.

To use web fonts on your site, they first need to be loaded, either via a font delivery network or by self-hosting. (This is explored in length in "Deliver font files with intent" on page 180.) Once loaded, they need to be referenced in your CSS file, like so:

```
body {
  font-family: "FAMILY_NAME", sans-serif;
}
```

There are numerous web-specific controls for typography mentioned throughout this book and there are certainly some quirks—especially with the current implementation of newer technology, such as variable fonts. But by and large, web typography is now on a par with print typography, and web designers can enjoy the same level of control that just a few years ago would not have been possible.

\longrightarrow

A little peek under the hood at my personal site, where I'm using web fonts for Degular—the same typeface used to set most of this book. I'm using the variable version so I can manually manipulate its optical size axis (see page 44) and, if you're curious, there are a fair few CSS custom properties in there for controlling the fluid type scales (see page 178).

Hello, I'm <u>Elliot</u> —a creative dire
& **typography** geek. You might
know <u>my work</u> with Google Fo
or Adobe Fonts, or the magazir
8 Faces & Lagom.

My new book

My new podcast

Web Inspector — localhost

Elements Sources

`_typography.scss`

```scss
1  /* --------
2  TYPOGRAPHY
3  -------- */
4
5  body,
6  input {
7    color: $color-dark;
8    font-family: "Degular Variable", sans-serif;
9    font-feature-settings: "kern" on, "liga" on;
10   font-optical-sizing: none;
11   font-size: var(--type-scale-step-0);
12   font-style: normal;
13   letter-spacing: normal;
14   line-height: var(--type-scale-step-1);
15
16   --vf-opsz: 1;
17   --vf-slnt: 0;
18   --vf-wght: 1;
19
20   @media screen and (min-width:40em) {
21     /* background-color: cyan; */
22     --vf-opsz: 20;
23   }
24
25   @media screen and (min-width:45em) {
26     /* background-color: magenta; */
27     --vf-opsz: 40;
28   }
29
30   @media screen and (min-width:60em) {
31     /* background-color: yellow; */
32     --vf-opsz: 80;
33   }
34
35   @media screen and (min-width:80em) {
```

Web typography is just... typography

There's very little we can do in print that we can't also do online, but web typography comes with the added blessing (or curse) of responsive design.

SEE ALSO

Deliver • Fluid type scales • Web fonts

What does "web typography" really mean? Generally, we're talking about type-setting on the web—and by implication, on-screen—and doing so in a way that takes the universal principles of typography, but augments them with some web-specific considerations. This is not about technology specifically, such as what features are currently supported by popular browsers or not—since this is very much a moving target—but more about having an awareness of how type can and should behave differently to print, given that the web is an inherently fluid medium.

Web typography considers how we load web font files, how we manipulate the type we have to work with, and how certain tools allow us to explore the optimum ways of doing that. In our chapter on fluid type scales (page 178), for instance, we explore in depth the ways in which we can use the built-in smarts of the browser to work out the best way to implement scales.

If there's one key area where typesetting in print and typesetting on the web (and for screens in general) differs, it's that print typography both benefits and suffers from the fixed proportions and constraints of the medium, while web typography both benefits and suffers from open and fluid nature of the medium. It means we need to be careful—fluid measures can quickly become way too long, as often happened when designers first embraced responsive design—but it also means we can set optimal minimal and maximum values, and then let the browser do the hard stuff in between, especially now that `clamp`[1] enjoys widespread browser support.

Regardless of the medium, the universal principles of typography remain the same.

[1] developer.mozilla.org/ en-US/docs/Web/CSS/ clamp

⟶

From 2014 to 2019, my wife and I ran a lifestyle magazine called *Lagom,* and although print based, we published a few articles on our website, too. There were a few ways in which the layouts differed between the printed and online versions, but by and large the typography was pretty close. Although the magazine is no longer published, those articles can still be found online at readlagom.com.

Pottery is magic. I can't think of another word for it. All of the elements can be explained: the centrifugal force that keeps the clay on the wheel, how during the firing at 348 degrees the chemically bonded water leaves the pot and it is irreversibly changed, how a glaze matures and makes the pot im[...] to water. All [...] are [...]

Making good pots is a mixture of remembering and forgetting. You've got to learn as much as you can, practise your techniques, have as much skill and knowledge as possible, and then go into the studio and try to forget it all—otherwise the temptation is to try and show off everything you know within one pot, and you end up with something over-thought and contrived. You've got to get out of your own head and let the beauty of clay, glaze, and form do its own thing. There are moments in my studio when I can no longer feel the passage of time. It doesn't happen often, but perhaps two or three times a month, I'll hit a rhythm in my making, and a whole morning will pass in a moment. That isn't an exaggeration. I'll sit at the wheel with 70 or 80 balls of clay weighed out, press play on my music, and the next moment, there'll be 80 cups sitting next to me. It can be a rather disorienting experience.

When I was learning pottery, I learned alongside a number of other people. We all noticed this sensation. There's a Hungarian psychologist called Mihaly Csikszentmihalyi, who coined the term 'flow'

readlagom.com

93%

nd then I got ill. Really quite ill. I spent two years in bed with depression and undiagnosed bipolar disorder. Fitful restarts, desperate attempts to get going again — nothing seemed to work. After years of what felt like success, I felt like a failure.

I'm not sure I would have recovered if I hadn't discovered pottery. Craft lends itself to metaphor. You take a raw material — be it wood, clay or stone — and you turn it into something. It takes time, care, and skill. As I learned pottery, I felt like I was slowly remaking myself — changing, going through fire, and coming out the other side as something else. It's hard not to see yourself reflected back by the process.

Keep your content *flexible*

We don't know how big the user's screen will be — and that's okay. Let's plan for it.

SEE ALSO

Fluid type scales • Units • Web typography

In the early days of the web, designers mimicked the centuries-old model of page-based layouts, especially so in the days of Flash when websites had fixed dimensions that were based on the average screen sizes of the time. But HTML is inherently fluid (turn off CSS to see how unstyled HTML fills the browser window by default) and when the concept of responsive web design arrived in 2010[1] this in-built fluidity was reembraced by the web design community.

However, screen size has never been a reliable metric to work with, and this became ever more apparent when it came to responsive design. In web design, app design, or screen design as a whole, the viewport is the canvas on which we have to play with. It's not the same as the screen size, and nor is it the same size as the browser (or app) window itself, since that inevitably contains what's known as "chrome" — tabs, toolbars, scrollbars, etc. — unless viewed in full screen. And even then, some phones might force critical information like battery life or reception signal into the screen, therefore eating into the usable space. So it's the viewport's width and height that we have to consider above all else, and with the almost infinite combination of different phone models, OS versions, app-specific nuances, and user preferences, the idea of an "average size" simply does not exist.

And that's before we even get onto the fact that pixels don't exist! They do, obviously, but for a while we had a shared notion of how physically big an actual pixel was, and how "one pixel" in CSS mapped to one pixel on the screen. Now, pixels are so small, and screens are so hi-res, that a CSS pixel is nothing more than an abstract concept (see page 144).

All this is to say that when we come to sizing type for screens, we should do so *relatively*. Relative to the viewport. Relative to the other elements around it. Relative to the user's display preferences. Relative to the environment, even! We're now at a point with digital typography where we've not only moved on from the notion of fixed pages, but we've also finally embraced the fact that there's no finite "font size" (for more on that, see page 142).

[1] This was primarily thanks to Ethan Marcotte's seminal article on *A List Apart:* alistapart.com/articles/responsive-web-design

———→

Viewports rarely occupy the entire screen. Browser tabs, address bars, OS docks, and other elements take up some of the total available screen real estate. Even if we consider the four core device types — large desktop / monitor, laptop, tablet, and phone — each of those has multiple possible screen sizes due to differentiations in model, device version, manufacturer, and the software being used on each. The website shown here is every-layout.dev, which is not only responsive, but uses fluid type scales to adapt the size of the type to the viewport.

Future-proof your site with *fluid type scales*

Let the browser determine how to elegantly move between a type scale that works for small and large viewports.

SEE ALSO

*Design system •
Type scale • Viewport*

Recent advances in browser technology, combined with a maturing approach to web design, thanks to some diligent designer-developers, have led to some interesting universal approaches to web typography.

One of those, Utopia,[1] is a methodology created by James Gilyead and Trys Mudford that allows us to create fluid type scales (and spacing scales) so that extreme changes in sizes are reserved for larger viewports. In the process, the need for complicated in-between steps usually handled by media queries is entirely removed. And once the system is set up, the heavy lifting is done by the browser, thanks to some clever math.

I'm generally avoiding specific technical instructions in this book, because technology gets outdated quickly, but the Utopia methodology is "universal" by nature. It's about understanding that we can mainly just design for the extremes and then utilize browser technology to figure out the hard parts in between. We can always step in when we have to, but if we can avoid writing multiple media queries in our CSS, then our typography is future-proofed for new devices and dimensions that might become popular in the future.

To apply the Utopia methodology to your web typography, there are a few simple steps:

1. Visit utopia.fyi/type.[2]
2. Pick a minimum (e.g., 320 px) and maximum (e.g., 1600 px) viewport width.
3. Set your primary (i.e., body text) font size for those minimum and maximum scenarios (e.g., 16 px for mobile, 24 px for the largest screen).
4. Decide on the type scale for the minimum and maximum sizes (they can be the same, but more contrast is usually better for the larger sizes), and test.
5. Copy the generated CSS.
6. Use the CSS custom properties for your `font-size` declarations.

The best part of this is that if we ever change our mind about the scale or the specific sizes used, we just redeclare the custom properties in the `:root` and everything else automatically updates.

[1] utopia.fyi/type

[2] We don't necessarily have to use the tools on this particular website, and if not you can skip steps 1 and 5, but it generates some handy calculations for us.

→

Look at the screenshots at the bottom and note how the body type is approximately the same size in both settings; however, on the wider viewport, the heading is that much bigger. This is because the scale with wider intervals is used for larger viewports.

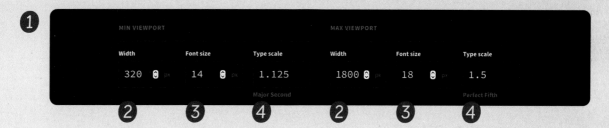

MIN VIEWPORT			MAX VIEWPORT		
Width	Font size	Type scale	Width	Font size	Type scale
320 px	14 px	1.125	1800 px	18 px	1.5
		Major Second			Perfect Fifth

① ② ③ ④ ② ③ ④

Scale step	Viewport width		
⊕	**320**	**1800**	⊕
⊖ 5	25.23	136.69	
4	22.43	91.13	
3	19.93	60.75	
2	17.72	40.50	
1	15.75	27.00	
0	**14.00**	**18.00**	
-1	12.44	12.00	
⊖ -2	11.06	8.00	

⑤

```css
:root {
  --step--2: clamp(0.50rem, calc(0.73rem + -0.21vw), 0.69rem);
  --step--1: clamp(0.75rem, calc(0.78rem + -0.03vw), 0.78rem);
  --step-0: clamp(0.88rem, calc(0.82rem + 0.27vw), 1.13rem);
  --step-1: clamp(0.98rem, calc(0.83rem + 0.76vw), 1.69rem);
  --step-2: clamp(1.11rem, calc(0.80rem + 1.54vw), 2.53rem);
  --step-3: clamp(1.25rem, calc(0.69rem + 2.76vw), 3.80rem);
  --step-4: clamp(1.40rem, calc(0.47rem + 4.64vw), 5.70rem);
  --step-5: clamp(1.58rem, calc(0.07rem + 7.53vw), 8.54rem);
}
```

⑥

```css
h1 {
  font-size: var(--step-5);
}

h2 {
  font-size: var(--step-4);
}
```

82

Deliver font files with intent

Web font files need to get served to the end user and we have some control over that journey.

SEE ALSO

Subsetting · Web fonts · Web typography

To use web fonts on our web pages, the font files need to be served from some-where, and, to remove the need for hosting the font files ourselves (in other words, served from the same place as the rest of our website's assets), we could use a font delivery service such as Google Fonts or Adobe Fonts' Web Projects.[1]

Services like these don't just deliver the files from another location, but usually do some smart things in the background, too, via an API. For instance, we can specify the exact weights and styles we might need just by changing something in the Google Fonts URL string, and what we get back is a smaller, subsetted font file that's optimized for faster delivery.

In the interest of not having this book become outdated by technical changes to these services, here's an *approximation* of the code most web font delivery networks use (please refer to their docs for actual usage instructions):

```
<link href="https://exampledeliverynetwork.com?
family=INSERT:weight=INSERT:style=INSERT" rel="stylesheet">
```

Although the font file(s) will ideally be optimized to be as small as possible, we're also getting some CSS along with this, and you can inspect that by pasting the URL into a new browser tab. This CSS file usually just contains the `@font-family` declarations, which again, will look *approximately* like this:

```
@font-face {
  font-display: swap; [2]
  font-family: 'INSERT_FAMILY_NAME';
  font-style: INSERT_NORMAL_OR_ITALIC;
  font-weight: INSERT_NUMERIC_WEIGHT_VALUE;
  src: url(INSERT_FONT_FILE_NAME.woff2) format('woff2');
}
```

[1] The service formerly known as Typekit.

[2] This line forces the browser to render the text using a system font first, then re-render the text in the correct typeface once the web fonts have loaded.

At the time of writing, the way that OpenType features are included in web fonts that come via the delivery networks tends to vary. Including OpenType features in the file dramatically increases the number of glyphs and therefore the total file size—and therefore the overall bandwidth of the site. In an ideal world, we'd have a situation like this:

1. The font delivery network serves the smallest possible file, probably omitting OpenType-related glyphs.
2. Once this core subset is loaded, serve the additional glyphs in a new subset, and re-render the type with those new glyphs.

Because of how the APIs of the delivery networks currently work in this fashion, it might be preferable to self-host your font files if you want that extra level of control.

We can also specify a range of glyphs to load if we don't want the entire font to be loaded, therefore saving on some precious bandwidth. For instance, adding `unicode-range: U+0025-00FF;` inside our `@font-face` rule would include all characters in the Unicode range U+0025 to U+00FF. This can also be used to get just one single character; instead of specifying a range, we can explicitly target one unicode value such as U+26 for an ampersand.

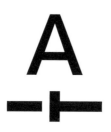

Use *OpenType* features on the web

OpenType is well-supported in modern browsers, but there are still some nuances.

SEE ALSO

Alternates • Inheritance problem • Kern • Fractions • Ligatures • OpenType • Small caps • Stylistic sets • Swashes

You might notice a common message throughout this book: a recommendation to use OpenType features as a way of doing much more with your typography. In desktop apps, controlling these is pretty straightforward via a GUI, but on the web, there are a few nuances when it comes to OpenType. The good news though is that OpenType is now widely supported in all major browsers. Just a few short years before writing this book, it was a very different and often painful story!

Let's turn on proper fractions, as recommended on page 162. To do so, we'll use the four character code[1] "frac":

```
p {
    font-feature-settings: "frac"; /* Turn proper fractions on */
}
```

What if they're already on, set somewhere else in the CSS, and we want to turn them off? We simple add either "off" or "0":

```
p {
    font-feature-settings: "frac" off; /* Turn proper fractions off */
}
```

I personally find the use of "0" a little confusing, because there are other OpenType features that use numerals after the four-character codes. For example, "swsh" 2 will give us the second variety of swash (if two varieties are indeed available in the font):

```
p {
    font-feature-settings: "swsh" 2; /* Use the 2nd kind of swash */
}
```

[1] Here's a handy list of the common four-character codes we'll need when using OpenType on the web:

c2sc: Small Caps from Caps
calt: Contextual Alternates
case: Case-Sensitive Forms
dlig: Discretionary Ligatures
frac: Fractions
hist: Historical Forms
hlig: Historical Ligatures
kern: Kerning
liga: Common Ligatures
lnum: Lining Figures
locl: Localized Forms
onum: Oldstyle Figures
ordn: Ordinal
subs: Subscript
sups: Superscript
smcp: Small Caps
swsh: Swash
ssxx: Stylistic Sets
tnum: Tabular Figures
zero: Slashed Zero

[2] wakamaifondue.com

Optional layout features

Some are turned on by default, but can be turned off. Others are turned off by default, but can be turned on.

`dlig` Discretionary Ligatures Off by default ☑ Show

`Ligature Substitution`

ยี ay aD aN cH cK cE DD eT eR Ee ED eN fF fR iNT iD iN kR le
lL lE lo lS oo oN PP Res Reb RX RR Ri Rg Ra Rs Re sS Th Tv Ta To
Te TH Te Ta Y Xe Xa YN ali aH alm aN ac aP at ab aD cos ck
cY cE co cc dd de ed ex ee Y fth ff fS ht ing ilg ts ip ix iN
kas ku ke ko ka ky lig ll ny ng oo PP fth Reu Res ri RM rK ry re
rv rr ry ra sS tu tv ra tz Th Tg ts Tu te ti DN vu vo ve va uN
wo wa wH Xe Xi

`kern` Kerning On by default ✓ Show

This feature appears to only modify glyphs generated by other features.

Character Set

362 characters ☑ Categories

Letter — Uppercase Latin

A	B	C	D	E	F
0041	0042	0043	0044	0045	0046
G	H	i	J	K	L
0047	0048	0049	004A	004B	004C
m	N	O	P	Q	R
004D	004E	004F	0050	0051	0052

But there's an elephant in the room: I love the simplicity of the four-character codes, but the reality is that `font-feature-settings` offers only low-level control and causes an inheritance problem — outlined on page 192 — where you have to keep redeclaring the entire string. The newer, high-level controls, such as `font-variant-ligatures` for ligatures, or `font-variant-numeric` for controlling alternate numerals, offer more flexibility. However, at the time of writing, they still don't enjoy wider browser support, so `font-feature-settings` (with some workarounds) is safest for now.

Finally, now for the warning that comes with all OpenType lessons: none of the code above will work if your font doesn't actually contain the OpenType features required, and not all fonts are created equal. Even if you see the feature on the type specimen page, that might not be in every font. If you have the actual font files yourself, you can see what's inside using an inspection tool such as Roel Nieskens's extremely useful *Wakamaifondue,* pictured to the left.[2]

Go deeper with
variable fonts

Manipulate elements of the typeface's design, and move past traditional weights and styles.

SEE ALSO

Axes • Italics • Obliques • OpenType • Weight • Widths

Variable fonts — technically OpenType Font Variations — are a relatively new technology that allow the end user control over parameters that previously would have been controlled only by the type designer. It frees typefaces from the traditional constraints of specific weights, widths, and any other parameter that would've usually resulted in a static font file. Want to make your bolds that little bit bolder? Just adjust the weight axis. Want to ever so slightly compress your type to fit more words per heading? Just adjust the width axis. Variable fonts allow us to make specific refinements to a typeface's properties, all from one font file. And the possibilities are potentially endless.

On the web, the fact that all of this information is contained in one file is a huge bonus, as it only means loading one asset. While it's true that the average variable font file is larger than one or two static font files, it's almost always more beneficial to use a variable font. Even just loading four static files for Regular, Regular Italic, Bold, and Bold Italic would usually consume more bandwidth than a single variable font file. And that single variable font also contains all of the other potential weights, widths, and any other variation you might find in the family — plus all of those in-between styles. Honestly, it's hard to argue *against* using variable fonts in most circumstances, especially now that they're widely supported in most browsers.

Support for using variable fonts in desktop design apps is also at a good level and most offer a user interface with sliders to control the various axes. It's also worth noting, though, that some variable font values can be set automatically. In Figma and InDesign, at the time of publication, the optical size axis is adjusted automatically as the font size is changed, so manual control over this axis means unchecking this default setting. In nondesign apps, such as word processors, sliders for the variable axes might not be available, but they should fall back to the named instances (i.e., the standard weights and styles) in the relevant dropdowns.

Go and play with some variable fonts — once you have, you won't look back.

→

Weight, width, and slant (referenced in CSS as *wght, wdth,* and *slnt)* are just three axes that might exist in a variable font — in this case, Anybody, by Ty Finck. Even just these three axes allow us to radically alter the type, and yet almost any parameter could become an axis if the type designer so chooses.

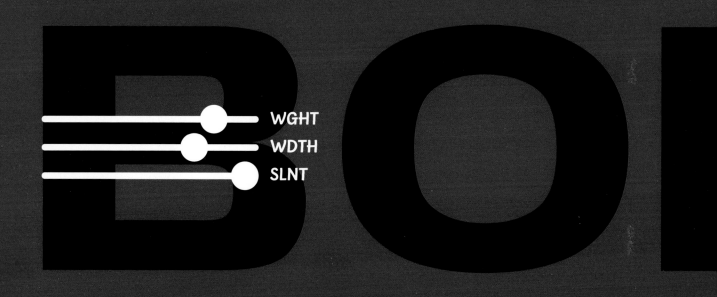

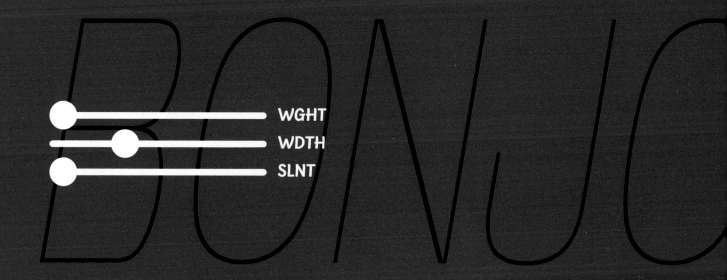

Control it all with *axes*

Axes provide the means of manipulating individual parameters within variable fonts.

SEE ALSO

Inheritance problem • Parametric axes • Variable fonts • Web typography

Variable fonts allow the end user — i.e., the person working with the text, who's usually but not necessarily a designer — to manipulate the appearance of the type in ways not previously possible with static fonts or at least not without having to employ multiple different font files. This control happens via axes. In most major desktop design applications, these axes are represented visually as sliders in the software's user interface.

The type designer defines which parameters users can control via axes. It's common for most variable fonts to contain a weight axis, which means that instead of selecting between predefined points on the scale such as Light, Regular, Bold, and Black (known as named instances), the user can choose an integer, for example, in between Bold and ExtraBold. In numeric terms, this might mean choosing a value such as "774" rather than "700" (Bold) and "800" (ExtraBold).

Even if we decide to select the more traditional instances of weight, doing so with a variable font means we can do that with just one font file. These instances are usually marked on the sliders as points that can be "snapped" to, and shortcuts are also provided in the regular Fonts dropdown we all know and love: selecting a "Bold" weight will effectively jump to that specific point on that font's weight axis.

Weight, however, is just one axis. Other common axes include width, italic, slant, and optical size. In CSS, these are known as the "registered" axes, but the type designer can map any parameter to any axis they choose, and these are known as "custom axes." In the variable version of Chee, type designer James Edmondson allows us to control the type's "yeast" and "gravity" properties (see opposite, top). In Climate Crisis,[1] type designers Daniel Coull and Eino Korkala allow us to control the type's "year" property (see opposite, bottom).

For more on balancing the extreme with the subtle, turn the page to learn about Parametric axes.

1 kampanjat.hs.fi/climatefont

———→

[TOP] Chee's custom axis "yeast" transforms both the width of the letterforms as well as their contrast, while its "gravity" axis affects where the thicker strokes sit in each character. Note how, when the two axes are combined, an almost infinite number of variations can be produced.

[BOTTOM] The "year" axis in Climate Crisis (which starts with a value of 1979 and extends to 2050) causes the letterforms to degrade as the slider moves from the past into future, reflecting the damage done to the polar ice caps over time.

yeast gravity

HANDGLOVES
HANDGLOVES
HANDGLOVES
HANDGLOVES
HANDGLOVES
HANDGLOVES
HANDGLOVES
HANDGLOVES
HANDGLOVES
HANDGLOVES
HANDGLOVES
HANDGLOVES
HANDGLOVES

Aa Aa Aa Aa Aa Aa

year

86

Use *grade* to maintain consistency

But beware: print and screen behave in opposite ways.

SEE ALSO

Multiplexed · Weight · Variable fonts

Some typefaces come in different grades; that is, slightly modified versions suited for different environments. The concept was initially developed to account for low-quality printing methods, or for printing on different paper types due to the way that ink bleeds into matte paper paper stock more than it does with glossy stock. With some details of type disappearing as the ink bleeds into the paper, alternate grades were created to anticipate some of these imperfections.

At first glance, grade might appear similar to weight: when viewed side by side, some grades appear lighter or heavier. But look closely and you'll see that grade actually has more in common with optical size, where contrast (the difference between the thickest strokes and thinnest strokes) is adjusted to optimize the type for different settings. In many ways, grade is actually a lot like the concept of ink traps but applied to the design of the type as a whole.

The most important thing about grade, though, is that whereas weight is designed to make different parts of the text look different from each other, grade is designed to maintain consistency. Type printed in one grade on a magazine's matte paper should ideally look identical (or at least as close as possible) to type printed in a different grade on the magazine's glossy insert.

And grade is not just limited to print — it can prove extremely useful on screens in achieving consistency between dark type that appears on a light background and light type that appears on a dark background. This is due to the way that light-on-dark type appears to "bloat" when compared to the seemingly thinner dark-on-light type. Grade offers a subtle way to counter this effect (more subtle than switching between weights, that is) and, if a grade axis is present within a variable font, we have an even finer level of control: we can tweak the type ever so slightly to ensure consistency across all of our different typesetting contexts.

[TOP] The custom "GRAD" axis in Roboto Flex allows the end user to fine-tune the grade. Note how grade, unlike weight (except in multiplexed fonts), doesnt affect the overall width of the glyphs.

[BOTTOM] On screens, light-on-dark text will appear slightly bloated, so, if possible, switch to a lighter grade when designing for Dark Mode. The opposite is true in print, however, which does result in this being hard to illustrate in a book!

meticulous

GRAD -200

meticulous

GRAD 133

meticulous

GRAD 0

meticulous

GRAD 94

meticulous

GRAD 150

Jeff Finck
THE NOR
REACH T

Set in the near future
soaring temperatures
attempt to understand

Jeff Finck
THE NORTHERN
REACH TRILOGY

Set in the near future, with the Earth ravaged by
soaring temperatures, displaced groups of humans
attempt to understand who has landed in an area

Refine and refine again
with *parametric axes*

*Dive deep down the rabbit hole of
granular-level refinement.*

SEE ALSO

*Axes • Metrics • Optical
sizes • Variable fonts •
X-height*

Variable fonts allow us a lot of extra control over type. But what if we could go
even further and dig into the real minutiae of what optimizes type at an almost
subatomic level? To tweak specific parts of letterforms' constructions that in
other variable fonts are manipulated only in conjunction with other parameters?
Well, it's possible with the help of parametric axes.

Before we continue, I should clarify that it's possible for a type designer to
assign *any* parameter of a design to a variable axis, and parametric axes are
not technologically distinct from any other kind of axis, per se, but rather are
a grouping of axes that represent "expert level" control that's more about subtle
refinement than it is about expression. They first emerged out of the work
conducted by Font Bureau for the variable fonts Amstelvar and Roboto Flex (both
of which were commissioned by Google Fonts).

When we manipulate an optical size axis, let's consider what's changing as we
move the slider. Typically, at the lower end of the axis (i.e., the smallest optical
size), x-height will be large and contrast will be low; at the higher end of the axis
(i.e., the largest optical size), x-height will be small and contrast will be high. In
other words: more than one thing is changing. And these can be broken down even
further, because if we accept that contrast is a subparameter, then it means we're
also altering the thickness of strokes in both the X dimension (think of the width of
the vertical stems of an uppercase "H") *and* the Y dimension (think of the height of
the horizontal crossbar of an uppercase "H"). Parametric axes give us control over
elements such as these opaque shapes in letterforms, as well as the transparent
shapes such as counters, and Y-axis alignment zones (ascender height, cap height,
x-height, and descender depth).

These four fundamentals—opaque widths in the X dimension, opaque widths
in the Y dimension, transparent spaces in the X dimension, and alignment zones
in the Y direction—form the core of the parametric axes concept proposed by
type designer David Berlow but could in theory be applied to any type design.
Importantly, they're intended to be used as further refinements to the more
common axes. In other words, get as far as possible with your optical size axis
and then refine ever so slightly with one or more of the parametric axes.

→

On each line, a different
parametric axis is
manipulated in the
Amstelvar variable font.
The black type is rendered
with the lowest value of
each axis, and the pink
type with the highest; it's
therefore possible to see
the extremes of each axis.
Note how some extremes
can actually create
undesirable results—but
the idea with parametric
axes is to manipulate axes
together. For instance, it
would be logical to make
changes to the YTLC,
YTUC, YTAS, and YTDE
axes at the same time,
and unwise to only alter
one of them.

XTRA
Parametric Counter Width

XTRA
Parametric Counter Width

XOPQ
Parametric Thick Stroke

YOPQ
Parametric Thin Stroke

YTLC
Parametric Lowercase Height

YTUC
Parametric Uppercase Height

YTAS
Parametric Ascender Height

YTDE
Parametric Descender Depth

YTFI
Parametric Figure Height

HamburgO

HamburgO

HamburgO

HamburgO

HamburgO

HamburgO

HamburgO

HamburgO

HamburgO

Beware the inheritance problem

Employ CSS custom properties to make your code future-proof and your life a little easier.

SEE ALSO

Axes • OpenType • Variable fonts • Web typography

1 pixelambacht.nl/2019/ fixing-variable-font- inheritance

In "Use OpenType features on the web" on page 182, I mentioned the inheritance problem that can occur when using `font-feature-settings`. The issue is that if we set up something like this in our CSS, turning proper fractions on for all paragraph elements...

```
p {
    font-feature-settings: "frac" on;
}
```

... and then use swash glyphs for all span elements...

```
p span {
    font-feature-settings: "swsh" on;
}
```

... the fractions will get overridden by the swashes. To prevent that, we have to write this:

```
p span {
    font-feature-settings: "frac" on, "swsh" on;
}
```

Having to redeclare the entire string every time could become arduous pretty quickly. And although there aren't that many cases where you'd necessarily *want* to have multiple OpenType features turned on for one element, the problem gets harder to manage with variable fonts because `font-variation-settings` behaves in the exact same way as `font-feature-settings`.

Roel Nieskens outlined this challenge in *Boiling eggs and fixing the variable font inheritance problem,*[1] highlighting how the following CSS...

```
body {
    font-variation-settings: "wght" 666;
}

em {
    font-variation-settings: "slnt" -14;
}
```

... will result in all `em` elements appearing slanted, but with the wrong weight, since the `wght` declaration is being overridden by the `slnt`.

To counter this we could redeclare the string...

```
em {
    font-variation-settings: "wght" 666, "slnt" -14;
}
```

... but we can make our CSS much neater and more future-proof by using CSS custom properties (opposite):

The slant setting for the "with water" text overrides the weight setting, forcing it to become slanted correctly, but rendered in the wrong weight. The solution is to redeclare the weight along with the slant, but things can get messy quickly.

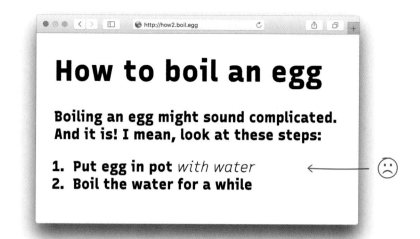

And, returning to our original OpenType example, we could do the same thing for our fractions and swashes:

```css
:root {
    --custom-wght: 100;
    --custom-slnt: 0;
}

* {
    font-variation-settings:
        "wght" var(--custom-wght),
        "slnt" var(--custom-slnt);
}

body {
    --custom-wght: 666;
}

em {
    --custom-slnt: -14;
}
```

```css
:root {
    --custom-frac: off;
    --custom-swsh: off;
}

* {
    font-feature-settings:
        "frac" var(--custom-frac),
        "swsh" var(--custom-swsh);
}

p {
    --custom-frac: on;
}

p span {
    --custom-swsh: on;
}
```

For a little bit of extra setup at the beginning, this results in much tidier CSS down the line and should tide us over until the day we no longer need to use these low-level settings.

Going further

Icons & symbols are like type — and often *are* fonts

Typeface have long contained ornaments and decorations, and many contemporary designs are entirely symbolic.

Considering that letters and words are in themselves symbols (visual representations of sound and speech) it's only natural that they're frequently discussed in typographic contexts. Iconographic and decorative glyphs have long been present in fonts, including long before the digital age, but contemporary digital fonts frequently contain icons in their glyph set, too. It's worth looking for these extra glyphs when you choose a font, as they make the type infinitely more usable. Symbols such as numbers in circles are great for issue numbers in a magazine. Arrows are perfect when adding captions. Ornaments can be extremely useful when adding extra flourishes to a logo in a way that matches the style and weight of the main type.

Of course, some symbols are considered essential. No font is properly usable without some of the basics, such as math operators or currency signs. And, as with diacritics, fonts with more international currency symbols will be more widely usable and therefore more robust for global brand usage.

The rendering of many icons, including emojis, is handled due to them being distributed as font files, and recent advances in color font technology allow icon designers to do even more with their emoji designs, as well as let end users manipulate the colors used. In fact, the power of color fonts has the potential to really elevate how we work with symbols in font files, emoji or otherwise. Turn the page for more...

SEE ALSO

*Color fonts •
Internationalization*

⟶

[TOP] Examples of various symbol glyphs found in some fonts. Note how, in emoji fonts, the underlying meaning of the character is shared across different typefaces, even though their visual interpretations differ — just like characters in regular fonts.

[BOTTOM] Emoji fonts that contain multiple weights also behave just like nonsymbol fonts in that their stroke thickness can be changed to best suit the context. Compare the Light weight of Noto Emoji on the left with its Bold weight on the right.

Tabac ①②③④⑤⑥⑦⑧⑨⑩❶❷❸❹❺❻❼❽❾❿✹✩✬★✭✫★✬★✩

SideNote ← ↑ → ↓ ↔ ↕ ↰ ↱ ↲ ↳ → ⤴ ⤵ ⟶ ⟵ → ← ★ ☆ ☹ ☺ ☻

Minion 3 ❧ ❧ ❦ ☙ ☾ ☽ ❧ ❧ ❦ ❧ ❦ ❀ ✿ ❁ ❀ ❋ ◈ ◅ ▻

Case ■ □ ▲ △ ▴ ▶ ▷ ▸ ▼ ▽ ▾ ◀ ◁ ◂ ◆ ◇ ○ ◌ ● ⊠ ☑ ✓ ← ↑ → ↓ ↔ ⚓ ↖ ↗ ↘ ↙ ⟨⟩

Apple Emoji

Noto Color Emoji

90

Expand your palette with layer fonts & *color fonts*

Who says text should use just one color? Layer fonts and color fonts open up so many more possibilities.

Layer fonts and color fonts, while different, effectively work towards the same goal: to move beyond "flat" colors when setting type.

Although they're just regular font files, layer fonts break out different layers into styles, so we duplicate our text box and select a different style for each one, overlaying them to create a new composite. In Francis Chouquet's Lustik, for example, the Back style uses handrawn squares for each character, and the Front style uses seemingly abstract shapes (see opppsite, top). When combined using a different color for each, they create legible characters. And when we use not just different colors but also different blend modes, we can create some truly interesting results. In Jamie Clarke's Rig Shaded, each style — Face, Extrude, Shadow, and two options for Shading — helps build a three-dimensional object, and even offers an inline stroke in the Bold weight (see another example on page 151).

Color fonts keep all of the potential options within one file, which is great in that it means there's no need to duplicate text boxes, but it does also mean that it's harder to turn off different layers if they're not needed. Plus, at the time of writing, support for color fonts is a pretty moveable target — especially as color fonts themselves can be broken down into SVG fonts (effectively an image stored for every glyph), which work well in desktop design apps, and COLORv1 fonts, which work better on the web and are ultimately more powerful — but in terms of support, it's early days.

In the interest of keeping this book relatively timeless, I've very consciously avoided over-focusing on contemporary technology that's yet to become established as a norm; however, there's a lot to be excited about, especially when we consider how it's possible (or very nearly possible) to specify custom colors for gradients, too.

Depending on how generous the type designer is feeling, a color font can come with one or more palettes (the default colors used to render it). End users (that's us) can select a different palette to use, make our own palettes, or even just override one or more of the colors in any given palette. In practicality, this means we can achieve expressive, logo-like typesetting that would previously have required long hours spent in our vector-editing app of choice.

SEE ALSO

Icons & symbols • Stylistic sets • Variable fonts

⟶

From top to bottom: Using blend modes when combining Lustik's two layers mimics overprinting techniques. Combining different layers within Rig Shaded allows us to create 3-D type, and each layer can be used or (not used) as required. Foldit uses gradients that can be colored, and it's a variable font, too. Adobe's Trajan Color showcases multiple palettes, which in an OpenType SVG font, can be selected using stylistic sets. Gilbert Color uses a variety of colors across its character set.

MERCII

Lustik (2 layers)

BELLUTON

Rig Shaded (4 layers)

Fold Fold Fold Fold Fold Fol
Fold Fold Fold Fol

Foldit (color font)

COLUMNS COLUMNS
COLUMNS COLUMNS
COLUMNS COLUMNS

Trajan Color (color font)

münchen

Gilbert Color (color font)

Populate your *font menu* meaningfully

If only it was as easy as downloading some font files.

SEE ALSO

Font • Format

In order to use a particular typeface, first its fonts need to appear in our apps' Font menu. On the face of it, we just need to install the fonts, right? These days there are a variety of ways that Font menus get populated and only some involve installation.

Some apps bring fonts with them, but only for use in that particular app, and this is often the case with browser-based apps. Figma, for instance, has a very large font menu populated predominantly by a custom subset of the Google Fonts library, plus a few others. Google's Workspace apps use a handful of nonsystem fonts, but allow you to easily add any font from the Google Fonts library to your Font menu.[1]

If you've got a Creative Cloud subscription, you'll have access to the Adobe Fonts library and, once activated, these fonts can be used in any app on the machine that's synced to your Creative Cloud account. Although these fonts *are* technically installed, the files are obfuscated in such a way that means the physical files are hard to locate. The Monotype Fonts service works in a very similar way, and both Creative Cloud and Monotype Fonts allow third-party fonts to be managed and synced by their services.

Let's not delve into specifics of different apps and services, though. The point is that there are lots of ways to populate a Font menu and not all apps' Font menus are going to be the same. But however you get fonts in there, it's worth remembering that there can be conflicts; i.e., identically or similarly named fonts, but slightly different versions. It might be that you have a local font file that contains different OpenType features to one coming from a service like Adobe Fonts. Or a variable version you're using in Figma that's conflicted with a static font you installed locally. Or a font that's identical in every way, but one version is coming from Adobe Fonts and the other from Google Fonts.

In all cases, it pays to use a font manager. Activating and deactivating fonts not only helps you keep your Font menu sane if you have a large font library, but it also helps when dealing with conflicts.

[1] A detailed guide is available on fonts. google.com/knowledge/ choosing_type/adding_ fonts_to_google_docs

→

Here's an approximation of font-management software interacting with the Font menu that shows up within any app that allos the user to change the font. Note how the unactivated (grayed out) fonts in the font manager don't appear in the Font menu's list.

Fonts

▲

Cabinet Grotesk

Carol Gothic

Case VAR

Chalkduster

Changing

Cinegenic

Clash Display

Climate Crisis

Cochin

Decoy

Def Sans VF

Degular

Degular Display

Degular Mono

Degular Text

Difot

DIN Regular

DIN Condensed

▼

All Fonts

Active Fonts

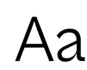

Cabinet Grotesk

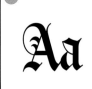

Carol Gothic

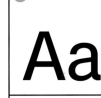

Case VAR

Chalkdu

Changing

Clash Variable

Cinegenic

Clash Di

Climate Crisis

Cochin

Comic Sans

Copperp

Support indie type *foundries*

While you can get your fonts from the big companies, developing a relationship with the smaller, often one-person foundries can go a long way.

You know my favorite thing about type foundries? It's that almost all of them are independents. I mean, sure, there are the huge ones everyone's heard of, including those that acquire independent foundries, but most of the time, they're very small teams, working on their own. Often, they're just one person. Can you call yourself a foundry if you're just one person? Sure you can!

I don't sit on either side of the fence—I've worked for huge companies and tiny companies, and I've bought fonts from the massive conglomerates and the one-person-bands—but I do love the feeling of supporting those who are doing it by themselves, often from a modest home studio. And I'm always keen to point out to designers that befriending foundries can be extremely helpful, since once you've got a relationship with them, they're more likely to accept any feedback or requests you might have, consider some bespoke licensing, and maybe even give you new fonts to try out—or perhaps even for free! There have been so many times when a type designer friend has helped me out with an issue or an opinion.

How do you befriend a foundry, exactly? Well, just reach out to them via the contact details on their website or via social media. The great thing about so many type foundries being small outfits is that the person running the comms is probably also the person designing the type, or they at least have good exposure to the person who is. Of course, that's not to say that the big folks aren't receptive to questions, feedback, requests, etc., but there's a more immediate connection with the indie folks. So go and support your independent type designers today!

SEE ALSO

Choose a typeface • Licensing • Typeface

⟶

A selection of independent type foundries' websites along with type.lol, which serves as a directory of type foundries.

↑ ohnotype.co
← blazetype.eu
↓ hoodzpahdesign.com

Santa Ana Sans

This is Santa Ana Sans, a geometric sans with just enough zazz.

12 styles

Light, Light Italic, Regular, Italic, Medium, Medium Italic, Semibold, Semibold Italic, Bold, Bold Italic, Extra Bold, Extra Bold Italic

Higher x-height

↑ type.lol
↓ jamieclarketype.com
fontwerk.com ↘

JAMIE CLARKE TYPE

Home Fonts Lettering About Blog

Crafted letters and innovative fonts

HELLO!

Fontwerk

McQueen
Superfamily

Fontwerk

Yes, *we need more fonts*

It's not like we have enough songs, is it?

SEE ALSO

Family · Licensing · Typeface

Do we need more fonts? Please see the page opposite for the short answer. Oh, you want a longer one? Alright, here you go:

There are so many fonts out there and so many options within families that, when looking at pure numbers alone, it might be tempting to declare that we have enough already. But typeface design, like all creative expressions, knows no bounds. Saying we already have enough type in the world is like saying we already have enough music. Music, too, is abundant and many pieces of music are so similar to others — in Western music, there are only 12 notes, after all — that we could argue that there's no need for yet more of it. But I think we can all accept that that would be absurd. Type allows type designers to express themselves creatively, and type users to put those creations to use as further expressions of our own — much as with musicians and listeners.

In TypeTogether's book, *Building Ligatures,*[1] Veronika Burian argues for the need for more typefaces and says:

> "Trends, technology, media, and even language evolve. These changes require an appropriate typographic response that becomes an expression of contemporary culture; and each generation has their own expression."

Let's also move beyond considerations around expression, generally, and consider that we need fonts to do things that others cannot.

Burian notes that, until recent history, type design has been dominated by the Western world, but in a more global society, empowered by the internet, *"we need more and better language support, which means better fonts, expansion into new scripts, and designs that are respectful of regional traditions while also being a tool for expression and diversity."*

Creative requirements for type and technical requirements for fonts will always shift with cultural changes across the globe, and making do with a finite set of fonts isn't compatible with this notion. So we should absolutely draw influence and expertise from history, but type can never stop moving. Yes, we'll *always* need new fonts.

[1] TypeTogether, 2022

→

As an aside, notice how different all of these typefaces seem not just in style, but in *perceived* size — and yet they're all set at the exact same font size and with the exact same leading value. Be sure to read about how the em square is the main reason behind the perceived size difference in type on page 22.

yes yes yes yes
yes yes yes yes
yes yes yes yes
yes yes yes yes
yes yes yes yes yes
yes yes yes yes
yes yes yes yes
yes yes yes yes

Latin is just one script & *writing system*

And "script" and "writing system" aren't quite the same thing.

SEE ALSO

Diacritics • Glyphs • Internationalization

This book talks about typography within the context of the Latin script, but we should remember that Latin is one of many, many writing systems around the world. The Latin script was based upon the Greek script, and uppercase letterforms from Greek were also the foundation of the Cyrillic script. Some other examples of writing systems include Arabic, Hebrew, the various Indic scripts of south Asia, the old *and* newly invented scripts from sub-Saharan Africa, the Syllabics grouping for languages used by the indigenous populations of North America, and the Hangul writing system invented for Korea.

It's also worth understanding that although we often use the terms "script" and "writing system" interchangeably, there *is* a difference. A script is a visual interpretation of speech, and, when it's combined with a set of rules and usage conventions (which are known as an orthography), then we have a writing system. Yes, languages have some of their own specific rules — the alphabets may vary, the characters represent different sounds, diacritics differ — and yes, these can even vary by region, but generally speaking there's a Latin writing system, a Greek writing system, a Korean writing system, etc. Some writing systems even combine different scripts, and in Japanese, three different scripts are used: Hiragana, Katakana, and Kanji.

Different scripts don't just mean different letterforms or rules for how to set type, either. Italics aren't relevant in most Asian writing systems. Indic scripts have no notion of x-height. And in many cases, getting text to render correctly as the user types it can be hugely challenging if the wrong (i.e., default) type-setting settings are used. This is largely because of shaping, which is explored on page 210.

⟶

All of these words and phrases from various different scripts are all set in typeface from the huge Noto Sans megafamily. From top to bottom: the Bengali, Myanmar, Bamum, Hebrew, Armenian, Tai Le, Hiragana (one of three Japanese scripts), Devanagari, Mongolian, Hangul (used for Korean), Greek, Thai, Arabic, Cyrillic, Simplified Chinese, and Kannada scripts.

জনমগ

ਹੰਘੀਂਗ਼ਂਂ੍V। ਂ

Fr∩n

すべての

ਤੁਪ੍ਲਂਂੱ

'Ολοι οι

Μμθέ

人生而自

ਹੰਰਂਰੰਰਂਰਂਕ੍ਲਾ

לכ אדם יש

ਹੀਂਰ ਗ੍ਹਾ

जें कि राष्ट्रसभक

모든인간

تمان

беручи

ಎಲೆಮನ

Do better at
internationalization

The sad truth is that not enough fonts support multiple languages, let alone multiple scripts.

SEE ALSO

*Classification •
Internationalization*

It's not an overstatement to say that for many years, a large number of type designers, type foundries, and type distributors took a very Western-centric, Latin-centric, and arguably even Anglo-centric view on the world of type. It's only in very recent history that that's started to change, with more emphasis being placed on other languages, writing systems, and markets.

A huge challenge that many designers face is working with a brand typeface that works well across languages that use the latin script, but doesn't support, for example, Ukrainian (i.e., the Cyrillic script), as the company seeks to expand its reach. What do we do for our client in that situation? We're usually faced with the following choices:

1. Choose a separate typeface for the new language requirements — which will dilute the brand and create inconsistency.
2. Rethink the entire brand's type system entirely and pick a new typeface that supports every language required — which is a very expensive process and usually not viable.
3. Commission a bespoke extension to the typeface to include the script required — which is also a very expensive and potentially lengthy process.

None of those situations are ideal, and most people simply opt for the first one as the easiest (and cheapest) way out. The best approach is to choose a typeface that supports multiple scripts right from the get-go. But it's also fair to say that we rarely always know how many scripts we're going to need. Even if we say, *"as many as possible,"* the reality is that there is a relatively small number of typefaces with large multiscript coverage.

Even the term "non-Latin" is problematic as it's hardly fair to define something by that which it *isn't,* and yet — at the time of writing — no replacement terms have successfully mitigated the problem. But it's encouraging that ATypI have formally dropped the Vox-ATypI classification system [1] in recognition of it being so Latin-centric.

This much is true: we need to do better at internationalization.

1 atypi.org/2021/04/27/atypi-de-adopted-the-vox-atypi-typeface-classification-system

⟶

Ever seen this little critter appear in your text boxes? The symbol is known as "tofu" and is there to tell you one thing: the font you're currently using doesn't have a glyph for the character you're trying to type. In the vast majority of Latin-first fonts, you'll see this if you try to type a so-called "foreign" character — just copy-and-paste a non-Latin character from the internet and you'll probably see this happen (unless that script *is* supported in the font). But in some fonts with a limited glyph set, you might even encounter this if the type designer hasn't added a relatively common non-English glyph such as "ø". *Shame!* The presence or absence of tofu can therefore be a good way to help us decide on the suitability of certain typefaces and their fonts. And the proliferation of tofu also tells us something else: we need to do better at internationalization!

Do *much* better at *internationalization*

As users of Latin type, we take shaping for granted, and when shaping goes wrong, it can mean unreadable text in other scripts.

SEE ALSO

Classification · Diacritics · Internationalization

The considerations around internationalization are not just limited to the need for multiple scripts in our fonts. Many fonts don't even have the glyphs needed to cover Central European languages (as outlined in the previous chapter.).

When working with text in a different language to their own, something many designers misunderstand is that having the glyphs required by other scripts is only part of the internationalization puzzle. This is because many writing systems require the software used for setting type to also respect its conventions. Changing the text direction from left-to-right to right-to-left is not enough — the type must be rendered with the correct shaping engine.

Shaping is when the software assigns the correct glyphs to the characters in the text and then decides exactly where to place that glyph. In Latin, we have it pretty easy — the most noticeable effects of shaping are when individual glyphs get swapped out for a ligature (substitution) or when kerning pair data gets used to improve the spacing around a pair of glyphs (positioning). If shaping doesn't happen, the type might not be optimized, but it'll still be readable.

In other writing systems, however, a lack of shaping, or improper shaping, means that text could be entirely unreadable. For more information, see Ramsey Nasser's article *Unplain text.*[1] For an amusing look at the problems this causes for Arabic text, see his blog *Nope, Not Arabic.*[2]

In Adobe's software, be sure to switch to the *World Ready Paragraph Composer* when setting non-Latin type. Above all else, refer to the expertise of someone who's fluent in the language you're working with.

[1] increment.com/ programming-languages/ unplain-text-primer-on-non-latin

[2] notarabic.com

→

Ramsey Nasser's Harfbuzz shaping server (github. com/nasser/shapeserver) enables correctly shaped 3-D text in Three.js. The screenshot at the top shows the word "hello" incorrectly shaped (as is often the way in Latin-centric software), while the screenshot below shows the shaping being applied correctly.

Internationalization & licensing go hand in hand

Even the huge corporations can find this stuff hard.

SEE ALSO

*Internationalization ·
Licensing*

I'd like to tell you a story:

For around 50 years, the Swedish home furniture brand Ikea used Futura for their corporate typeface and then, from 2003, an adaptation of Futura called Ikea Sans. However, in 2009, they switched it to Verdana and when this change went public, the design world went wild with rage. Verdana (designed by Matthew Carter for Microsoft in 1996) was intended for screens (and screens that were relatively lo-res by today's standards), and yet here was a massive brand using it for all of their materials including on its packaging, in its brochures... *everywhere.* Although unconfirmed, I imagine that the growth of the company's digital business also contributed to this decision to use a digital-first typeface. And, with Verdana being a system font, available on virtually every computing device in the world, I'm assuming there would've been no licensing fees to be paid either.

Whether Ikea felt pressured by the design world's reaction to Verdana is unknown, but ten years later, the company cited the need (again) for better internationalization and changed typeface once more. This time to Noto.

The Noto megafamily was born out of a collaboration between Google and Monotype, and its *raison d'être* is to serve as many languages and writing systems as possible. Adopting it as the brand typeface for an international company makes a lot of sense. And because it's available to use for free from Google Fonts, there would presumably be no licensing fees to pay for its use on the staff workstations, or as a web font.

This story probably isn't going to get made into a film, but it does highlight some considerations around internationalization and licensing, and shows that these challenges affect even the very big brands. Is the only option to use a free font that everyone else can use, too, thus removing any uniqueness for the brand? No, but the reality is that very few typefaces have robust language coverage and more needs to be done in this area (see related rant on page 208).

Neither Futura, Ikea Sans (a customized version of Futura not shown), nor Verdana have support for Asian glyphs, as indicated by the "tofu" icons. Noto Sans, however, does. Also note the similarity between the vertical metrics in Verdana and Noto Sans — something that no doubt made the transition easier in the company's various design systems.

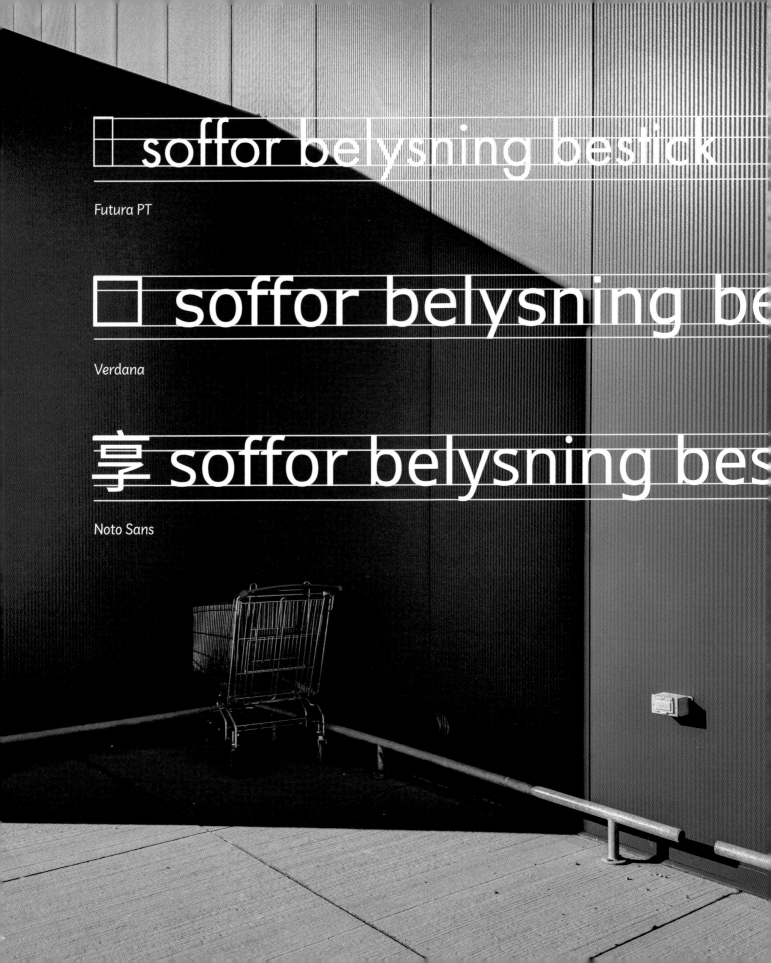

soffor belysning bestick

Futura PT

soffor belysning be

Verdana

享 soffor belysning bes

Noto Sans

Follow *Nix's hierarchy of typographic needs*

A framework for achieving typographic nirvana.

SEE ALSO
*Typography matters •
We need more fonts*

You might be familiar with Maslow's hierarchy of needs,[1] the triangle of five layers of human "needs," with basic physiological needs at the bottom (sustenance, sleep, shelter) and self-actualization at the top, with each of the five layers building on the one beneath it. The idea is that you can't have one of the layers without the previous needs being met; and therefore to achieve the fullest sense of personal growth, there are quite a few things that need to come before it.

Monotype's Charles Nix has a talk[2] in which he takes Maslow's hierarchy of needs and applies the same idea to typography, resulting in what he calls *Nix's hierarchy of typographic needs.*

The base need (bottom layer) is **font functionality**, where the typeface and the typography doesn't even matter; there just needs to be something to relay the message. With that as the foundation, the next layer is **font security**, where the user is safe in the knowledge that by using the font, they're free of any legal or monetary obligations. Then comes **typographic love and belonging**, where typography really begins. We care about type and feel a part of the typographic community. This moves onto **typographic esteem**, where our choices generate esteem for ourselves and esteem that comes from others. Finally, with all other needs met, we have **typographic actualization**, where our typographic choices do the perfect job of reflecting a brand's values.

Although this is an arbitrary concept, it's a useful consideration when we think of the many users of type: from folks who don't care at all to professional font nerds. Where do we see ourselves on this scale? What can we do to educate others and move them up a layer? And what can we practice so that we can reach our own "typographic actualization"?

1 en.wikipedia.org/wiki/
Maslow%27s_hierarchy_
of_needs

2 monotype.com/resources/
expertise/hierarchy

Typographic actualization
Visionary typography

Typographic esteem
Differentiation, distinction, contrast

Typographic love and belonging
Joining the typographic community

Font security
Indemnification through licensing

Font functionality
Fonts as functional assets

It depends

In typography, context is everything.

SEE ALSO

Line height • Measure • Optical trickery

My absolute favorite answer to any question about whether or not something is the right or wrong typographic approach is... *it depends*. And while that might seem a little like a cop-out answer, in truth it's the most honest response.

The first reason is that "it depends" acknowledges the need for context, and when typesetting, context is everything. Should this weight be used? Well, it depends on the optimal size it's being read at, its role in the document's hierarchy, and what other weights are in use in the text around it. Should this measure be used? Well, it depends on other elements on the page, and the leading, and again the font size. Should this alternate glyph be substituted? Well, it depends on how and why this particular context makes it more or less suitable than the default. Just as leading influences measure (wider text boxes need tighter leading), almost any one typographic choice influences all others. One choice cascades into yet more—and yes, that can be daunting. But embracing this cascade of cause and effect is the mark of a true typographer! That's why regular folks just stick to the defaults.

The second reason is that so much of typography is about rule breaking. On the face of it, manually moving an opening quotation mark outside of its containing box doesn't sound like something we should do, but try it, and you'll see how the optical alignment of the column looks much better (for more, see page 136). But should we do that all the time? Is it on the web, powered by a CMS, in text controlled by an editor rather than a designer? Perhaps not. The manual workaround might not be justified by the additional time and effort.

And so every rule, and every breaking of a rule, should be treated as a guideline, with nothing set in stone apart from, perhaps, that eternal truth of evaluating every single typographic decision based on context. Because, well, *it depends*.

→

Sometimes you just need to break words into little bits, set them in a ridiculously elaborate typeface, reduce the leading until the characters are overlapping, and just *go with it*.

100

Continue your typographic journey

It's time to see how deep this rabbit hole goes.

You'd think all of these principles would cover a fair amount of ground, wouldn't you? And I hope that they have. But there's still lots in the wonderful world of typography that I haven't really been able to explore, or at least explore with more than a passing mention.

If you're looking for jumping-off points as we reach the end of our time together, I'd recommend continuing your journey by delving into the following typographic subjects:

* Special consideration for typography in AR / VR
* Platform-specific considerations for iOS and Android app development
* Web font performance, variable-to-static bandwidth comparisons
* The different kinds of parentheses and brackets, when to use them, and how well they're supported in different fonts
* Further considerations for accessibility beyond legibility basics
* Ordinals and superscript / subscript
* Unicode points and writing systems other than Latin
* Implementing icon fonts on the web as part of a design system
* The technical specifics of working with color fonts in the browser
* Type design itself

More than anything, though, I hope that this book has ignited, restored, or expanded a love for all things type and shown that even the most subtle typographic tweaks can lead to a radically improved reading experience. I hope you'll return to these pages for ongoing guidance, inspiration, and perhaps even a little comfort. Spread the word: *typography matters!*

BIBLIOGRAPHY

Thinking with Type by Ellen Lupton (Princeton Architectural Press, 2010); *Stop Stealing Sheep and Find Out How Type Works* by Erik Spiekermann (The Other Collection, 2022); *Building Ligatures* by TypeTogether (TypeTogether, 2022); *Lettering & Type* by Bruce Willen & Nolen Strals (Princeton Architectural Press, 2009); *The Elements of Typographic Style* by Robert Bringhurst (Hartley & Marks, 2008); *Inside Paragraphs* by Cyrus Highsmith (Princeton Architectural Press, 2020); *The Anatomy of Type* by Stephen Coles (Harper design, 2012); *Designing Fonts* by Chris Campe & Ulrike Rausch (Thames & Hudson, 2020).

About the Author

Elliot Jay Stocks is a designer, author, speaker, and musician who has long been obsessed with type. He was an early adopter of and vocal advocate for web fonts, and became known for his blog posts and conference talks on the subject of web typography. He captured this new-found enthusiasm for typography by founding the printed magazine *8 Faces,* which sold out of its first issue in under two hours, later became a book that raised over £50,000 in Kickstarter funding, and had an accompanying blog, run by Elliot's longtime friend Jamie Clarke, with over 225,000 followers.

While running *8 Faces,* Elliot became the Creative Director of Typekit and helped evolve the service from its web font origins into a fully integrated part of the Creative Cloud, now known as Adobe Fonts. After leaving Adobe, Elliot held creative director roles in companies big and small, and cofounded the lifestyle magazine *Lagom* with his wife. From 2020 to 2023, he collaborated with Google to create the online typography resource known as Google Fonts Knowledge.

Elliot has long been a familiar face at design and tech conferences around the world, and at the time of publication, has spoken at over 80. He has also taught a variety of workshops for several years—almost entirely on the subject of typography. His work has been profiled in publications such as *Communication Arts, Creative Review, Computer Arts, Page, The Independent,* and *Design Week.*

Since leaving Google and returning to life as an independent designer, Elliot runs the newsletter *Typographic & Sporadic* and hosts the podcast *Hello, Type Friends!* In his almost-nonexistent spare time, he records electronic music as Other Form.

Elliot lives in the countryside just outside Bristol, UK, with his wife, their two daughters, and their two dogs.

Acknowledgments

The illustrations in this book make extensive use of Unsplash's free library of photography on unsplash.com. Although no credit is required by the website, I'd like to acknowledge the work of the photographers whose imagery I've used: Annie Spratt (pages 11 & 33), Bernard Hermant (page 217), Birgith Roosipuu (page 85), Cesira Alvarado (page 97), Charles Deluvio (page 213), Codioful (pages 27, 67, 71, 73, 83, 93, 145, 165, 177 & 207), Dan Cristian Pădureț (page 45), Evie Shaffer (page 39), Jazmin Quaynor (page 219), Kiwihug (page 31), Kseniya Lapteva (pages 69 & 153), Lance Reis (page 201), Max Fuchs (page 215), Milad Fakurian (105), My Mind (pages 117, 131 & 209), Main Patel (page 107), Spencer Watson (page 123), and Wolfgang Hasselmann (page 43).

I'd like to thank my wife Samantha and our daughters Thea and Gwen, for their love, patience, and unwavering support while I wrote and designed this book, especially while I gave up on client work during the summer of 2023 to get it over the line. But more importantly, thank you for being such wonderful people to spend a life with. I'm so lucky to have you at my side, and this book is for you.

Ellen Lupton for her kind and generous foreword as well as her early influence on my love for type thanks to her *Thinking with Type* book. Jonathan Simcosky, my editor at Quarto, for inviting me to write this book in the first place, and the easy-going guidance throughout. David Martinell, my art director at Quarto, for putting up with my boundary-pushing artwork requests. Gabrielle Bethancourt-Hughes and Ron Hampton, my copyeditors, for helping sculpt my sentences into something way better than their original form.

Jamie Clarke for the friendship, advice, last-minute sanity check, and of course the SideNote typeface used for the illustrations' captions throughout the book. (See you in The Rising Sun, mate!) Ty Finck for the back-and-forth voice messages that have become a little bit like an audio diary for me throughout this whole process, as well as all those lovely typefaces. Emma Luczyn for my wonderful logo. James Edmondson of OH no Type Co. for reviewing my use of Degular and Swear, and for letting me test out Degular Mono before it was publicly released. Francis Chouquet for lending his handwriting, calligraphy, lettering, and type to page 34. John Boardley for the historical image research and reviewing. Oliver Schöndorfer and Indra Kupferschmid for their work on the font matrix. Doug Wilson for the Linotype image research. Laurence Penney for reviewing the font format chapter. Roel Niskins for reviewing the inheritance chapter. Erik Spiekermann for the years of advice and accidental mentorship in the type world. My colleagues at Adobe Fonts for what in hindsight were some of the best years of my professional life. My parents for always encouraging my creativity from a young age and never pushing me towards a "sensible" career choice. Everyone who continues to follow my antics via my newsletter *Typographic & Sporadic*. Thank you.

Index

quarto.com

© 2024 Quarto Publishing Group USA Inc.
Text & illustrations © 2024 Margin Media, Ltd.

First published in 2024 by Rockport Publishers, an imprint of The Quarto Group,
100 Cummings Center, Suite 265-D, Beverly, MA 01915, USA.
T (978) 282-9590 F (978) 283-2742

All rights reserved. No part of this book may be reproduced in any form without written permission
of the copyright owners. All images in this book have been reproduced with the knowledge and prior
consent of the artists concerned, and no responsibility is accepted by producer, publisher, or printer for
any infringement of copyright or otherwise, arising from the contents of this publication. Every effort
has been made to ensure that credits accurately comply with the information supplied. We apologize
for any inaccuracies that may have occurred and will resolve inaccurate or missing information in
a subsequent reprinting of the book.

Rockport Publishers titles are also available at discount for retail, wholesale, promotional, and bulk
purchase. For details, contact the Special Sales Manager by email at specialsales@quarto.com or by
mail at The Quarto Group, Attn: Special Sales Manager, 100 Cummings Center, Suite 265-D, Beverly,
MA 01915, USA.

10 9 8 7 6 5 4 3 2 1

ISBN: 978-0-7603-8338-4

Digital edition published in 2024
eISBN: 978-0-7603-8339-1

Library of Congress Cataloging-in-Publication Data

Designed & illustrated by Elliot Jay Stocks
Typeset in Degular and Swear from OH no Type Co. and SideNote from Jamie Clarke Type

Printed in China